7 - FEB 2020		Essex Works. For a better quality of life
/ FED ZUZU		SHA
	r _y .	

Please return this book on or before the date shown above. To renew go to www.essex.gov.uk/libraries, ring 0845 603 7628 or go to any Essex library.

Essex County Council

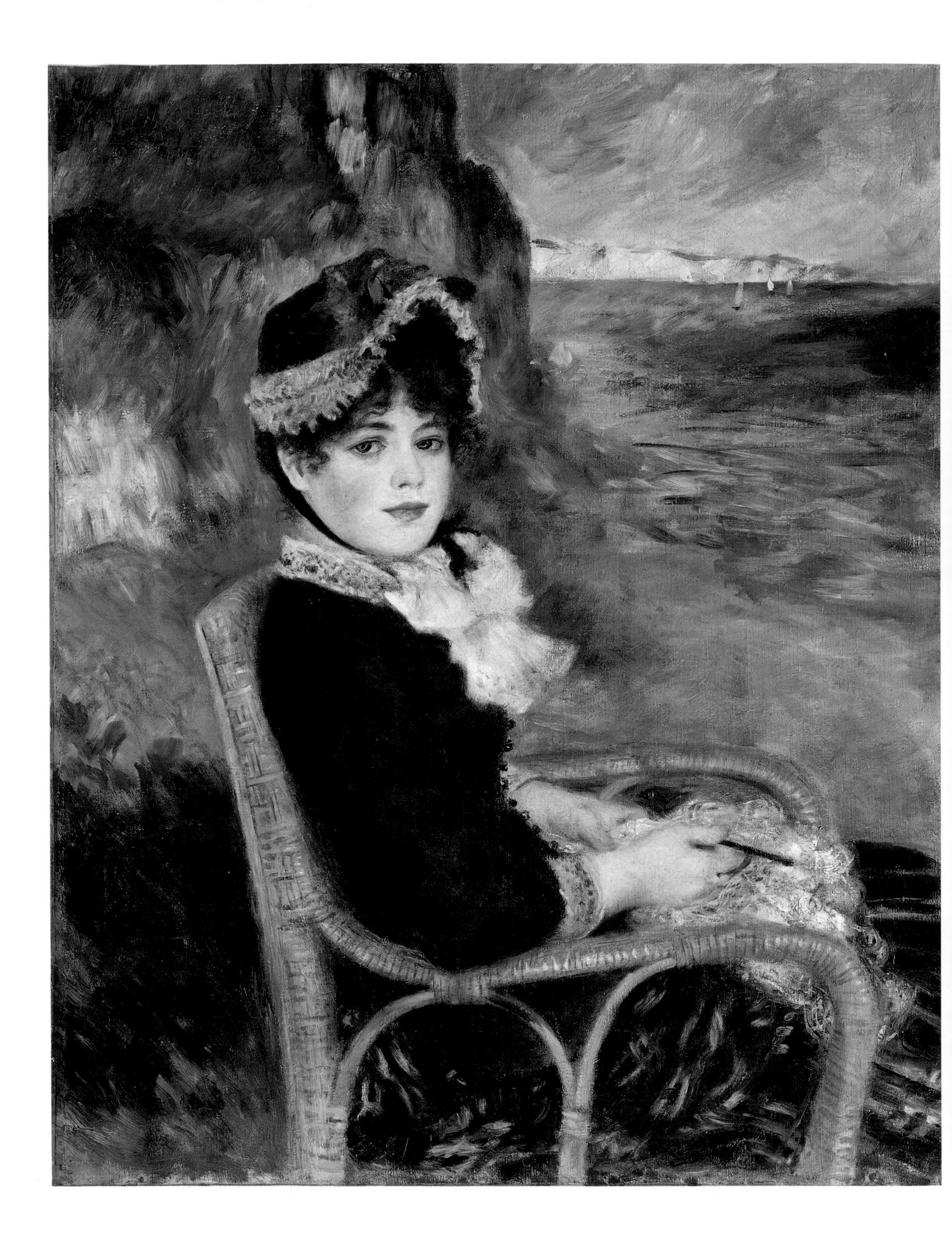

Pierre-Auguste Renoir

1841-1919

A Dream of Harmony

FRONTISPIECE:

By the Seashore, 1883

Oil on canvas, 92 x 73 cm (36.2 x 28.7 in.) New York, The Metropolitan Museum of Art, H. O. Havemeyer Collection

To stay informed about upcoming TASCHEN titles, please request our magazine at www.taschen.com/magazine or write to TASCHEN America, 6671 Sunset Boulevard, Los Angeles, CA 90028, USA; contact-us@taschen.com; Fax: +1-323-463-4442. We will be happy to send you a free copy of our magazine, which is filled with information about all of our books.

© 2012 TASCHEN GmbH Hohenzollernring 53, D–50672 Köln www.taschen.com

Original edition: © 1986 Benedikt Taschen Verlag GmbH
Produced by: Ingo F. Walther, Alling
English translation: Hugh Beyer, Leverkusen
Cover design: Sense/Net Art Direction,
Andy Disl & Birgit Eichwede, Cologne, www.sense-net.net

Printed in China ISBN 978-3-8365-3965-4

Contents

6 Renoir's Family, Friends and Teachers 1841–1867

> 16 A New Style of Art 1867–1871

The Great Decade of Impressionism 1872–1883

30 Masterpieces of Realist Impressionism

The Crisis of Impressionism and the "Dry Period" 1883–1887

68 Sickness and Old Age 1888–1919

80 Renoir's Late Works

92 Pierre-Auguste Renoir 1841–1919: His Life and Work

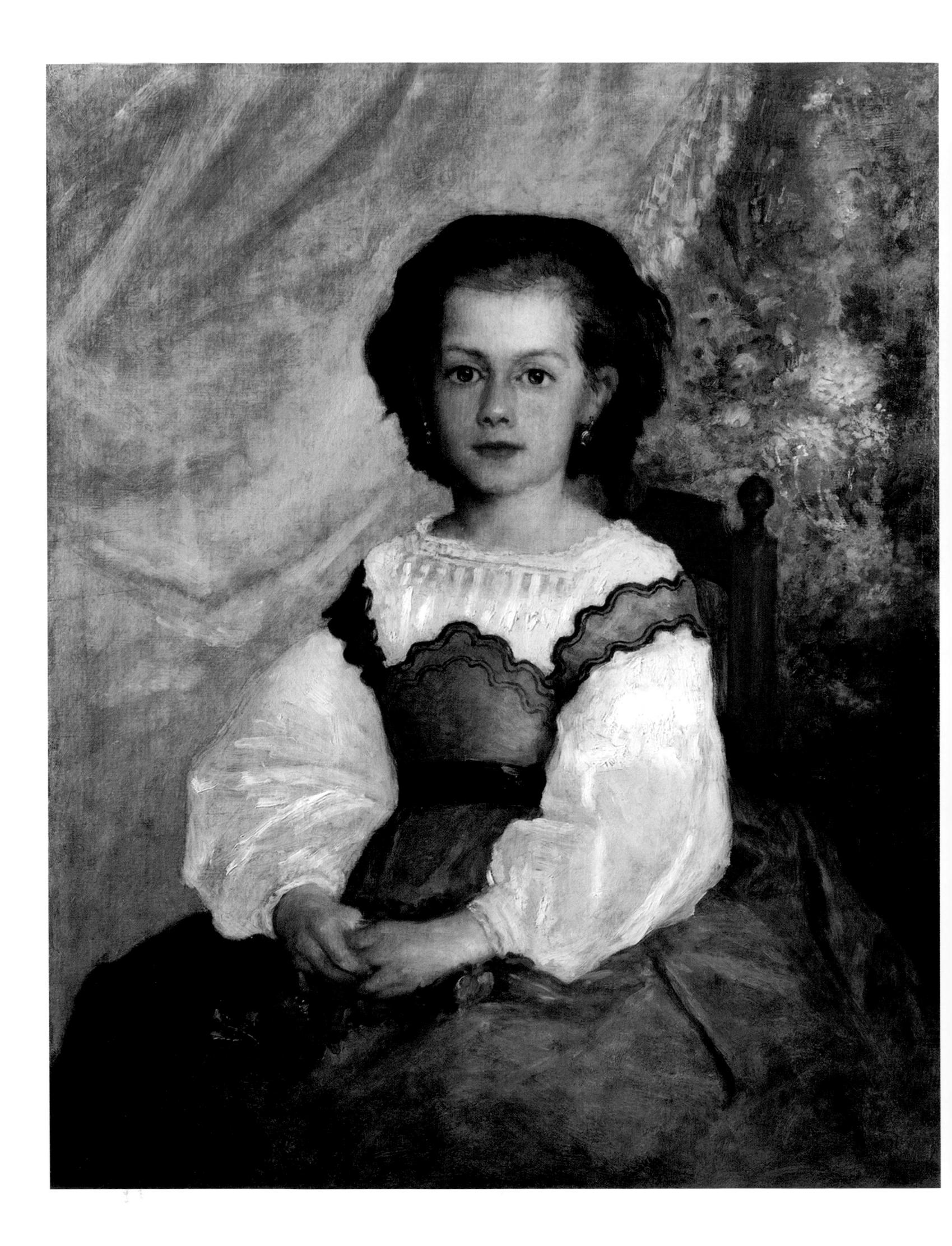

Renoir's Family, Friends and Teachers 1841–1867

When we look at one of the great collections of nineteenth-century French paintings and finally reach Pierre-Auguste Renoir, we may feel touched by a certain festive cheerfulness which surpasses that of any of his predecessors. Art as something uplifting, a feast for the eye – this is how we can describe both the greatness and also the limitations of his art. Renoir had almost sixty years of active life as an artist, during which he is said to have painted about 6000 pictures. With the exception of Picasso, this was undoubtedly the most prolific achievement of any painter, and his best pictures now sell for over a million pounds. Born in Limoges on 25 February 1841, Renoir came from a rather narrow middle-class background. His father was a tailor. And when he decided to embark upon the dubious career of an artist, he had no idea how famous he would become.

Renoir's father Léonard was by no means a rich man, and his craft did not bring in a lot of wealth, neither in Limoges nor in Paris, where his family moved in 1845, hoping for better prospects. At that time Paris was the capital of one of the leading world powers. Unlike the surrounding nations, France had been able to prepare her unification as early as the Middle Ages. The whole country was completely centralized, both economically and politically, with Paris as its heart and crowning glory. People were able to look back on several centuries of glorious history. The bourgeoisie had achieved control of political affairs in a series of great revolutionary power struggles. It had borne on its shoulders that little Corsican officer Napoleon Bonaparte, who had ruled over the whole of Europe. The glamour of those times could still be felt, long after the success of his conquests had been blown to bits and broken by the other European nations' desire for freedom. When, as a result of the third bourgeois revolution of 1848, Louis Bonaparte acquired the title of French Emperor and took his place as Napoleon the Third among the European potentates, he was able to do so on the strength of his uncle's fame.

Art played an extremely important part during the Second Empire. A rich body of literature had developed, which included works by authors of more popular appeal as well as a number of sensitive poets. There were sharp-witted realists who wrote descriptions of contemporary life, and there were more critical writers like Gustave Flaubert and the young Émile Zola. The theatres were full of audiences who really appreciated the plays of Victorien Sardou and Alexandre

"If I imagine I might have been born among intellectuals! It would have taken me years to get rid of the prejudices and to see things as they really are. And I might have got clumsy hands."

PIERRE-AUGUSTE RENOIR

PAGE 6: *Little Miss Romaine Lacaux*, 1864 Oil on canvas, 81 x 65 cm (31.9 x 25.6 in.) Cleveland, The Cleveland Museum of Art "How often I used to paint the *Emharkation to Cythera*. In doing so I first became familiar with the painters Watteau, Lancret and Boucher. More precisely: Boucher's *Diana* was the first picture that inspired me, and I have never ceased to love it, in the same way that one remains faithful to one's first love."

PIERRE-AUGUSTE RENOIR

Dumas Jr. Operettas by Jacques Offenbach, concerts, operas and ballets provided a rich harvest of artistic delight for the eyes and ears of the rich middle classes. The type of architecture that had become fashionable in Paris was of a very sumptuous kind, richly decorated in the baroque style. A thorough rebuilding programme, which affected the entire city of Paris, was initiated by its prefect, Baron Georges Eugène Haussmann. Magnificent avenues were created, as well as large expensive buildings, both private and public, such as the Grand Opera and the gigantic glass and steel construction of the Market Halls, the "Belly of Paris". Sculptors such as Jean Baptiste Carpeaux created the kind of sculptures that were appropriate to this Neo-Baroque pomp. There was a vast number of painters who produced oil paintings. Some did this extremely accurately, to the point of pedantry, while others were seductively daring in their endeavours. All of them attempted to arouse pleasant feelings with their art, which was displayed in salons and boudoirs, theatre foyers and restaurants - places where the better circles of society used to meet. Every year the Salon, a panel which consisted mainly of professors from the Academy, chose about two and a half thousand or more products of artistic endeavour, and the public were keen enough to rely on their judgement.

When Renoir first showed signs of being talented at painting and drawing, he could only make use of his gifts as an apprentice in a factory: thus, at the age of 13, he became a porcelain painter, decorating coffee cups with pictures of little flowers, idyllic shepherd scenes, and – for eight sous – the profile of Marie Antoinette. It may well be due to these early habits and impressions that, later on in his life, he developed a feeling for the shining luminousness of paint, for its delicate shades, and sometimes also its porcelain-like smoothness. During his lunch breaks, instead of having lunch, he would often go straight to the Louvre to paint antique sculptures. On one occasion, while he was looking for a cheap restaurant, he suddenly saw the *Fontaine des Innocents*, richly decorated with reliefs by the Renaissance sculptor Jean Goujon. "I immediately decided not to go to the pub, bought myself some sausage and spent my free hour walking round the fountain," he would recount later, and there are quite a number of paintings in which we can discern a faint echo of his early discovery of Goujon's nymphs.

Renoir only spent four years as a porcelain painter. The industrial revolution made an immediate and irreversible impact on his life: a machine for printing pictures on china had been invented, which made him and many other porcelain painters redundant. He now turned to painting ladies' fans and then church banners which were used by missionaries overseas. Thus he acquired a certain skilfulness and swiftness in using the paintbrush. Later, in his old age, he would look back with gratitude to the time when he had to copy Rococo masters again and again.

Renoir's industriousness soon began to bear fruit. By the time he was 21, he had earned enough money to study art academically. In April 1862 he joined the *École des Beaux-Arts* (the College of Fine Art) in Paris. It was run by the Imperial Director of Fine Art, Count Alfred de Nieuwekerke, who rejected realism in art as "democratic and objectionable". The students had to copy paintings, make accurate drawings of plaster casts and were encouraged to regard historical paintings more highly than any others. Renoir was taught by a number of

PAGE 9: *Arum and Conservatory Plants*, 1864 Oil on canvas, 130 x 96 cm (51.2 x 37.8 in.) Winterthur, Oskar Reinhart Collection "Am Römerholz"

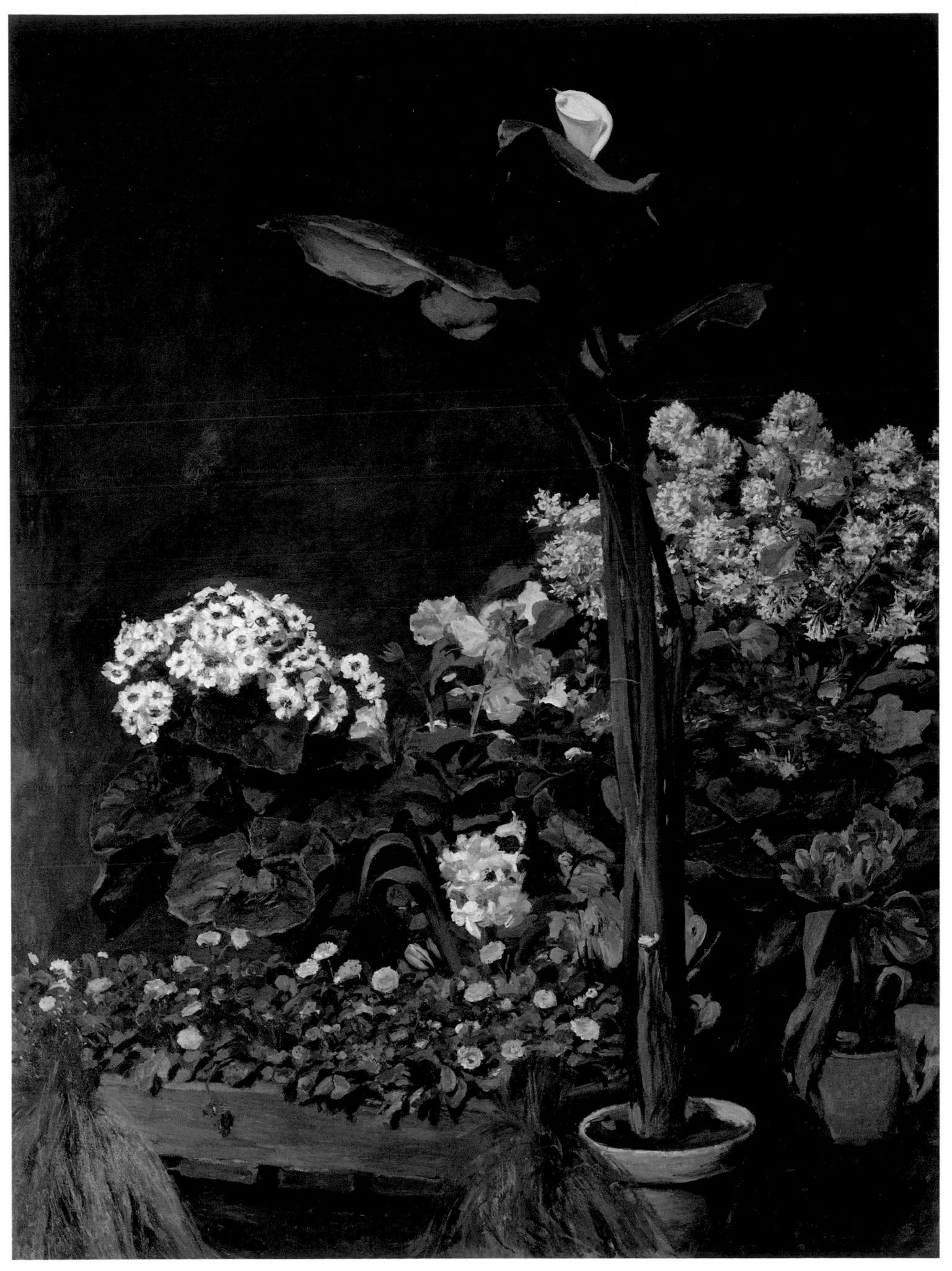

"When we look at the works of the ancients, we really don't have any reason for thinking that we are clever. Above all, what wonderful craftsmen these people were! They really knew their craft. And that is indeed everything. Painting is not a matter of sloppy sentimentalism. It is first of all the work of your hand, and you have to be a hard worker."

PIERRE-AUGUSTE RENOIR

professors, but his real teacher was Charles Gleyre who, twenty years before, had become famous for a rather frosty allegorical picture. Above all, Renoir used to go to private classes which Gleyre taught outside the École and in which thirty or forty students had to draw or paint nude models. Thanks to his previous experience he had a confident hand, and he was always full of keen enthusiasm to perform each task to the best of his ability. Whether it was by nature or because of the Rococo paintings he had copied previously, he used to love strong, glowing colours. These, however, were not particularly popular at the college. During the very first week there was a clash between Renoir and Gleyre. Years later, Renoir commented, "I had really done my utmost to paint the model. Gleyre looked at my picture and said, with an icy expression on his face: 'You obviously paint for your own enjoyment, don't you?' - 'But of course,' I replied, 'you can be sure that I wouldn't do it if I didn't enjoy painting.' I'm not sure if he understood me correctly," Renoir added. His answer was probably not meant as provocatively as it sounded, but it nevertheless summed up very nicely a totally new attitude to art: less solemn and dutiful towards "the noble goddess of art", but more sensuous, alive and personal.

There was one student who was even less inclined to bow to the doctrines of the teachers: Claude Monet. Renoir made friends with him, and also with Alfred Sisley and Frédéric Bazille (illus. p. 14). Monet was the most energetic among them. He had learned from Eugène Boudin how to see and paint a landscape under natural lighting conditions, and disliked the cold light of the studio more than anything else. In May 1863, at the so-called Salon des Réfusés, this group of friends saw Manet's Luncheon on the Grass for the first time (now in the Musée d'Orsay, Paris) - a picture which had met with ridicule and indignation among the general public. It had a somewhat perplexing theme and was painted in rather bright colours, which was quite unusual at the time. They immediately recognized how much they had in common with Manet. When, at the beginning of 1864, Gleyre retired from teaching, Renoir and his friends continued to work without a tutor. In spring Monet took his fellow painters to Chailly-en-Bière, a village in the Fontainebleau woods, to study nature. This was thirty years after another group of young painters had first thought it worth their while to paint the unobtrusively beautiful nooks and crannies of the woods and rivers near Paris. They were called the Painters of Barbizon, after their home on the edge of the Fontainebleau woods. Some of them, Charles François Daubigny, Narcisse Diaz de la Peña and Camille Corot, were still working in the area. The realistic way in which they depicted their native countryside was still rather controversial.

It was in 1864 that Renoir first submitted a picture to the *Salon*, and it was in fact accepted: *Esmeralda Dancing with a Goat*, which drew its theme from Victor Hugo's novel *Nôtre Dame de Paris*. It must have had that darkness about it which was considered to be suitable for galleries at the time and which was achieved by means of an admixture of asphalt. We can conclude this because Renoir, rather self-critically, destroyed it when Diaz, one of the Barbizon Painters, advised him not to use asphalt. The two of them became close friends, and the 57-year-old Diaz, who was earning quite a decent amount of money at the time, gave his 23-year-old colleague not only good advice, but also some financial assistance, which was very welcome.

PAGE 11: *At the Inn of Mother Anthony*, 1866 Oil on canvas, 193 x 130 cm (76 x 51.2 in.) Stockholm, Statens Konstmuseer

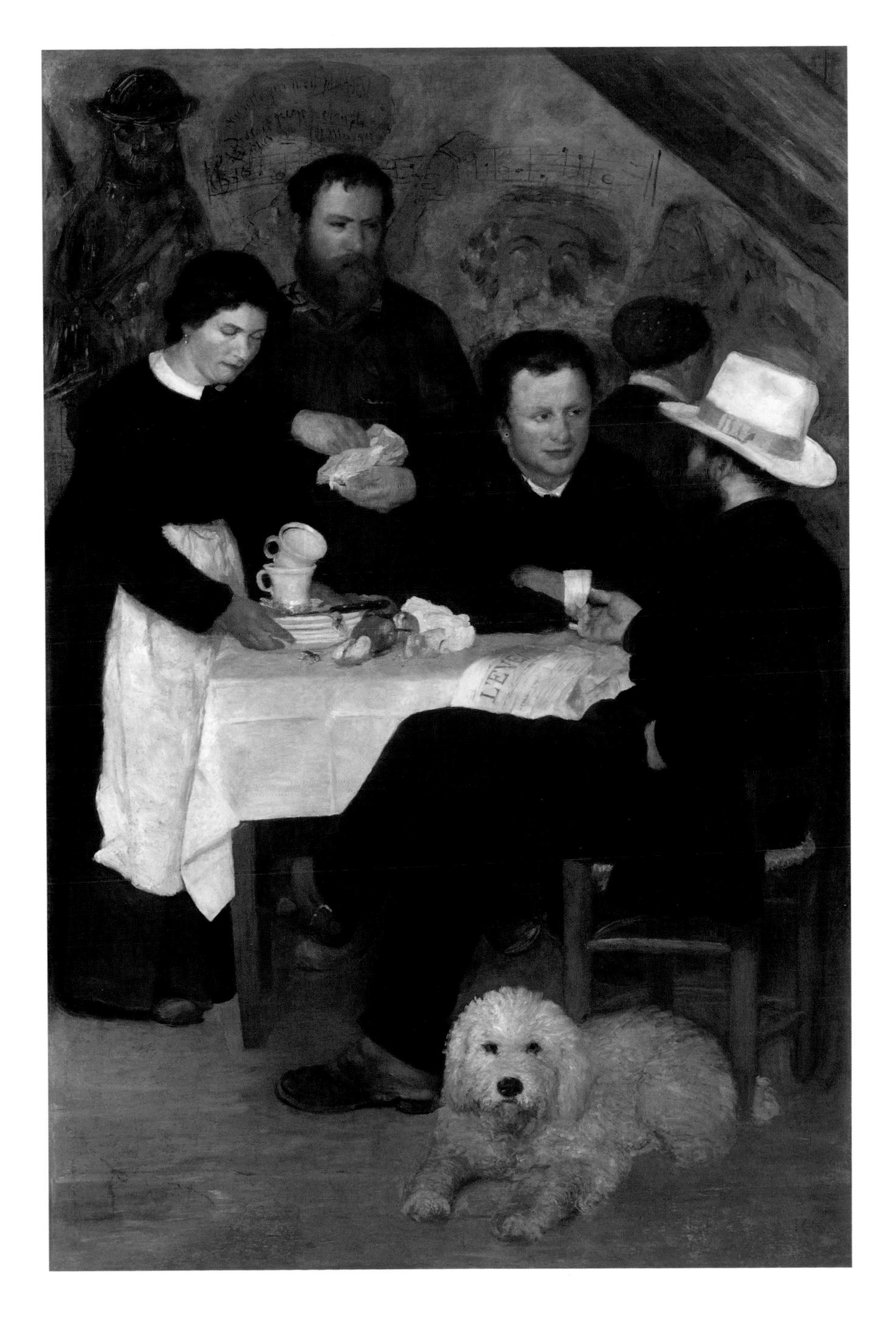

"It is in the museum that you learn to paint ... When I say you learn to paint in the Louvre, I do not mean scratching the varnish off the pictures to steal their techniques or to repaint the Rubens and Raffaels. You have to be a painter of your own time. But in the museum you acquire a taste for art which nature alone cannot give you. It is a painting, not a beautiful scene, that makes you say: I want to be a painter."

PIERRE-AUGUSTE RENOIR

The other painters whom Renoir admired at that time were Gustave Courbet and Eugène Delacroix. In 1848 Courbet had caused a great deal of excitement and indignation with his realistic paintings. These were pictures of stone breakers making roads, very simple landscapes, portraits and female nudes whose strong, peasant-like bodies were in fact true to life. He used to prefer very dark shades of colour, and the general appearance of his pictures was one of compact solidness. Most of them violated practically all academic rules of composition but had a certain beauty about them that appeared to be wrenched away from nature itself. Courbet's realism was closely related to his democratic and materialistic world view; as an admirer of the middle-class socialist Pierre Joseph Proudhon, he believed that a work of art should not just be appreciated in itself, but should be judged according to its function within society. This view had its origin in the Romantic Movement, of which Delacroix, the other artist whom Renoir admired, was an adherent. Among his early pictures there were quite a number of paintings with social relevance, thus contributing to the general trend of artists trying to break away from the rigid framework of the rules of Classicism.

Although Classicism had been very progressive in its day, it turned out to be rather a hindrance for further development after a while. Classicists showed very little sensitivity for the colourful elements of this world. Delacroix, on the other hand, helped colour to come into its own again, and he also allowed more scope for a reflection of reality in a work of art that was personal, passionate and imaginative. It was in fact the magnificence of the glowing colours in his pictures that Renoir felt attracted to. He would no doubt have agreed wholeheartedly if he had known of Delacroix's last entry in his diary: "The first obligation of a painting is to be a feast for the eyes."

In summer 1865 Renoir and his friend Sisley went down the Seine in a sailing boat as far as Le Havre, where they wanted to see the regattas. These were to become one of their favourite themes in later pictures. From their boat they painted the river and its banks, just as Daubigny had done. The *Salon* in fact accepted Renoir's works again. However, a year later, the panel decided to take a much harder line in their decisions, thus marking the real beginning of Renoir's tough struggle for the recognition of a new artistic style.

Renoir now spent most of his time with his friends in the village of Marlotte near Fontainebleau, where he painted them in his picture *At the Inn of Mother Anthony*: a group of people, cheerfully gathered round a table and discussing articles from the paper *L'Événement* (The Event). This was the periodical in which young Zola had published his critique of the 1866 *Salon* and defined a work of art as "a piece of nature seen through a person's temperament" (illus. p. 11). The individual people in the painting cannot be identified unambiguously, but his colleagues Sisley and Jules Lecoer are sure to be among them. Some music and cartoons had been scribbled on the wall, among them a sketch drawing of Henri Murger who had written *La Bohème* in 1851. All these young painters saw themselves as Bohemians, i.e. poor artists who felt passionately inspired by missionary zeal but who were misunderstood by the world. The 1867 panel of the *Salon* were particularly harsh with them and rejected Renoir's *Diana* (illus. p. 13). Renoir had painted a beautifully accurate nude, without the coarseness of Courbet's *Bather* fourteen years before, which had been scornfully rejected as a

PAGE 13: **Diana**, 1867 Oil on canvas, 195.7 x 130.2 cm (77 x 51.3 in.) Washington, D.C., National Gallery of Art, Chester Dale Collection

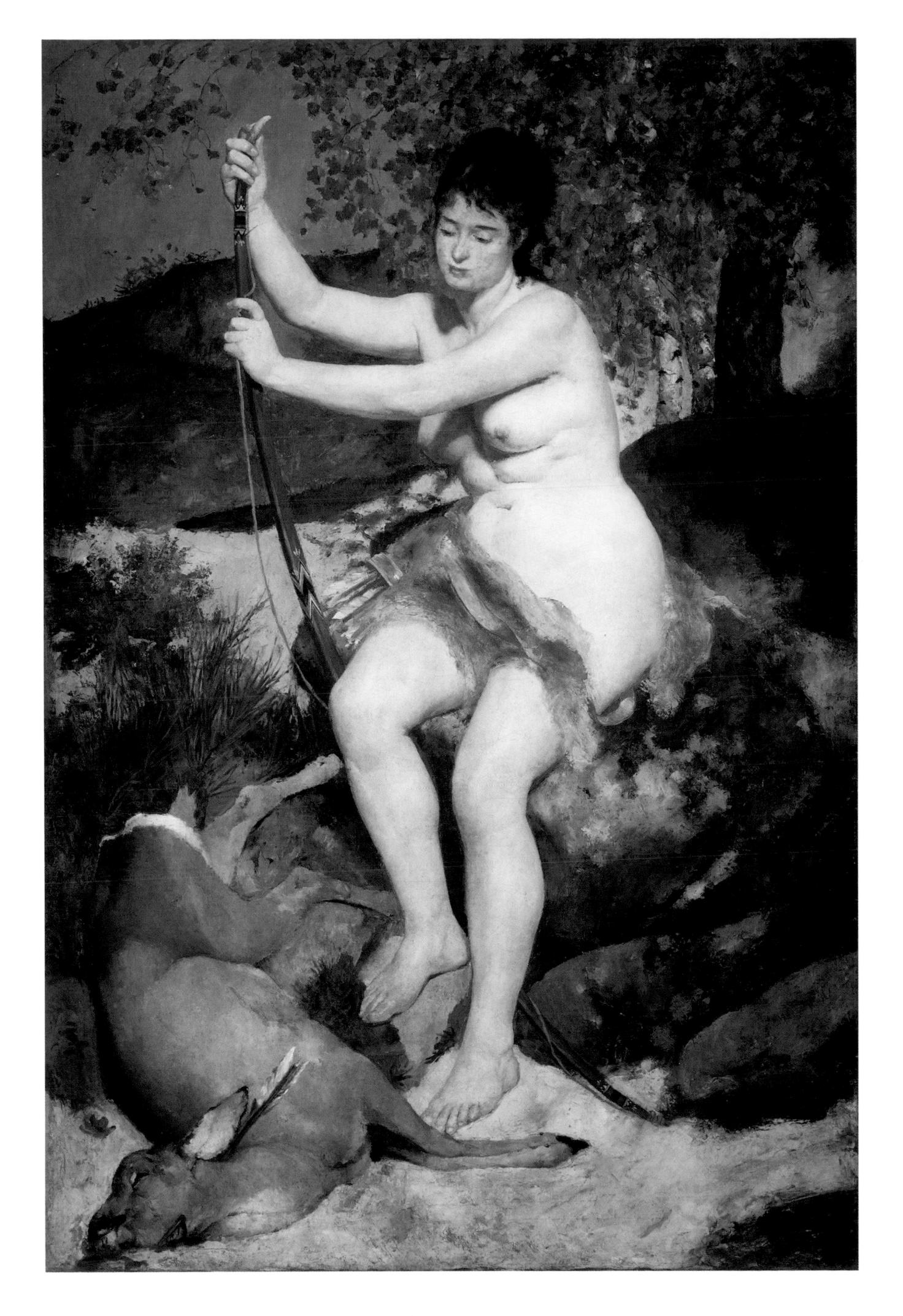

"Hottentot Venus". In fact, his *Diana* looked far more healthy and realistic than – as Zola put it – the pampered, lustful nudes, powdered with rice flour, of the fashionable painters of that time.

So he draped a loincloth of fur round his nude and also added a bow and a freshly killed deer, changing her into the ancient goddess of hunting. This concession to the *Salon's* academic partiality towards mythological themes, however, did not save his picture from being rejected. There was going to be a world exhibition in Paris that year, and the panel wanted to present an image of French art that was "without a blemish".

During the subsequent three years, though, Renoir succeeded in gaining recognition for his paintings at the *Salon*, even though they were even more modern in style. The panel had become considerably more liberal in their attitudes, mainly under the influence of Daubigny who had begun to speak up for the young Realists. The Imperial government (now in its last years) could not afford any unnecessary feelings of discontent among the middle classes.

These minor successes, however, did not save Renoir from material hardship. His savings had long come to an end. His wealthy friend Bazille allowed him to

LEFT: *Lise*, 1867 Oil on canvas, 184 x 115 cm (72.4 x 45.3 in.) Essen, Museum Folkwang

RIGHT: *Frédéric Bazille at His Easel*, 1867 Oil on canvas, 106 x 74 cm (41.7 x 29.1 in.) Paris, Musée d'Orsay

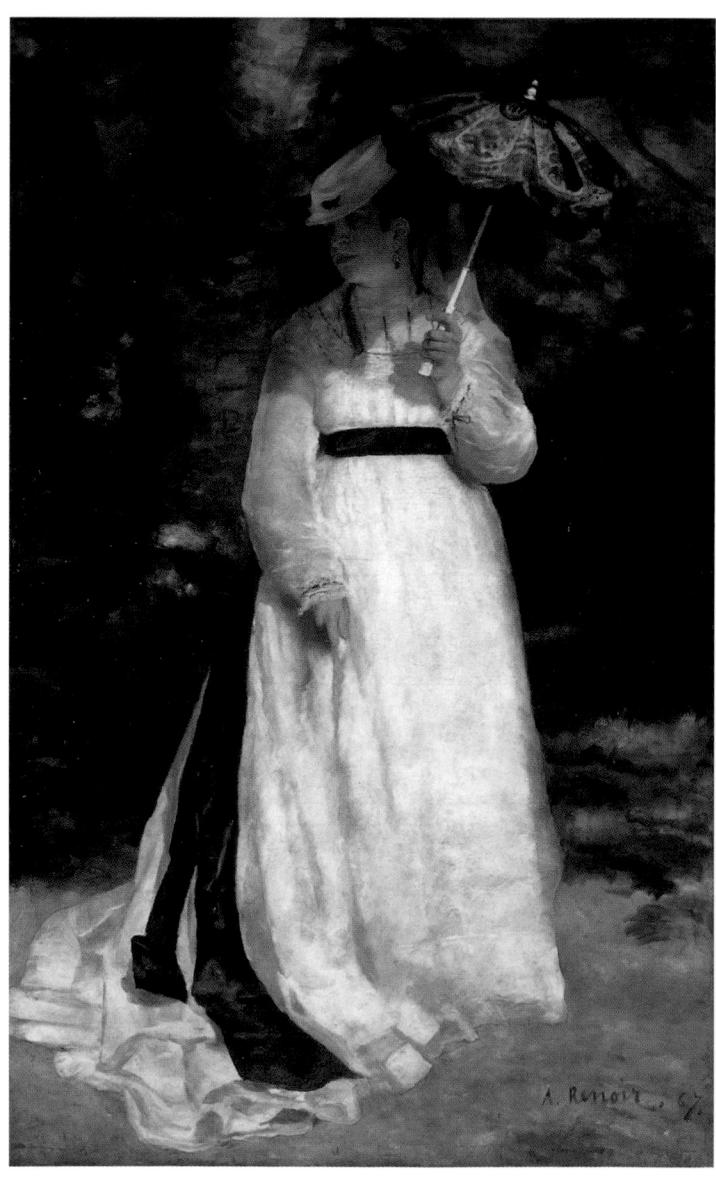

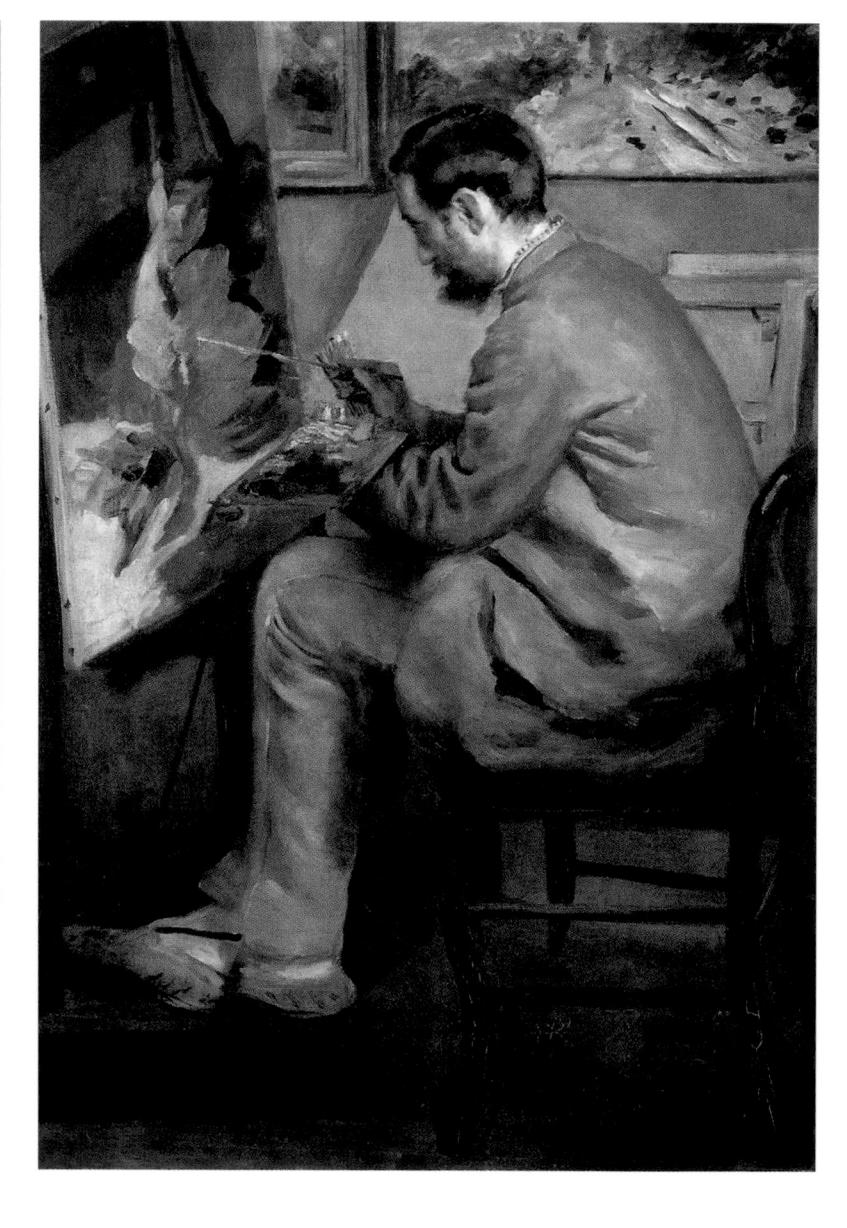

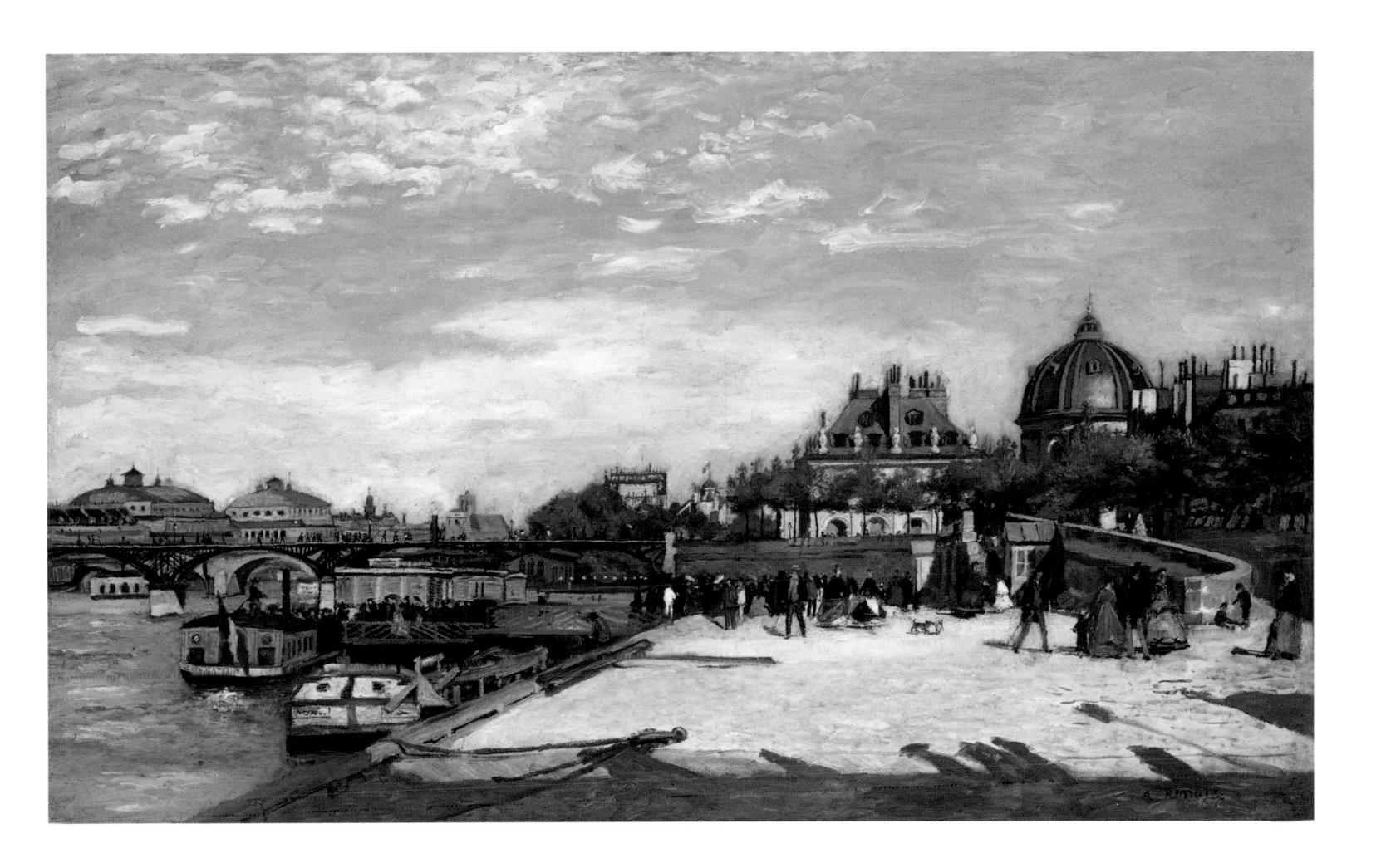

share his studio and to live there. Together they made a living by painting postcards. In summer 1867 Renoir put up his easel in the woods of Fontainebleau again, with the 19-year-old Lise Tréhot as his model (illus. p. 14). In summer 1869 Renoir lived with her and her parents in Ville-d'Avray just outside Paris. Occasionally he would take some food to Monet, who was living in abject poverty in Bougival. Renoir was not really any better off: "Although we don't eat every day, I'm still quite cheerful," he wrote to Bazille. It scemed to Renoir and Monet that the worst hardship was not being able to buy paint. During those months they would often go to La Grenouillère (The Frog Pond), a public swimming pool in Bougival, by the river Seine, and paint the same themes again and again. It must have been very touching to see how these two young artists together began to paint brighter and brighter pictures, in spite of their pressing material need. Like their colleagues Sisley and Camille Pissarro, they really had to fight hard to make ends meet and to eke out a living, but neither now nor in the hard years to come did they ever paint a picture that expressed any kind of weariness, anxiety, depression or pessimism.

The Pont des Arts, Paris, 1867 Oil on canvas, 62 x 102 cm (24.4 x 40.2 in.) Pasadena, Norton Simon Foundation

[&]quot;From time to time Monet used to get us an invitation for a dinner party. And then we stuffed ourselves with larded turkey, served with Chambertin."

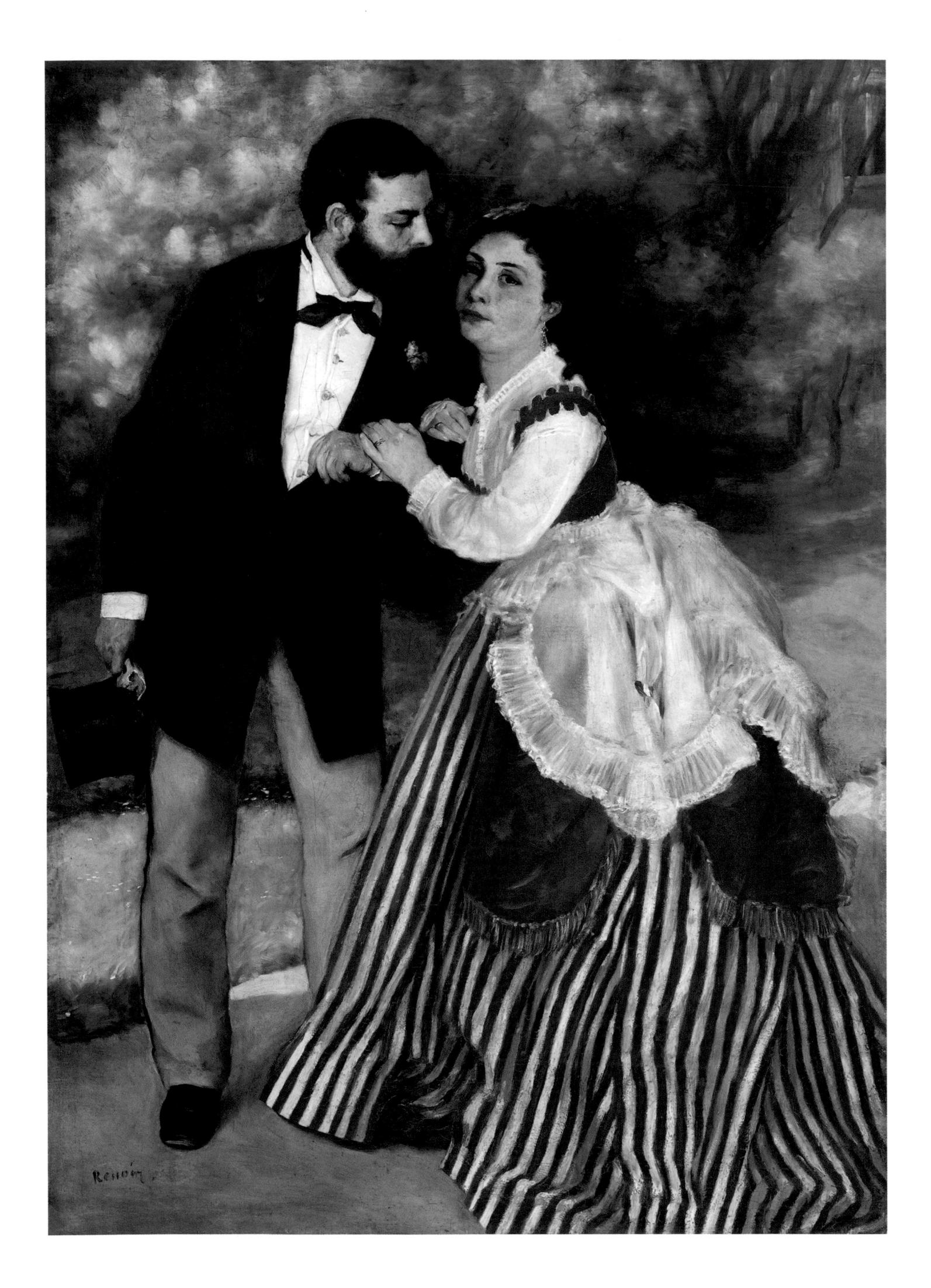

A New Style of Art

1867-1871

The young painters were struggling hard to find their new artistic principles. Whenever they were in Paris, they would go to the Café Guerbois in the Grande rue de Batignolles in the evenings, where they often had quite heated discussions. They were soon known as the Painters of Batignolles. Manet was at the centre of this group, which also included writers and art critics such as Zola, Théodore Duret, Zacharie Astruc and Edmond Duranty. Renoir, who was thin and rather nervous, never contributed much to the discussions. He was lively and intelligent with a sense of humour, but he did not believe in fighting or theorizing. For him painting was not so much a matter of strict programmes, but a beautiful craft which was to be practised humbly and joyfully. His paintings, on the other hand, turned out to be the most daring and progressive of all. The underlying principle was to paint only what could be seen with one's eyes and to render this as faithfully as possible. The Barbizon Painters, the peasant painter Jean François Millet and Courbet had started this. But most of their pictures had been painted in studios and lacked that brightness which made objects so beautiful outside, in the sunlight. In their endeavour to depict nature more and more truthfully the painters came up against the problem of coloured shadows. On closer inspection they discovered that there was in fact a great variety of different shades even in shadows, with blue as the predominant colour. This was something that could only be studied accurately outside, i.e. when faced with the subject itself, and for this reason Renoir and Monet used to work outside, in the open air. They could see how various objects changed their colours, depending on the lighting conditions and the colours reflected from other things around them. They noticed how the flickering of the air dissolved the sharpness of the contours and that not everything could be discerned equally clearly.

Certain objects lent themselves more than others to this way of looking: the foliage of trees, flowers, water, clouds, smoke, boats, beautiful women's skirts, delicate parasols, and people moving about casually and at ease. They loathed anything that smacked of tradition and strict rules. What they were looking for was beauty in the life of the people around them, life where it poured forth in all its freshness, i.e. in the intimate circle of the family, on a walk, during their leisure time, and wherever something new could be experienced: at sporting events or under the rapidly changing conditions of the big city.

Renoir's first masterpiece was his *Lise* of 1867 (illus. p. 14), which was exhibited at the *Salon* the following spring. It was a full-length life-size portrait of his

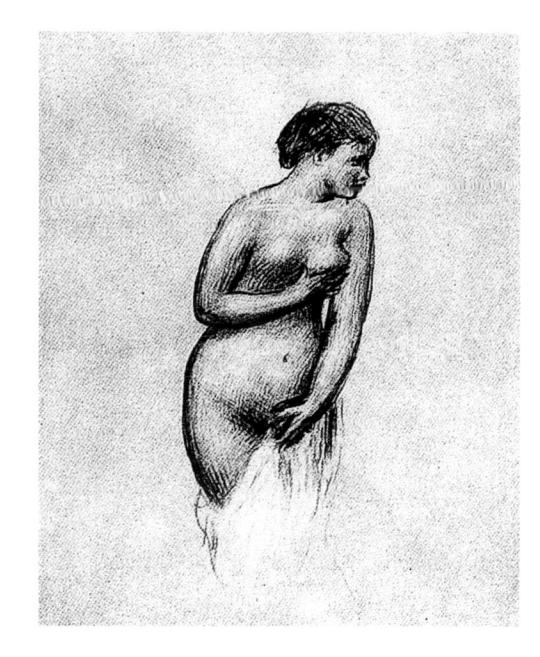

Standing Nude, 1919 Crayon, 37.3 x 29.8 cm (14.7 x 11.7 in.) Ottawa, National Gallery of Canada

PAGE 16: Alfred Sisley and His Wife, 1868 Oil on canvas, 105 x 75 cm (41.3 x 29.5 in.) Cologne, Wallraf-Richartz-Museum

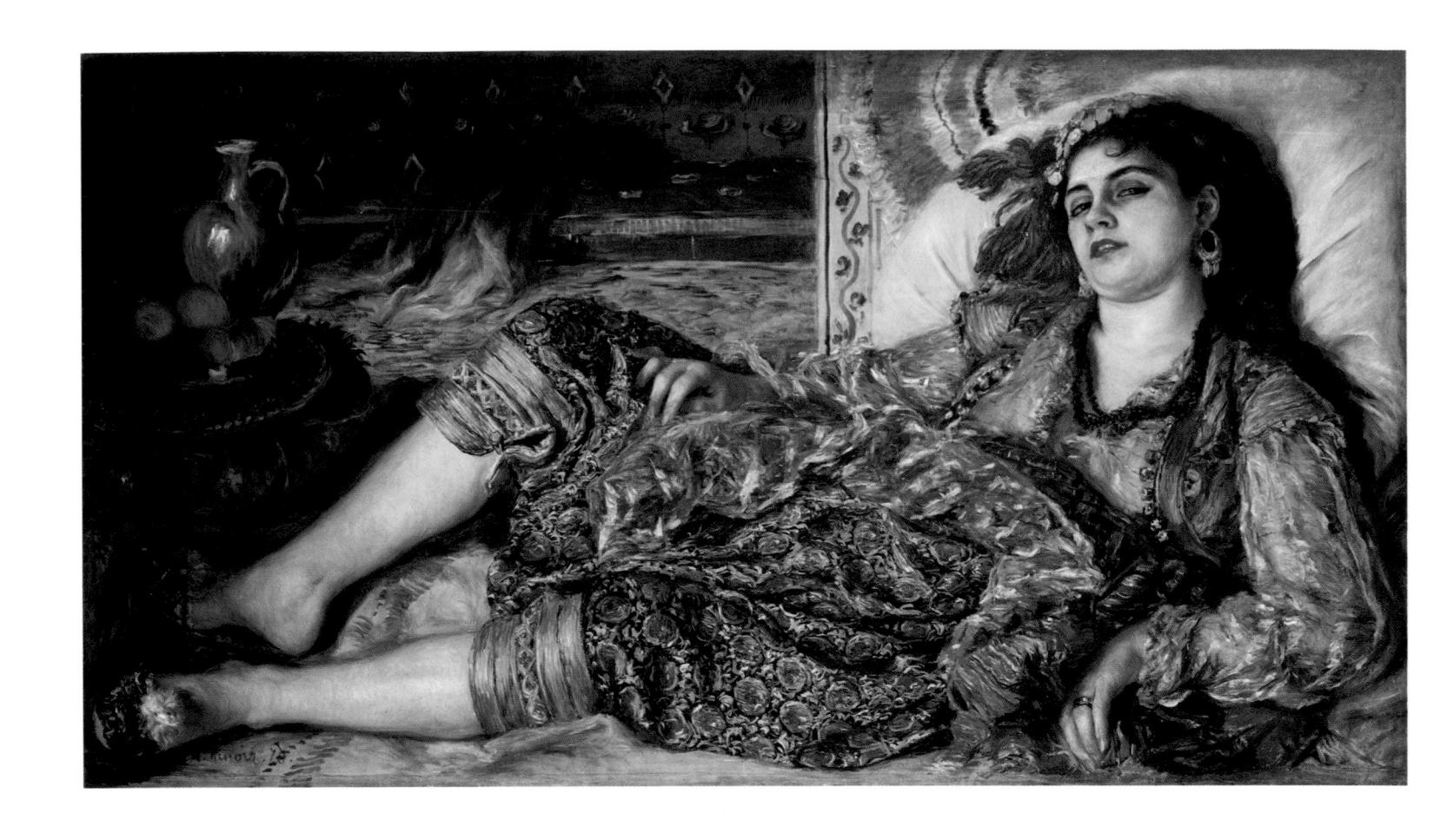

Woman of Algiers, 1870 Oil on canvas, 69 x 123 cm (27.2 x 48.4 in.) Washington, D.C., National Gallery of Art, Chester Dale Collection

young girlfriend Lise – something which was normally reserved for royalty. "The whole thing is so natural and has been observed so accurately that it will seem wrong because we are used to imagining nature in terms of conventional colours," wrote W. Bürger-Thoré, and Astruc called Lise "the daughter of the people, with all her typical Parisian features." Three years later Renoir used Lise as a model for his *Woman of Algiers* (illus. p. 18), a rather spectacular painting in that oriental style which was fashionable at the time and which had been started by Delacroix's *Women of Algiers*.

Renoir's picture of *Alfred Sisley and His Wife* (illus. p. 16) was only half as large. The woman's eyes and her skirt make it quite obvious that she is meant to be the more important of the two. His use of line and colour is well balanced and shows that he paid very careful attention to the laws of composition, which he had learned from many masterpieces in the Louvre. The interplay of light and reflected colour, on the other hand, is weaker here than in his *Lise*, and the figures do not merge with their natural environment as much. This used to be a typical feature of his large-scale landscapes. There is a certain lightness about Renoir's *Pont des Arts* (illus. p. 15), but at the same time its composition is firm and geometrically accurate, affording a glimpse of the very heart of Paris: the Academy of Art, the steam boat pier and the modern iron bridge.

Monet and Renoir's common efforts found their most beautiful expression in the pictures of the *Grenouillère*. Three paintings by Monet and three by Renoir can still be traced back to that time, and their style is almost indistinguishable. The crowd of people at the bank of the river and on the pier, the changing cabins, the bathers, the rowing boats and above all the glistening surface of the

"What delights me about Velázques is the joy that pours forth from his art, the joy he felt when he painted his pictures ... If I can feel the painter's passion with which he created, then I enjoy his own enjoyment with him."

PIERRE-AUGUSTE RENOIR

water with its many colourful reflections – all these elements had been captured with broad, sketch-like strokes of the brush. These pictures lack all composition in the conventional sense of the word; they are as turbulent as the cheerful crowds described in the stories of Guy de Maupassant.

"The impression of nature" was the most popular phrase in the discussions at the Café Guerbois, and now it had been put into practice in real pictures. Once the decision had been taken that scenes like this should be painted rather than a bathing Diana, it became obvious that the new subject had to be matched by new stylistic devices, and in the process of trying them out new subjects were discovered. The chance encounter of a random but attractive moment had to be captured as quickly as it occurred. Everything was in motion, and the light was forever changing. It was this continuous state of flux that had to be caught, with its luminous colours that brought something of a bright summer day into the room. These were the kind of pictures that gave birth to something that was not given a name until five years later: Impressionism.

"One morning one of us had run out of black; and that was the birth of Impressionism."

PIERRE-AUGUSTE RENOIR

La Grenouillère, 1869 Oil on canvas, 66 x 81 cm (26 x 31.9 in.) Stockholm, Statens Konstmuseer

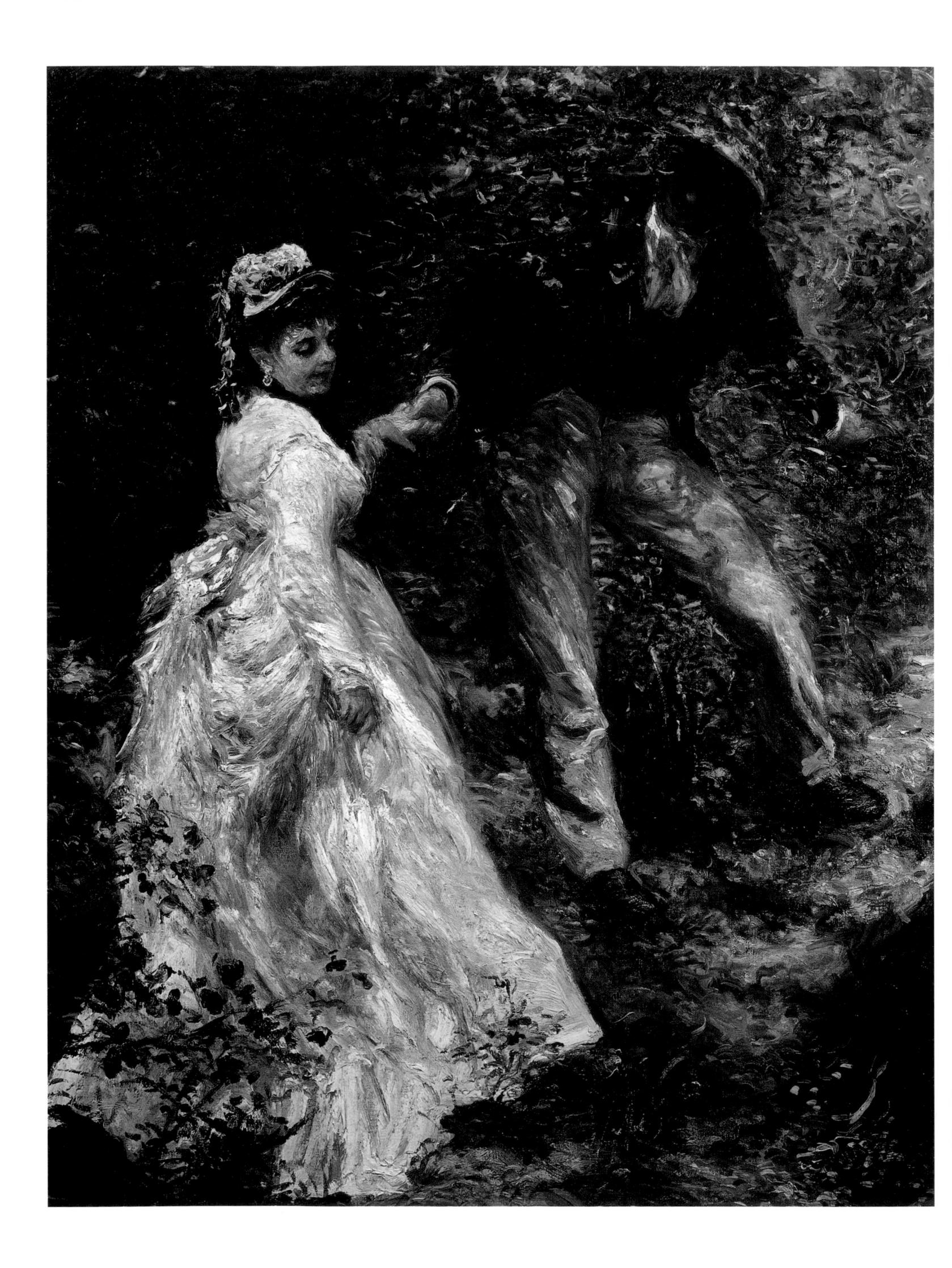

The Great Decade of Impressionism

1872-1883

In spring 1870 Renoir and almost all his friends were represented at the *Salon*. But in July war broke out with Prussia and her allies, and Renoir had to join the cavalry. Napoleon III and his armed forces were beaten, and France became a republic. In spring 1871 Parisian workers, craftsmen and many intellectuals and artists, too, rebelled and proclaimed the *Commune* as the revolutionary government. This first attempt to found a new state came to a bloody end. Renoir took very little notice of the dramatic events that were happening. But the sharp differences between the middle classes and the working classes, which had come to the surface, were to change forever the climate of the country, and both directly and indirectly, the situation influenced Renoir himself and the new art in general.

When Renoir submitted pictures to the *Salon* again in 1872, his *Parisian Women in Algerian Costumes* (National Museum of Western Art, Tokyo) was rejected. He had paid tribute to Delacroix with this painting. After the revolution the upper middle classes had become doubly suspicious of innovations of any kind. Nor did this attitude change in the years to come. They were now being fought by official critics and had to suffer scorn and ridicule. People like Renoir, who were not gentlemen of independent means, had to go though times of bitter hardship. But at this time of official rejection, ridicule and insult, a number of impoverished artists, many of them approaching forty, were finally forming themselves, as it were, into an artistic combat unit, fully developing their own new style and in fact unfolding it in all its splendour.

These were the years when the most mature works of French Impressionism were created and Renoir especially developed the full magic of his art and the prolific sumptuousness of his imagination and his stamina. Between 1872 and 1883 Renoir was at the height of his skill as an artist. Before then, in the 1860s, he had still been feeling his way and had been dependent on older masters, and later, in the 1880s, he was to limit himself considerably in his choice of subjects and fell into a certain monotony of never-ending variations on the same themes. But now almost every single one of his pictures could be enjoyed in its own right as a distinct masterpiece which was different from any other.

Surprisingly, the time shortly after the lost war and the Commune was one of great economic prosperity in France. The economy was blossoming, and even paintings were sold for unexpectedly large sums of money. A lot of this money passed through the hands of Paul Durand-Ruel, who had been instrumental in

"Nowadays people want to explain everything. But if one could explain a picture, it would no longer be a work of art. Shall I tell you which qualities I think are important for real art? It has to be indescribable and inimitable ... A work of art has to grip the spectator, engulf him, carry him away. The artist communicates his passion with it, it is the current which he radiates, and he uses it to draw the spectator into his passion."

PAGE 20: **The Promenade**, 1870 Oil on canvas, 80 x 64 cm (31.5 x 25.2 in.) Los Angeles, The J. Paul Getty Museum

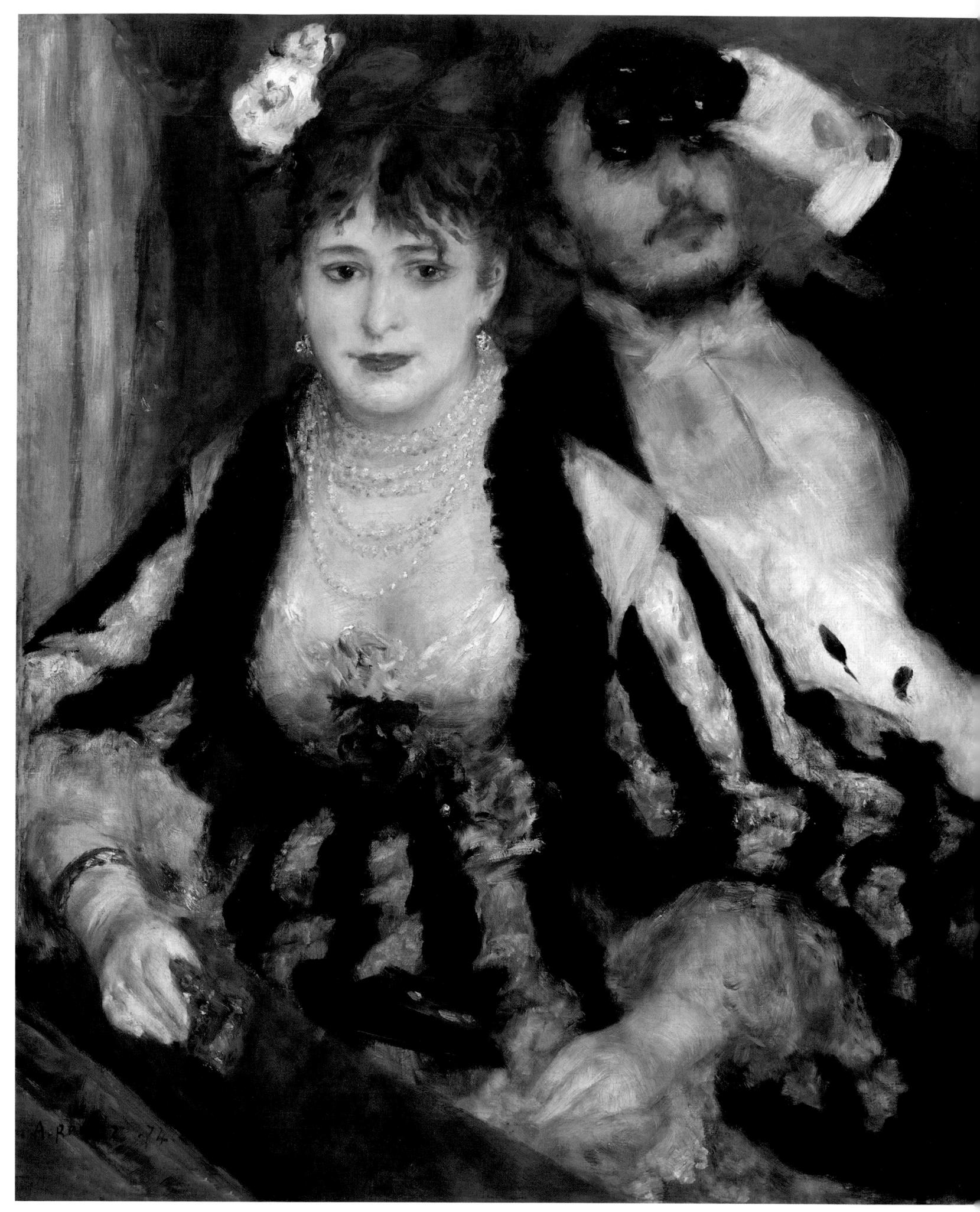

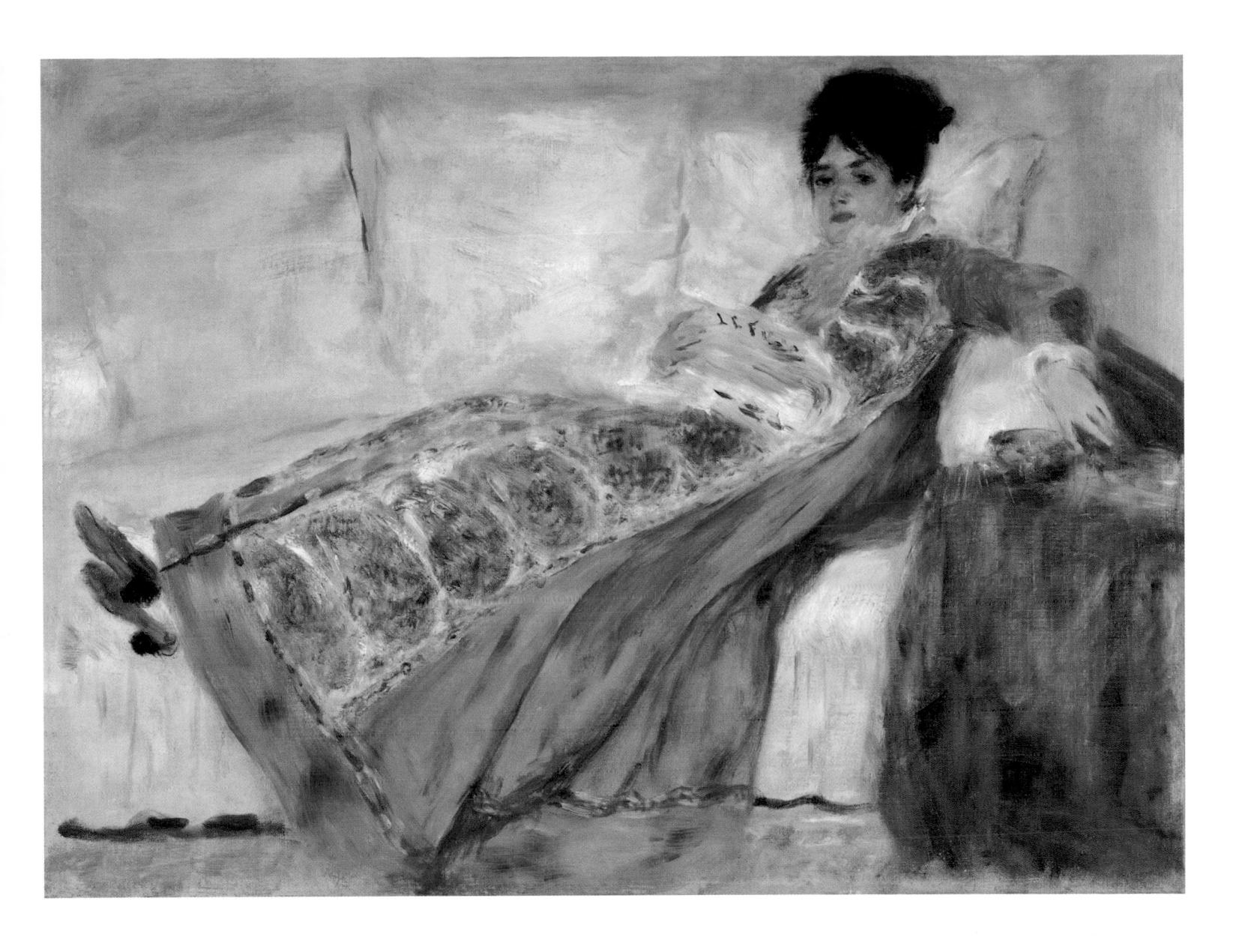

helping the Batignolles painters towards their success. Ever since he had taken over his father's art business in 1862, he had been using his intuition and his skill to fight for the recognition of the Barbizon painters. And in fact he soon began to make good business out of their paintings. This was because he immediately recognized quality when he saw it, and he was not lacking in courage. For years he would patiently take those artists under his wings who had been rejected by the official critics, and buy their pictures even when he knew that there was no certainty as to whether he would be able to sell them. In 1870 he met Pissarro and Monet in London, where they had fled from the Franco-Prussian war, and in 1873 he discovered Renoir. As their pictures were almost unsaleable he did not pay them very much, but for a man in Renoir's position even a small amount of money was most welcome.

Nevertheless, in 1873, Durand-Ruel found himself forced to reduce the assistance he had been giving Renoir and his friends. France was going through a bad industrial crisis, which also affected his art business. It was now up to the painters themselves to display their pictures and to offer them for sale. So they founded a so-called *société anonyme coopérative*, and on 15 April 1874 they opened their own

Mme. Monet Reading "Le Figaro", 1872 Oıl on canvas, 54 x 72 cm (21.3 x 28.3 in.) Lisbon, Museu Calouste Gulbenkian

PAGE 22: *La Loge*, 1874 Oil on canvas, 80 x 63.5 cm (31.5 x 25 in.) London, Courtauld Institute Galleries

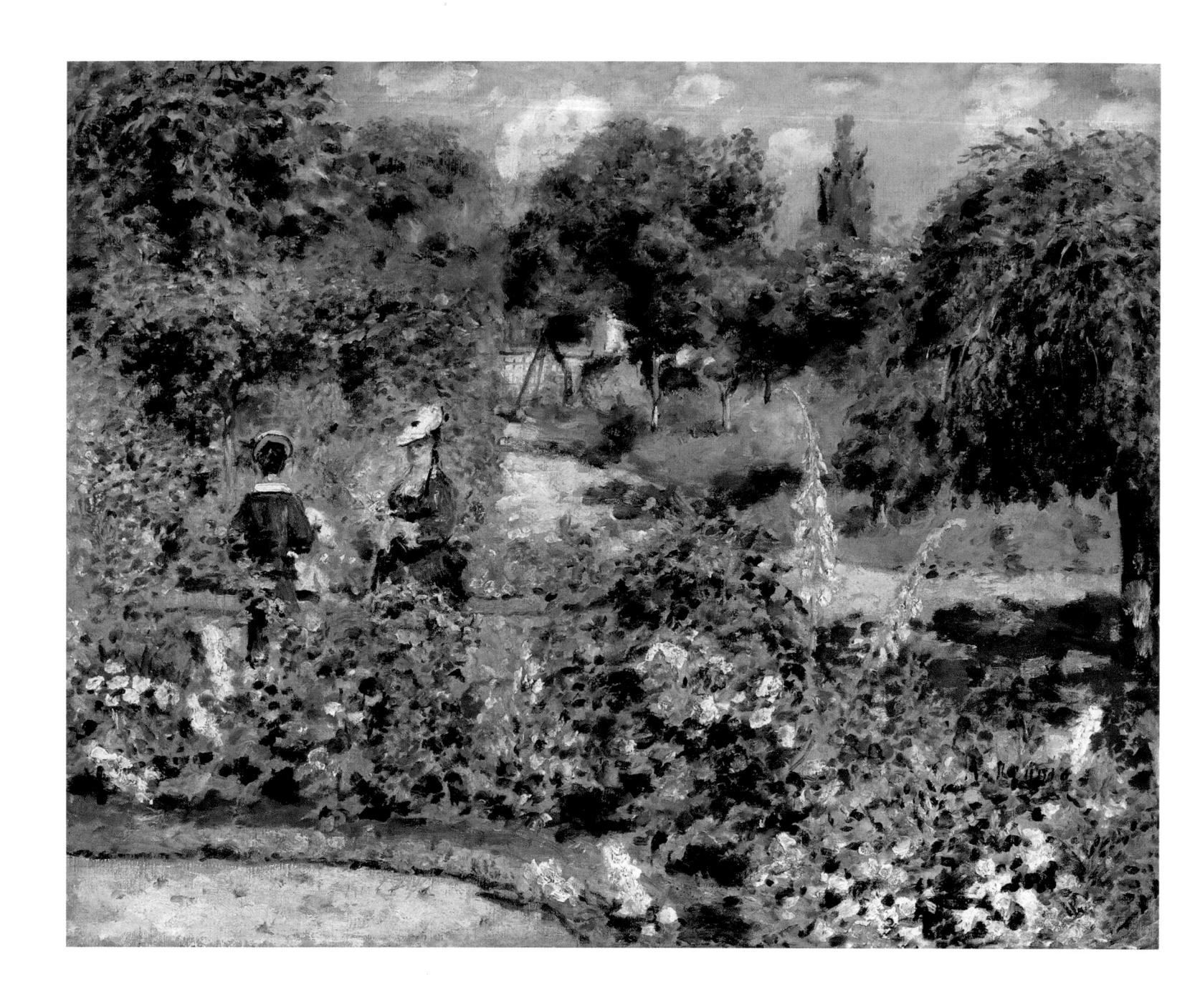

Garden at Fontenay, 1874 Oil on canvas, 51 x 62 cm (20.1 x 24.4 in.) Winterthur, Oskar Reinhart Collection "Am Römerholz"

exhibition on the premises of the photographer Nadar (Boulevard des Capucines), which had just become vacant. Renoir was represented by six paintings and one pastel drawing. On 25 April a critical article by Louis Leroy was published in the satirical magazine *Charivari*, a paper which had been printing Daumier's lithographs for the last forty years. The "impressionists' exhibition" was severely and sarcastically criticized for the dull lifelessness of the drawings, the shoddiness of the paintings, the lack of attention to detail, and the general slipshod nonchalance that was displayed in this "hair-raising exhibition". The writer said that the highest ideal of these new painters seemed to be that of their own impressions.

The "new school" had found its nickname, and other critics soon began to use the term "impressionists". For years now there had been a tendency among young artists to try and render vital impressions, and they had been discussing the best way of achieving this. The exhibition, though, did nothing to improve the image of the artists. They were called demented and comical, their pictures were regarded as pointless daubs and declarations of war on the very concept of

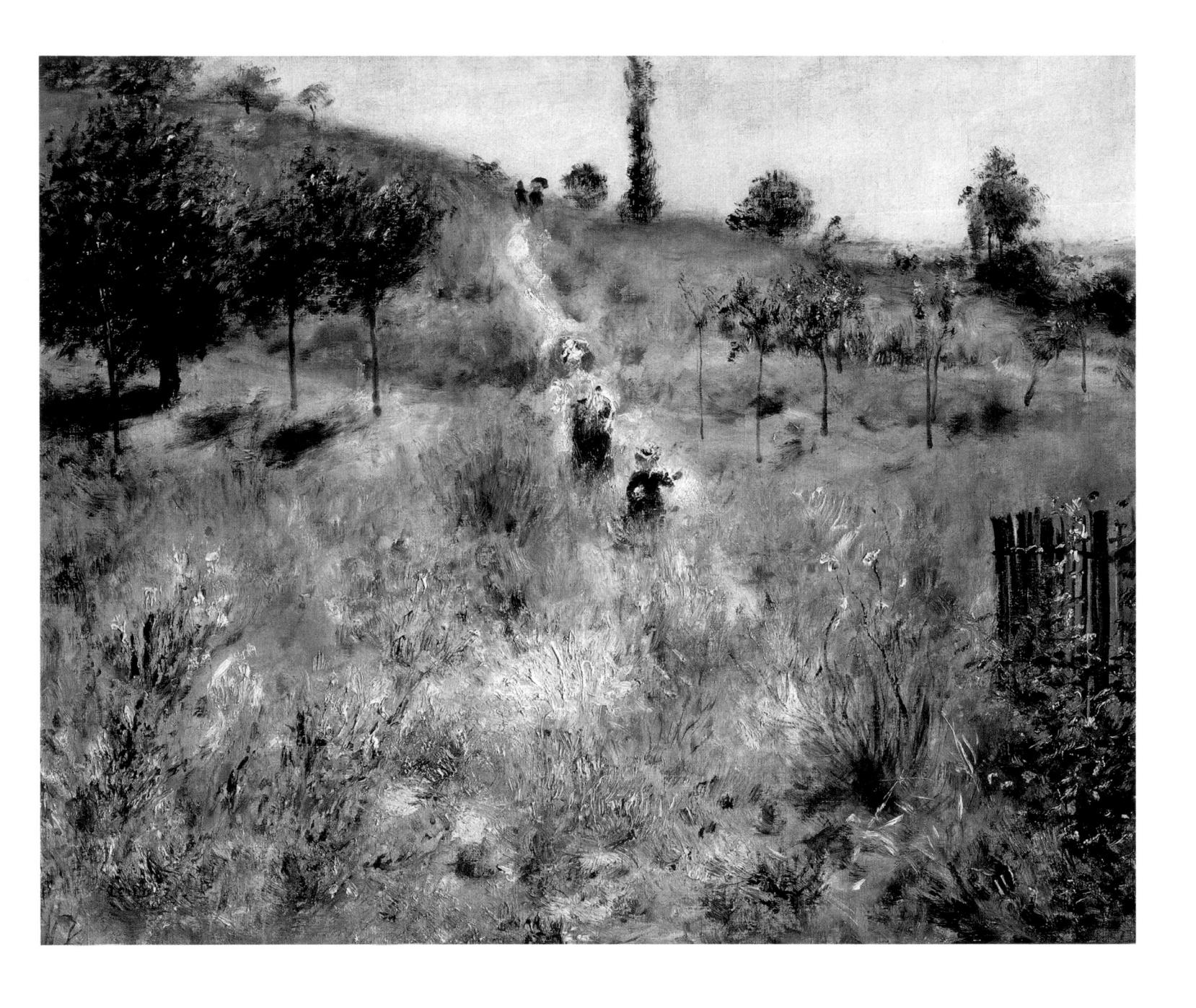

beauty. But this did not deter them. Once Monet had found a flat in Argenteuil on the river Seine, both he and Renoir were joined by Manet, and together the three artists painted quite a few of their sunniest open-air pictures. One of their neighbours, a naval engineer, owned several sailing yachts and also enjoyed painting. He often used to go sailing with Renoir and Monet, and as he was unmarried and wealthy, he also bought quite a few of their works. His name was Gustave Caillebotte, and when he died in 1894, he left all his pictures to the French state. These also included six major works by Renoir, which he had painted in 1875/76, such as his *Nude in the Sunlight* and *Le Moulin de la Galette*.

By now Renoir had already met the writer Théodore Duret who, in 1878, wrote the first more detailed and theoretical account of the aims and the successes of the Impressionists. He, too, started off by buying pictures, including Renoir's *Lise* for 1200 francs. This meant that the painter could afford to move into a better studio. But such moments of joy were very short-lived. The artists' society was running at a loss and had to be dissolved.

Country Footpath in the Summer, about 1874 Oil on canvas, 60 x 74 cm (23.2 x 29.1 in.) Paris, Musée d'Orsay

In April 1876 the Impressionists gave their second exhibition, this time at Durand-Ruel's gallery in the Rue Le Peletier. Renoir was represented by fifteen pictures, six of which had already been bought by Victor Chocquet, a new admirer of his art. Albert Wolff, an influential art critic, wrote in the newspaper *Le Figaro*: "Five or six madmen, ... blinded by their own ambition, have gathered together in that place to exhibit their works. Many people just kill themselves laughing when they see these shoddy pieces of work" Some people, however, made quite positive comments on the Impressionists. Edmond Duranty, a Realist writer, published a brochure called *The New Style of Painting*, in which he defended the depiction of contemporary everyday life, open-air painting and the attempt to capture brief moments. Renoir met Zola's publisher Georges Charpentier, who commissioned him for a portrait of his wife and children as well as several paintings to decorate his walls. This enabled Renoir to rent a house in Montmartre and to use its neglected garden as an open-air studio.

Conversation with the Gardener, about 1875 Oil on canvas, 51 x 63 cm (21.3 x 25.6 in.) Washington, D.C., National Gallery of Art, Ailsa Mellon Bruce Collection

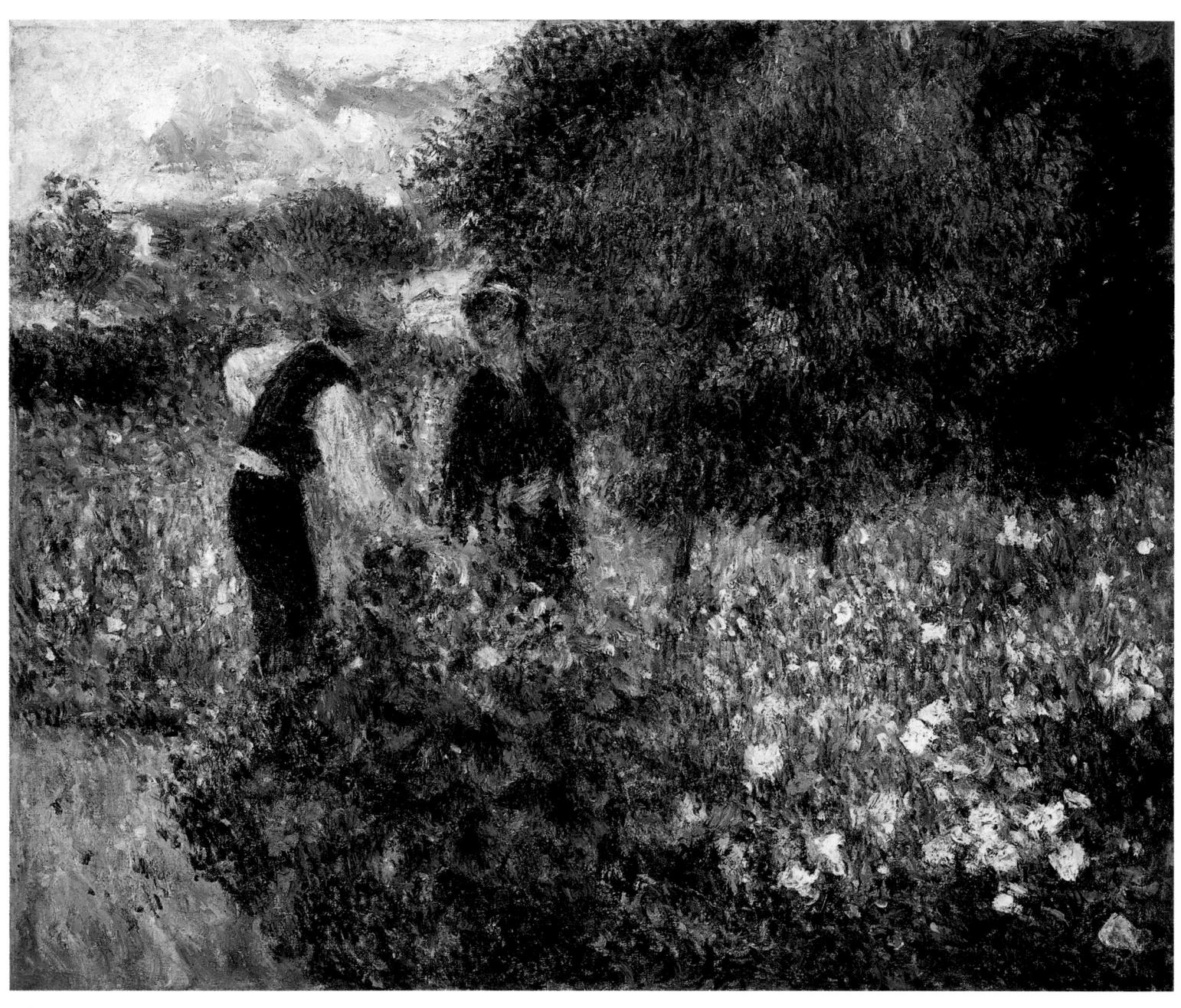

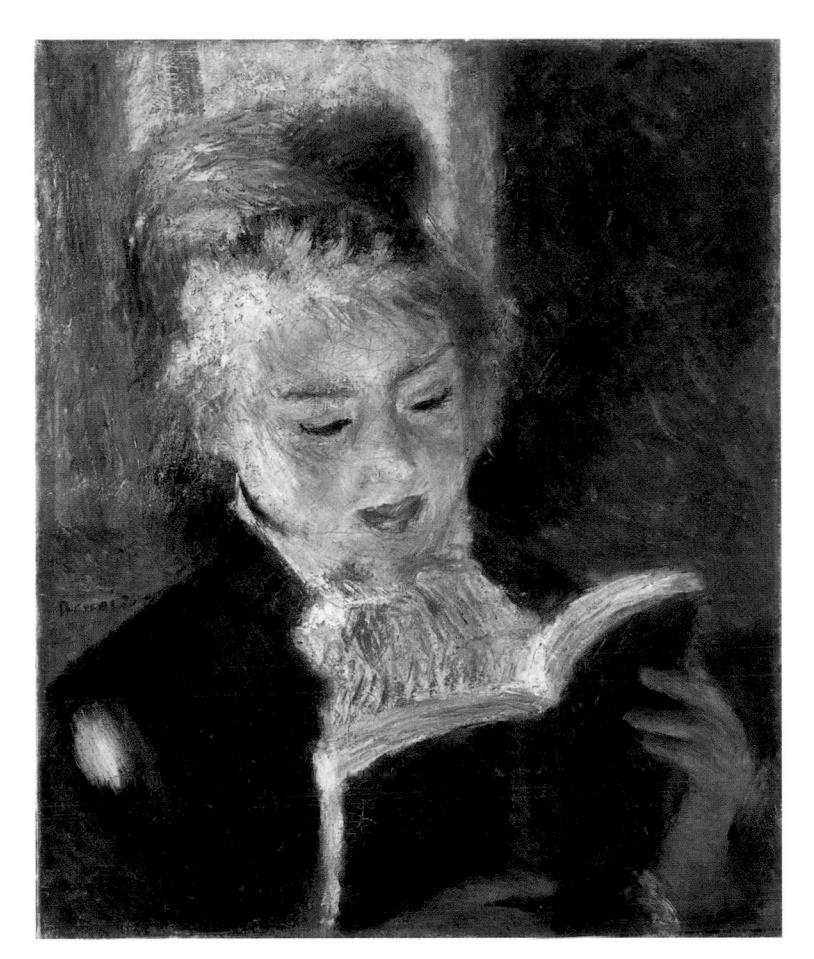

A year later, in April 1877, the Impressionists organized their third exhibition and, for the first time, described themselves as such, thus using their nickname. Caillebotte rented a few rooms for them in the Rue Le Peletier, and the preliminary work was done mainly by him and Renoir, who contributed over twenty paintings, including *The Swing* (illus. p. 37) and *Le Moulin de la Galette* (illus. pp. 34/35). Chocquet had a number of discussions with the people who visited the exhibition, and Renoir's new friend Georges Rivière began to publish a small magazine called *Impressioniste*, *Journal d'Art*, in which the new style was defended. But, as before, the critiques printed in the big newspapers were full of derogatory remarks, and so nobody bought anything.

The following year Renoir gave in and submitted a more moderate picture to the *Salon*. His *Cup of Hot Chocolate*, a charming portrait of a woman, was accepted. He himself admitted that he had painted it for purely commercial reasons. Nearly all art enthusiasts were only willing to buy pictures by an artist whose works had been exhibited at the *Salon*. Nevertheless, even in this painting Renoir did not abandon his ideals entirely. Nor did he betray them in 1879, when he exhibited his picture of Madame Charpentier and her children (illus. pp. 42/43) and finally achieved a genuine breakthrough and public success. Charpentier gave him an opportunity to show pastel drawings in an exhibition of his own, and he managed to find several other patrons, notably the diplomat Paul Bérard. During the next few years he spent quite a lot of time living and working in the grounds of his stately home Wargemont near Berneval in Normandy. He did not contribute to the Impressionists' exhibitions in 1879, 1880

LEFT:

Woman Reading, about 1875/76 Oil on canvas, 47 x 38 cm (18.5 x 15 in.) Paris, Musée d'Orsay

RIGHT:

Young Girl Reading, 1886 Oil on canvas, 55 x 46 cm (21.7 x 18.1 in.) Frankfurt, Städelsches Kunstinstitut und Städtische Galerie

[&]quot;My concern has always been to paint human beings like fruits. The greatest of modern painters, Corot – his women aren't 'thinkers', are they?"

"I arrange my subjects as I want them. Then I start, and I paint like a child. I want my red to sound like a bell. If I don't manage at first, then I put more red in and also other colours until I've got it. I'm no more intelligent than others. I haven't got any rules or methods. Anyone can look at my material or watch me paint – he will find that I don't have secrets."

PIERRE-AUGUSTE RENOIR

or 1881. The relationship between him and his old friends had become somewhat strained, and this may have been due partly to political differences of opinion. He detested the "anarchism" of some painters, such as François Raffaëlli and Armand Guillaumin, nor did he share Pissarro's socialist ideas. And he did not feel at ease with Edgar Degas's attitude of aggressive contempt towards the public for letting him down.

In 1881 the sale of some of his pictures enabled him for the first time to travel. In March he went to Algiers where the scorching sun and the wealth of different colours attracted him in the same way that they had fascinated the painter whom Renoir admired so much, Delacroix, on his visit half a century earlier. In autumn and spring he visited Venice (illus. pp. 56 and 57), where he felt enchanted by its lights and water; in Rome he was impressed by Raphael's strict fresco style, and near Naples the delicate but energetic mural paintings on the ancient houses of Pompeii reminded him of Corot's pictures. In Palermo, Sicily, he painted a portrait of Richard Wagner, who was still very young at the time, and although he quite admired him, he could not help feeling a certain impatience with the composer. And when he caught pneumonia on a holiday with his friend Paul Cézanne in Provence, he went straight to Algiers again, where the hot climate soon helped to restore his health.

While he was away, in April 1882, the seventh exhibition of the *Group of Independent Realist and Impressionist Artists* took place, where twenty-five of his paintings were shown, including his Luncheon of the Boating Party and views of Venice. However, he still had his reservations about the "independent artists", and so he insisted that his pictures should be marked as submitted by his agent Durand-Ruel and not by himself. Durand-Ruel, who had been going through quite a hard time as a result of another economic crisis, really needed this exhibition, and in fact the new understanding of art was now beginning to gain ground in wider circles. Renoir was quite welcome to display his works at the Salon as well, which he did regularly between 1878 and 1883. This gave him an opportunity to "get rid of that revolutionary image", which rather frightened him, as he put it. In 1883 Durand-Ruel organized a special Renoir exhibition at his new gallery on the Boulevard de la Madeleine. Towards the end of summer that year Renoir did some painting on the Isle of Guernsey; in the winter he and Monet went to Genoa together and then visited Cézanne in L'Estaque in Provence. From then on he would spend part of each summer and winter outside Paris. He often went to stay on the coast in Normandy and Brittany, and also the Côte d'Azur as well as Essoyes in Burgundy, the home of Aline Charigot, the charming little model whom he married in 1890.

From 1884/85 onwards a number of new elements entered into his art, thus marking a definite turning point. But before we discuss this in detail, we shall focus on the works he produced during that rich and joyful period of his life. This was the triumph of Impressionism, and it can be clearly defined in terms of Renoir's art and his life at that time.

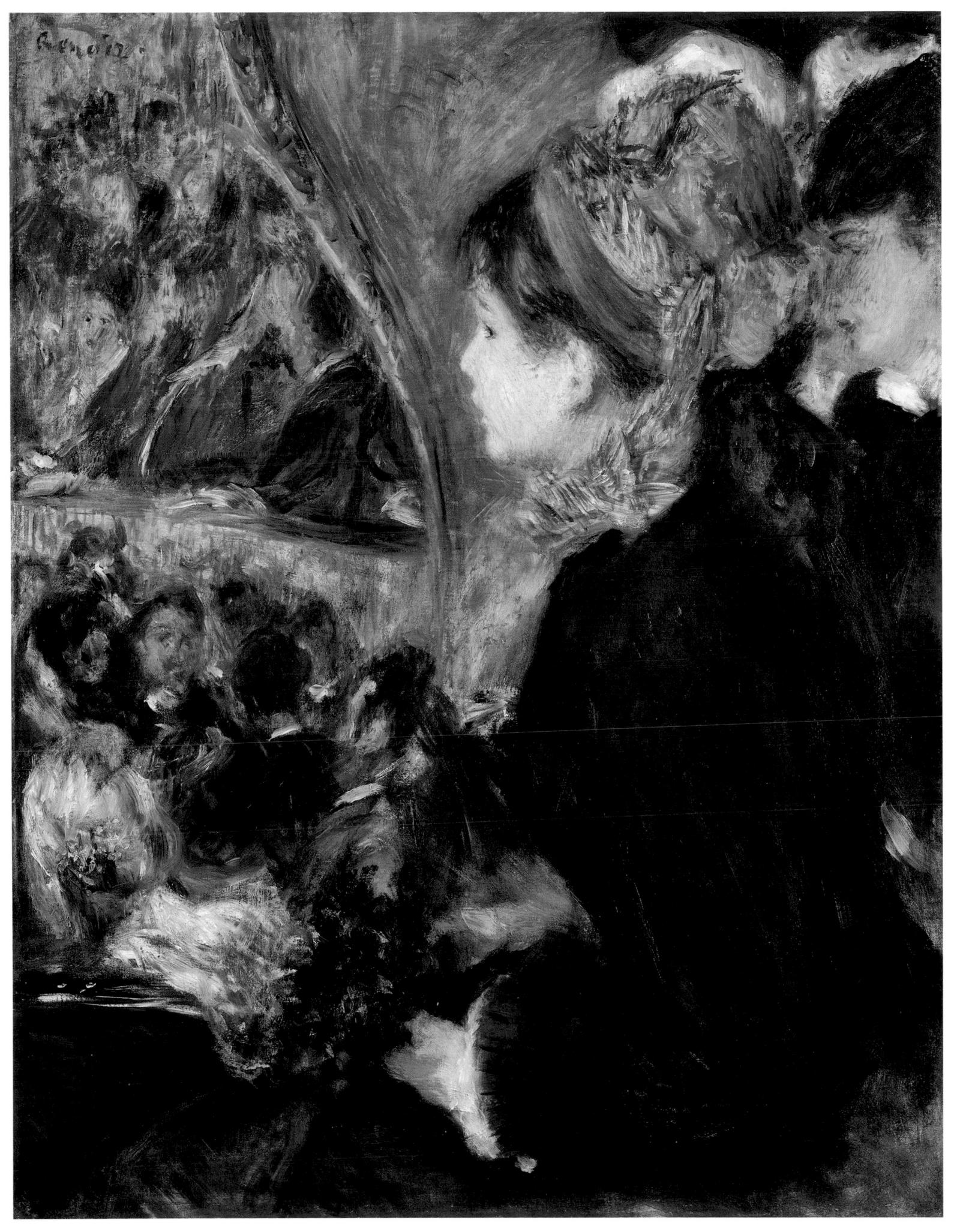

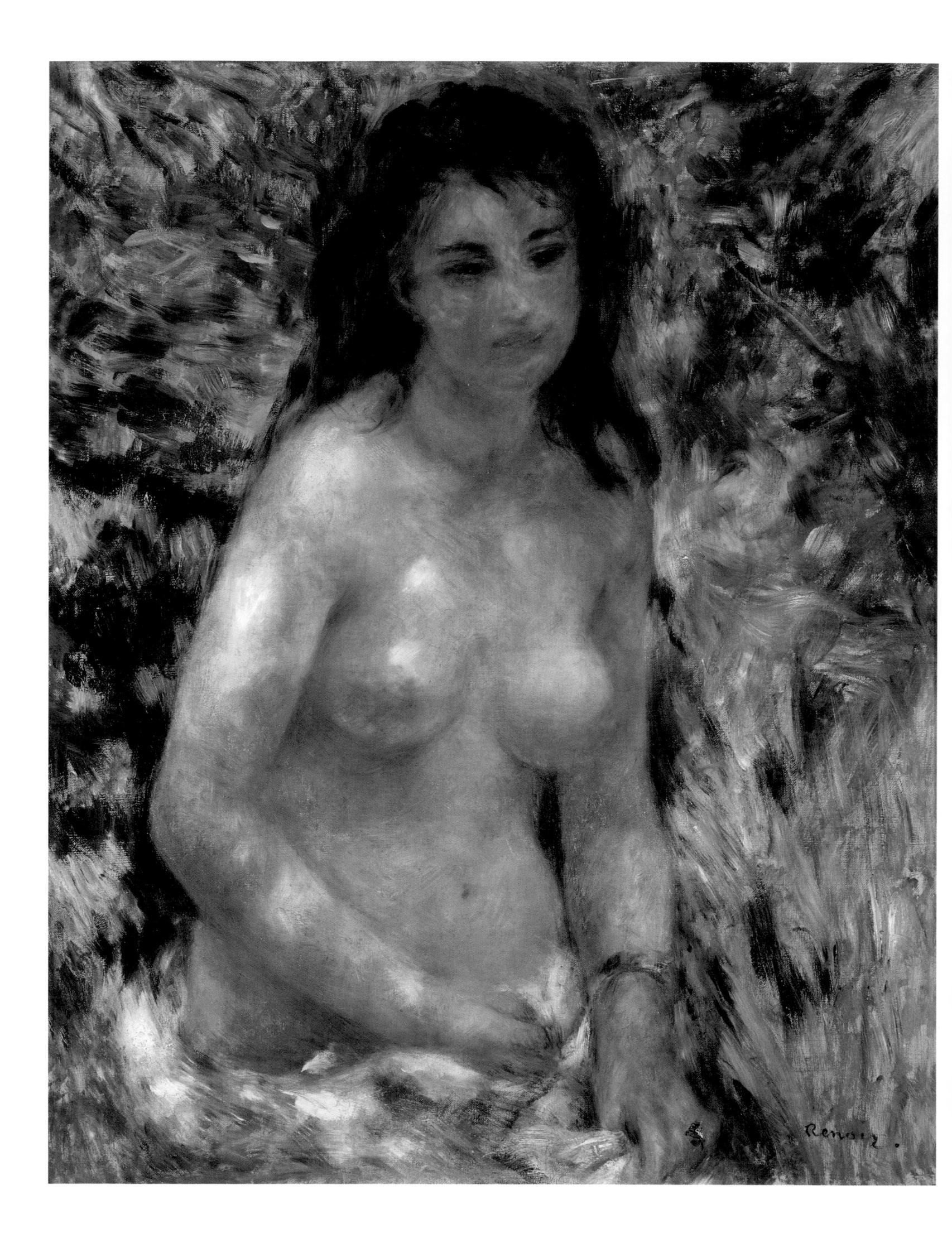

Masterpieces of Realist Impressionism

Renoir painted all those elements of real life that he saw and approved of: the life of the rich, on whose benevolence he depended in order to make a living as a painter, and also the little pleasures of the lower-middle-class Bohemians, the class to which he himself belonged and which looked very respectable and had nothing rebellious or tragle about it. But although his art did not encompass everything that could be said about society, we can still call it realistic because it shed some light on facets of life which did indeed exist. Also, it helped people to experience and accept themselves in a new way, both in their normal, humdrum existence and in their sensuality. For the first time they were able to look at important features of their lives from an aesthetic point of view, and this discovery is still relevant today.

There were a number of subjects which Renoir particularly concentrated on: portraits and portrait-like individual figures, dances, the theatre, the company of good friends, country walks, the hustle and bustle of the big city, and landscapes. Both his portraits and his pictures of people in general showed his special gift for expressing feminine charm; what is more, he knew how to express the whole range of that enticing attractiveness which could emanate from a woman. Again and again he manged to express very skilfully the enchantment of feminine beauty and to convey a feeling of deep joy. Renoir may have painted only a rather narrow area of human existence; indeed, there are no sad, angry, ugly or old women in his pictures, no profound or problematic characters, and even his male figures have a certain soft femininity about them. But hardly anybody has ever been able to capture that smile of blissful joy, the tantalizing sweetness of being in love and a luxurious, easy-going enjoyment of life. Having learnt his craft from the noble masters of the Rococo, he succeeded in reflecting all these feelings in the features and postures of his figures.

There were many "ladies' painters" in those days: skilled craftsmen of the art of painting and willing flatterers of the tastes of the upper-middle classes. They knew how to turn every banker's wife into a Renaissance duchess or a ravishing seductress. They painted costly clothes and furniture, and the faces of their figures had a certain soulless, stylized complacency and morbidness about them. Renoir, who had to live on his art, did not always manage to escape the danger of superficiality in his portraits. He was quite capable of painting a brilliant picture of gleaming silk and velvet, but he never did so unless his heart was in it,

Female Nude SeatedBlack crayon
New York, Private Collection

"Could you take the trouble to explain to M. Renoir that a woman's body is not a piece of putrid flesh with green and purple spots which indicate that a corpse has reached a state of complete decomposition. And this collection of coarse objects is in fact displayed in public, without any thought of the fatal consequences it might have."

ALBERT WOLFF IN LE FIGARO, 1876

PAGE 30: *Nude in the Sunlight*, about 1875/76 Oil on canvas, 81 x 64.8 cm (31.9 x 25.5 in.) Paris, Musée d'Orsay

Woman in a Rocking Chair, 1883 Pencil and crayon, 36.2 x 31 cm (14.3 x 12.2 in.) Chicage, The Art Institute of Chicago

"For me a picture has to be something pleasant, delightful and pretty – yes, pretty. There are enough unpleasant things in the world without us producing even more."

PIERRE-AUGUSTE RENOIR

PAGE 33: *A Girl with a Watering Can*, 1876
Oil on canvas, 100.4 x 73.4 cm (39.5 x 28.9 in.)
Washington, D.C., National Gallery of Art,
Chester Dale Collection

and so his natural naivety protected him from the false glitter of the fashionable. He would observe real life rather than studied poses, and his paintings were a celebration of the freshness and beauty of simple, unspoilt people.

His best pictures are of people with whom he had a personal relationship. He frequently used to paint his friend Monet and his wife Camille. Painted with broad strokes of the brush, Madame Monet can be seen recumbent on the sofa, reading *Le Figaro* (illus. p. 23). She is wearing a delicate, light-blue morning dress, and the sofa has been draped with white gauze. Her dark hair and eyes are in sharp contrast with the general summer-like brightness of this colourful painting. The Impressionists loved showing their subjects in the intimate privacy of their own homes, with a casual nonchalance that these people would not normally have displayed in front of complete strangers. And in order to preserve a natural and lifelike impact, the painters had to abandon the Classicist tradition of balance and symmetry. Instead they tried to capture individual moments and used asymmetrical and spontaneous elements to emphasize the fleeting impression of chance.

In fact this approach was noticeable even where Renoir had to do justice to people's demands, i.e. when they expected to be portrayed in a certain way to present a definite image. The picture of the publisher's wife, Madame Charpentier, and her children is a good example (illus. pp. 42/43). This intelligent and distinguished lady is shown as displaying a good deal of studied non-chalance. And although her little darlings have obviously been smartened up specially for the occasion, like dolls, there is nevertheless still something in their faces and their postures that looks attractively childlike and uncomplicated. The pyramid of figures, which includes a St Bernard dog, has been moved diagonally into the middle of the room, thus changing the classical scheme of composition into something rather extravagant. The surprisingly empty area in the bottom right-hand corner introduces a certain asymmetrical tension into the structure of the picture, and, together with the large gold-lacquer screen and its pheasants, shows the aesthetic pleasure which people at that time used to derive from Japanese art and its highly original decorative effect.

Renoir, of course, refused to jump on this Japanese bandwagon, but in this picture, where he had to render the way in which Madame Charpentier's room was decorated, he could not really avoid it. So he combined the glowing colours of the screen with the flowers, curtains, sofa cover and children's dresses and achieved an overall impression of a still life that was both clever and in good taste, with the black-and-white contrasts of the lady's dress and of the dog as the most emphatic elements. For Renoir neither black nor white were dead colours that always stayed the same. On the contrary, he knew how to make black come to life. Black was very common in people's dresses at the time, and Renoir often managed to bring this colour into its own by mixing red or blue into it. Quoting Tintoretto as his authority, he even used to call black the queen of colours.

The children form the most natural part of this portrait of the Charpentiers. Renoir painted a large number of children's portraits that year. He had a finely developed feeling for the rosy complexion of a child's skin, for the dreamlike purity and gentleness of their eyes, but also for that capricious self-confidence which was sometimes typical of those little ladies, and not just among the daughters of the Parisan middle classes.

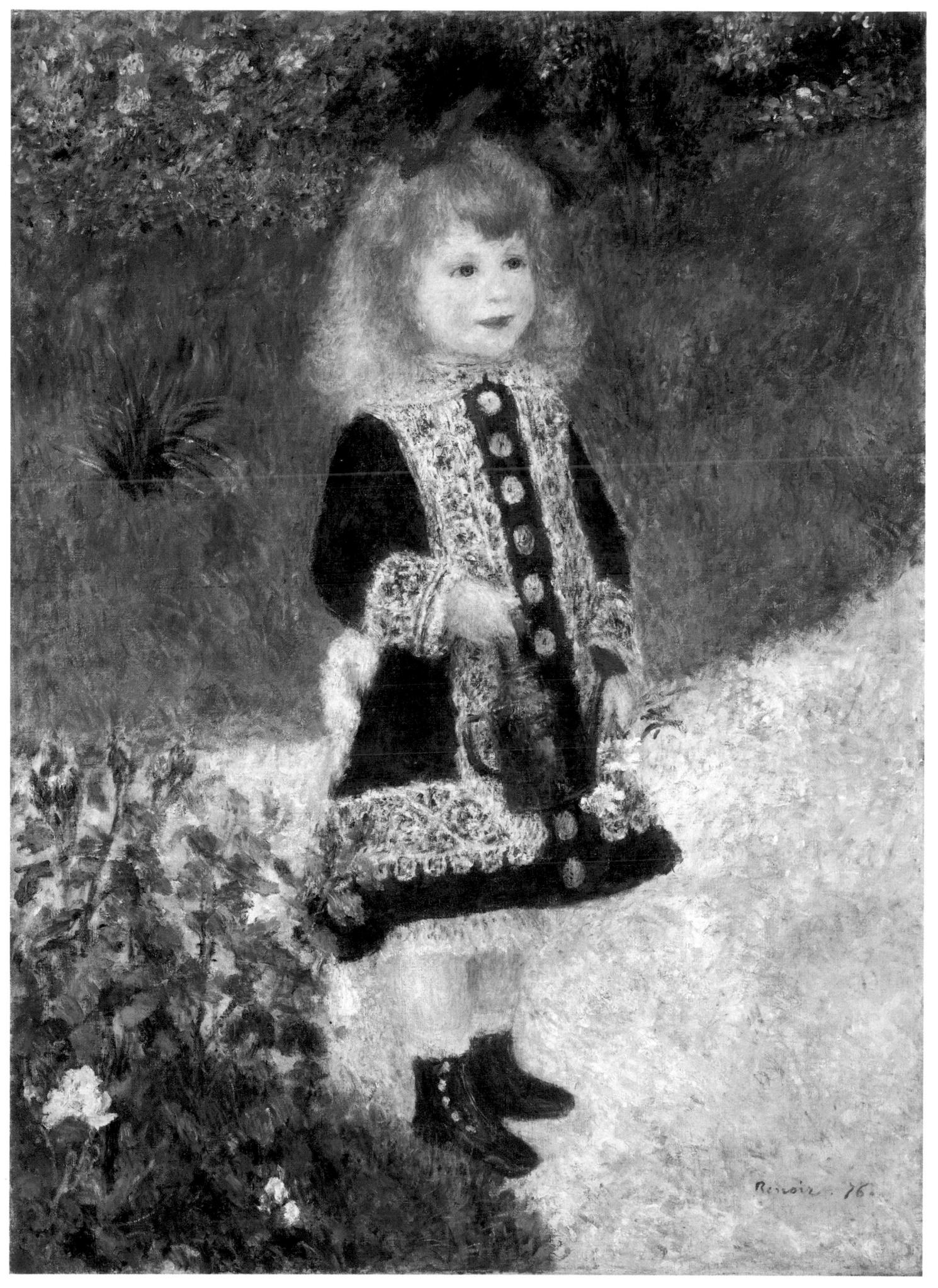

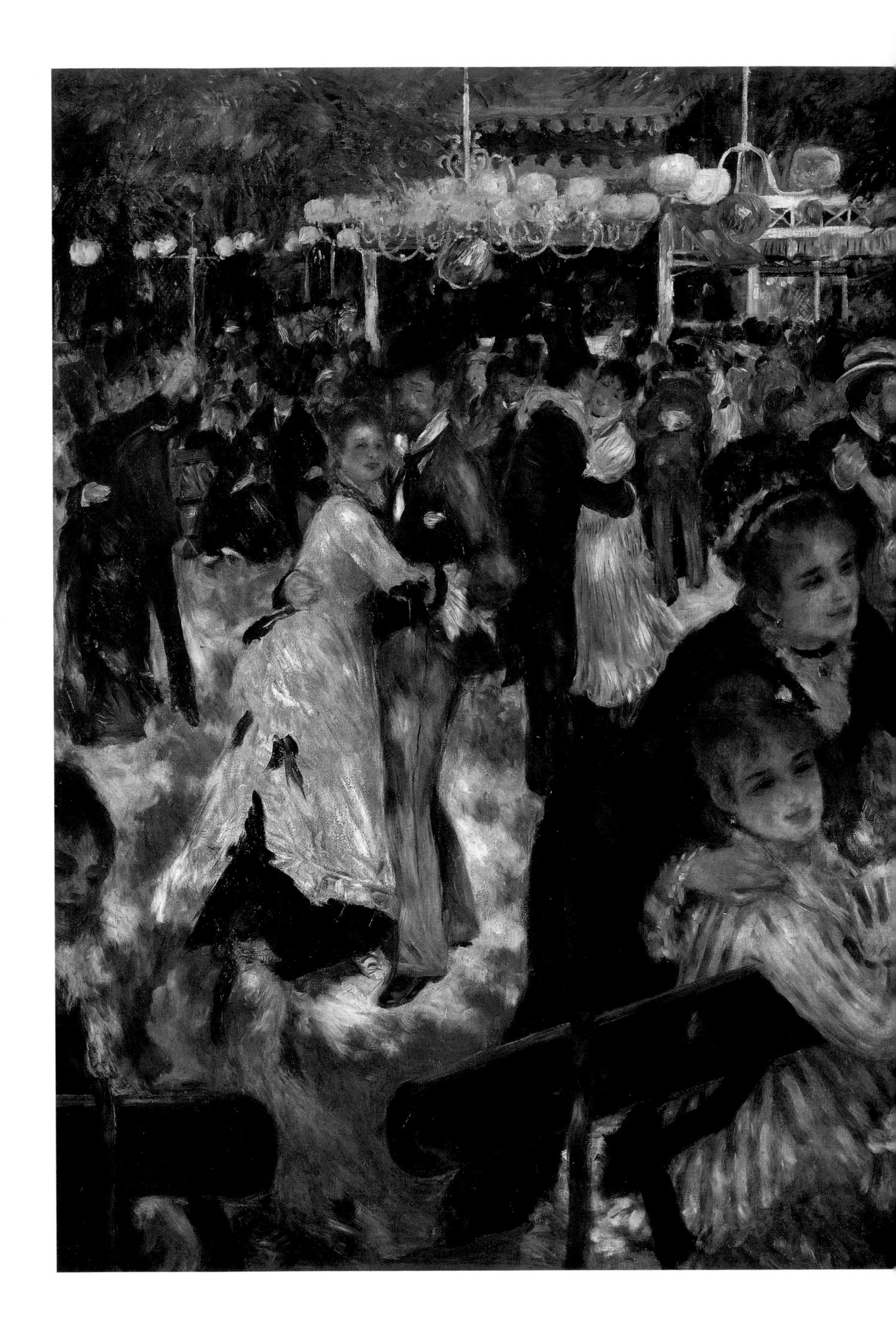

Le Moulin de la Galette, 1876 Oil on canvas, 131 x 175 cm (51.6 x 68.9 in.) Paris, Musée d'Orsay

"I used to find enough girls at the Moulin de la Galette who were willing to come to me as models, like the two at the front of the picture. One of them wrote to me on gold-edged paper, offering herself as a model, even though I had been meeting her quite frequently when she was carrying milk at the Montmartre. One day I learnt that a gentleman had furnished her a little flat, but her mother had linked it to the condition that she should not give up her job. I was afraid at first that the lovers of the girls I recruited at the Moulin de la Galette might prevent their 'women' from visiting me in my studio. But they were decent chaps, and some of them even served as models themselves. One mustn't think that these girls would just go out with anyone. Occasionally I was surprised at how virtuous they were, even though they came from the gutter."

PIERRE-AUGUSTE RENOIR

Apart from the portraits of friends and the ones that had been commissioned by customers, there are also a large number of pictures and studies which Renoir used to paint of professional models; these are so-called genre pictures, i.e. portraits of people who were somehow typical of the time and whose names we do not know. Artistically, they do not differ greatly from Renoir's real portraits. Nearly all of them are of women; Renoir liked them, and their pictures were easier to sell. His *Woman Reading* (illus. p. 27) is one such work: it is the picture of a blonde woman sitting by the window and reading a paperback novel. The bright paper of the book reflects the yellow sunlight onto her face, so that her face and her hair are filled with a brightness that comes from several different sources. In contrast to prevalent pre-Impressionist methods, light and shade do not serve to enhance the plasticity of the outlines, but the light, as it were, swallows up all contours and details, leaving no more than a ripple of yellow and red, accompanied by some colourful black.

People in the sunlight – this was one of the most widely discussed problems among the Impressionists, and Renoir picked up this theme in a number of female nude pictures, the most magnificent one being that of his model Anna, a semi-nude painting which he began in the garden of his studio in the Rue Corot in 1875 and showed at the second Impressionists' exhibition in 1876. It is the figure of an extremely well-shaped girl, bending over slightly, and is like some of the Greek sculptures of Aphrodite rising from the waves (illus. p. 30). Her long chestnut-brown hair runs down the length of her body, as do the patches of light and the subtle shades of purple and green that are reflections of the foliage that surrounds and protects her. Rising out of the blossoming shrubs, it seems as if she were a flower herself. The shrubs themselves consist of no more than a few yellow, blue and green strokes of the brush woven together by the artist. Never before had any painter achieved such a subtle merging of a nude human being with light and nature. Indeed, it would have been impossible to paint like that without a new awareness of life, of the sun, of the open air. At the same time, however, the picture affects us as if it were an ancient myth of nature. The girl, whose fingers and wrists are adorned in costly splendour, is both a child and a goddess of nature – a painted poem in which an ancient truth is expressed in a completely novel manner. No wonder that it left the critics baffled. Nevertheless, Caillebotte still bought the picture.

In his portraits, Renoir always aimed at painting his subjects in a posture that was both natural and characteristic, but at the same time captured a chance impression of a brief, fleeting moment. He continually tried to achieve impressions that were true to life, a tendency which also prevailed in his genre paintings of the life of the middle classes. Paintings of that kind were not highly regarded at that time. The leading trendsetters in the world of art believed that the most worthy objects of artistic endeavour were, first and foremost, themes from mythology and history as well as religious and allegorical depictions. As for those other pictures that merely showed the life of ordinary people, they preferred scenes which they regarded as "picturesque", i.e. scenes from Italy or the Orient. Members of the *Salon* panel as well as visitors of the exhibitions and prospective buyers used to demand that each painting should include either an element of suspense or a clever, amusing event, something that was somehow unusual, a story which the

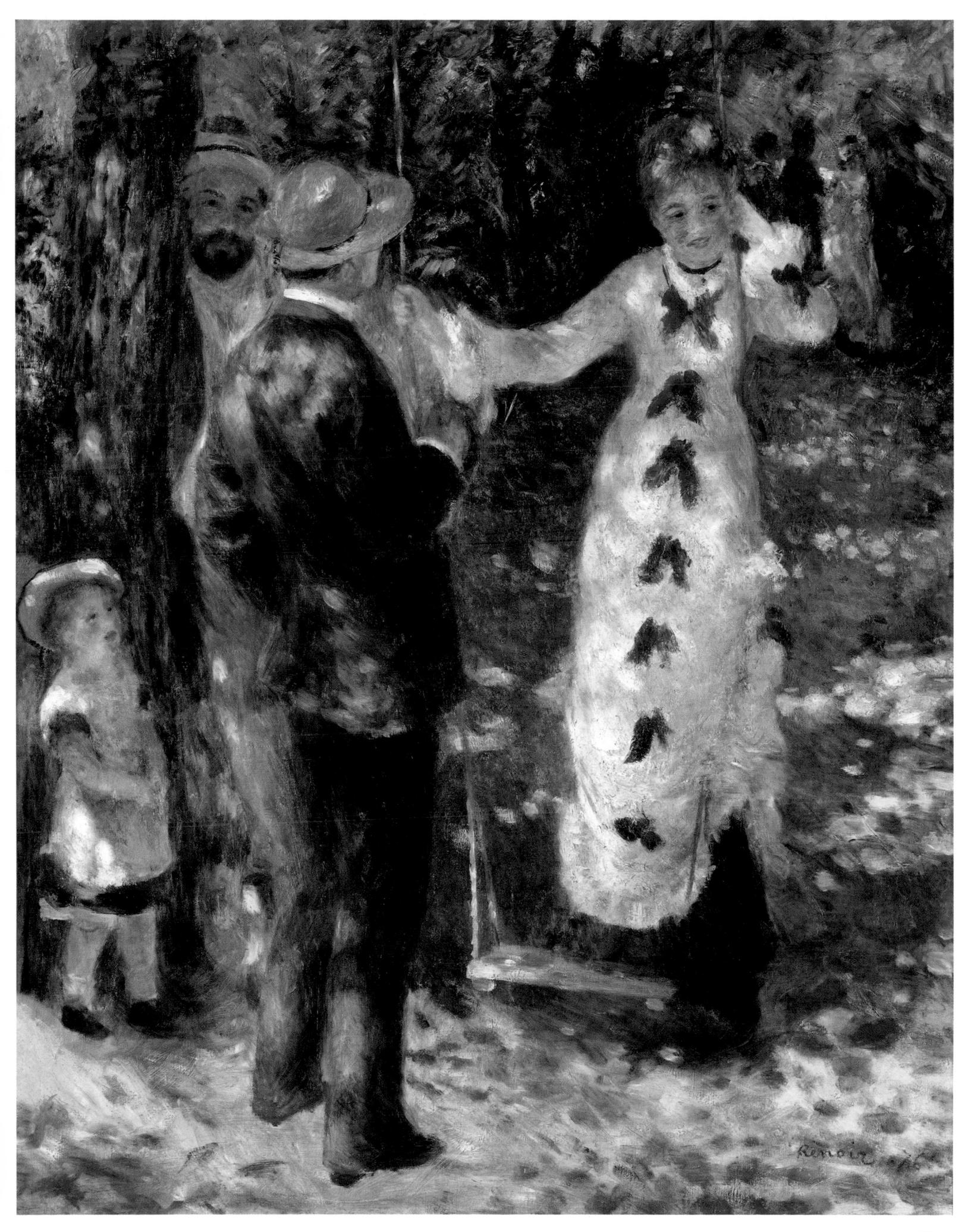

artist succeeded in telling by means of the skilful arrangement of the figures and the expressions on their faces. In Realism, on the other hand, as represented by Courbet, Millet and their first followers, it was maintained that there was beauty in simple, ordinary, everyday life, and that this could be portrayed in art. As a result, Realism was looked down upon as the "cult of ugliness".

Like other Impressionists, Renoir concentrated on the things which he regarded as the beauty of middle-class life in the big city of Paris. In fact, his pictures tell us little stories, too, but they are all taken from contemporary everyday life in Paris, or rather from a typical Parisian Sunday. His stories are always short. They are glimpses of people passing by, captured in brief moments, snatched from the ever quickening flow of modern life and scribbled down in the shorthand of the artist's own experience. They are deliberately void of climactic effects or indeed of anything unusual. Renoir never used to paint anything that could not have been repeated a thousand times in exactly the same way – and would still have remained something totally different and unique. It was the Impressionists who discovered the individual value of every single chance occurrence, and their conclusion that everything was in perpetual motion was forcefully expressed in their art. They recorded the attractive features of the ephemeral and the momentary.

Like his colleague Degas, Renoir also made his observations at the theatre and the circus. And when he painted a graceful ballet dancer and two little artistes at the Fernando Circus (illus. p. 45), he did so far more gently and lovingly than Degas with his sarcasm. Above all, however, he observed the spectators. *La Loge* (illus. p. 22) shows a couple waiting for the beginning of the show. The gentleman, Renoir's brother Edmond, remains in the background, and half of his face is covered by a pair of opera glasses, while the lady shows herself in all her beauty at the balustrade. She is portrayed in a posture that is almost classical in its simplicity. The stripes on her dress guide our gaze to the tranquil features of her gentle countenance. The pale pink of the camellia blossom in her hair and on her neck matches the shades of her powdered complexion which, in turn, has a greenish yellow sheen that reflects the cold light from the gas lamp. The entire picture, for which a little girl, Nini Lopez, served as a model, is an ode to the young woman's charm, and although Renoir faithfully recorded her self-conscious tension, it is completely fresh and without affectation.

We no longer understand nowadays how such an inspired and refined painting could possibly have met with scornful contempt, but when Renoir showed this picture at the first Impressionists' exhibition, the only person who was prepared to buy it was a rather insignificant art dealer called Père Martin. Renoir sold it for a mere 425 francs, which he desperately needed to pay the rent. Two years later he painted a similar theatre scene called *The First Outing* (illus. p. 29), showing a young girl's first visit to the opera. Her stunned expectation is captured beautifully in her posture and her expression, even though we can only see her delicate little face in the form of a very hazy profile. Before her eyes there is the scuttling movement of the crowds whose impatient hustle and bustle fills the neighbouring boxes. A certain type of atmosphere had been perfectly expressed, an atmosphere that tingled with excitement and that was an important element in the lives of people who simply loved going to the theatre.

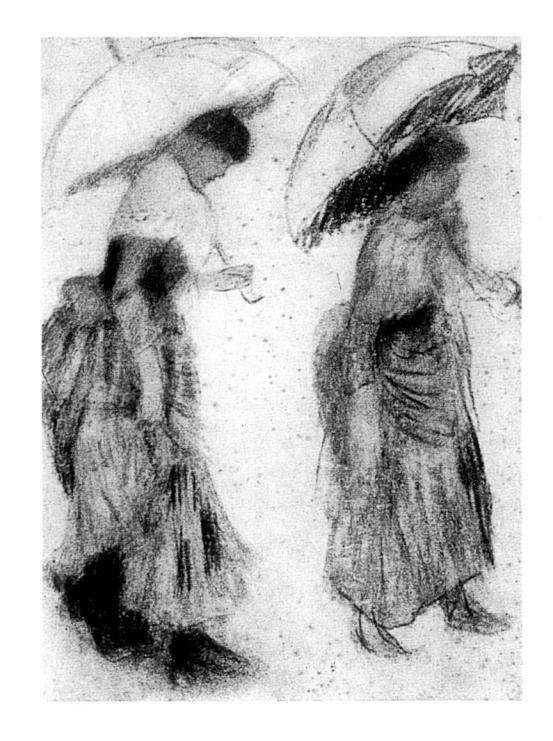

The Promenade, 1879 Pastel, 63 x 48.5 cm (24.8 x 19.1 in.) Belgrade, Narodni Muzej

PAGE 38: Young Woman with a Veil, 1876 Oil on canvas, 61 x 51 cm (24 x 20.1 in.) Paris, Musée d'Orsay

Banks of the Seine at Champrosay, 1876 Oil on canvas, 55 x 66 cm (21.7 x 26 in.) Paris, Musée d'Orsay

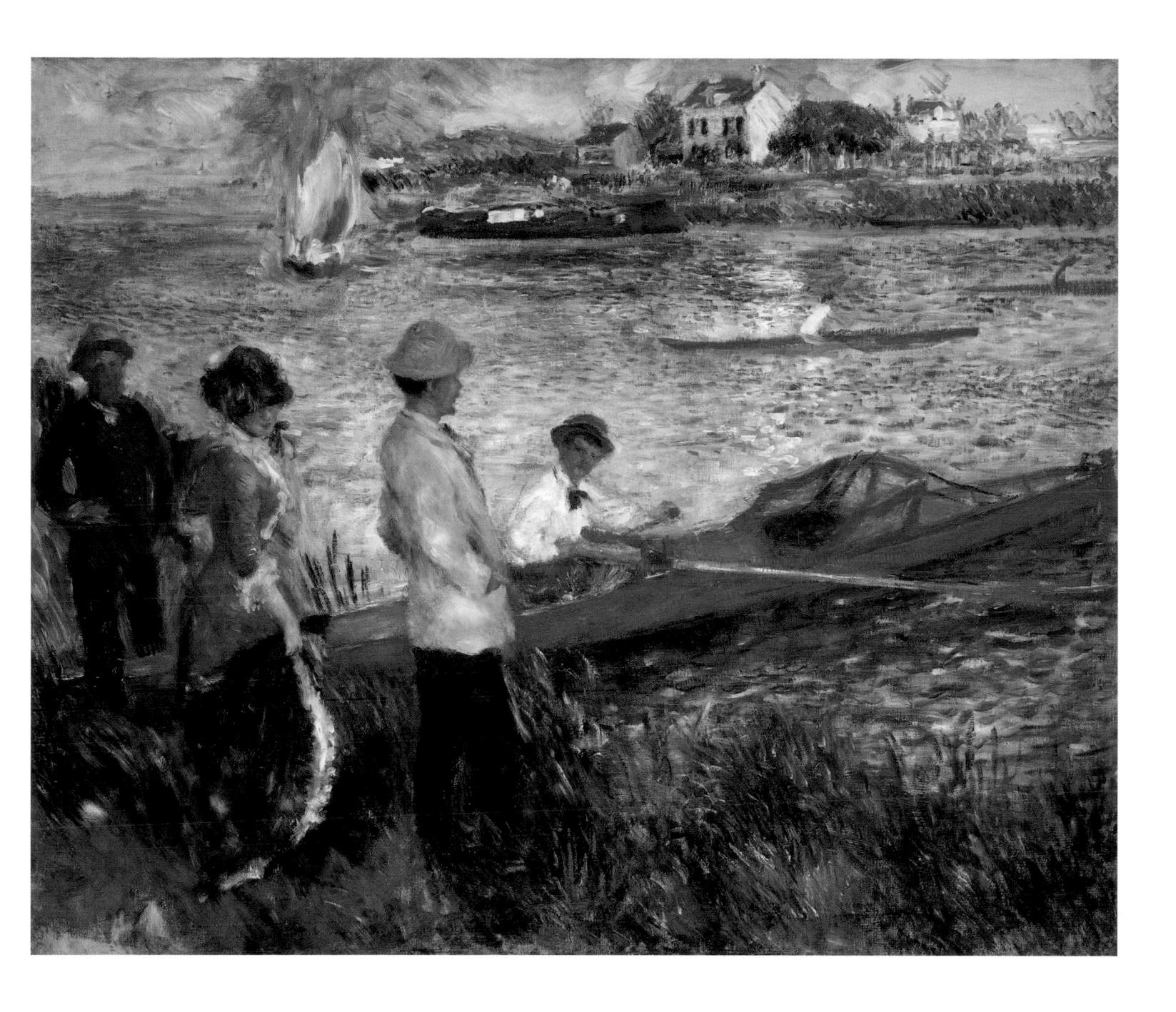

During the summer months, when the theatres were closed, there was another pleasure which Parisians used to enjoy: outings into the country. This was popular both among the respectable and the Bohemians.

At the La Grenouillère swimming pool Renoir had paid more attention to the overall colour scheme and the changing light. Now his open-air paintings were composed of individual figures, grouped together informally, smiling, flirting, chatting and generally enjoying the fresh air all around them, which is reflected in delicate yellow, blue and pink spots of colour. Renoir broke all academic rules of composition and arrangement. Shedding the straitjacket of rigid formality, he portrayed life as it really was, emphasizing everything that was cheerful and innocent. Unlike any other painter, he knew how to express the soft gracefulness of a woman's head turned tenderly to one side, the magic of a loving gesture, the warm radiance of dark, fawn-like eyes and the happy atmosphere of good friends or lovers gathered together. *The Promenade* (illus. p. 20) and *The Swing*

Oarsmen at Chatou, 1879 Oil on canvas, 81 x 100 cm (31.9 x 39.4 in.) Washington, D.C., National Gallery of Art

"How difficult it is to hit exactly the point on a picture where the imitation of nature has to stop. Art must never smack of the model, but it is important to feel nature."

PIERRE-AUGUSTE RENOIR

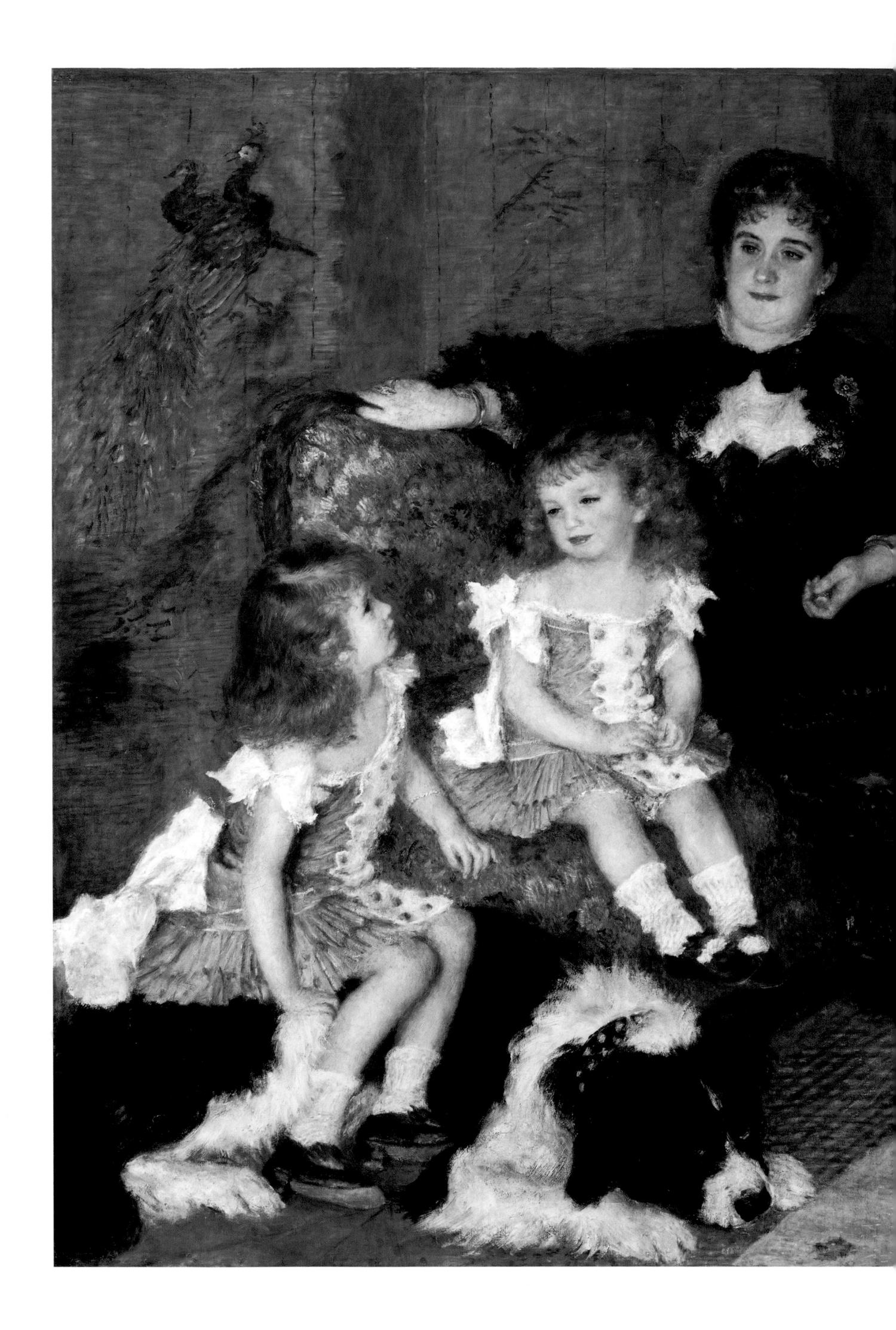

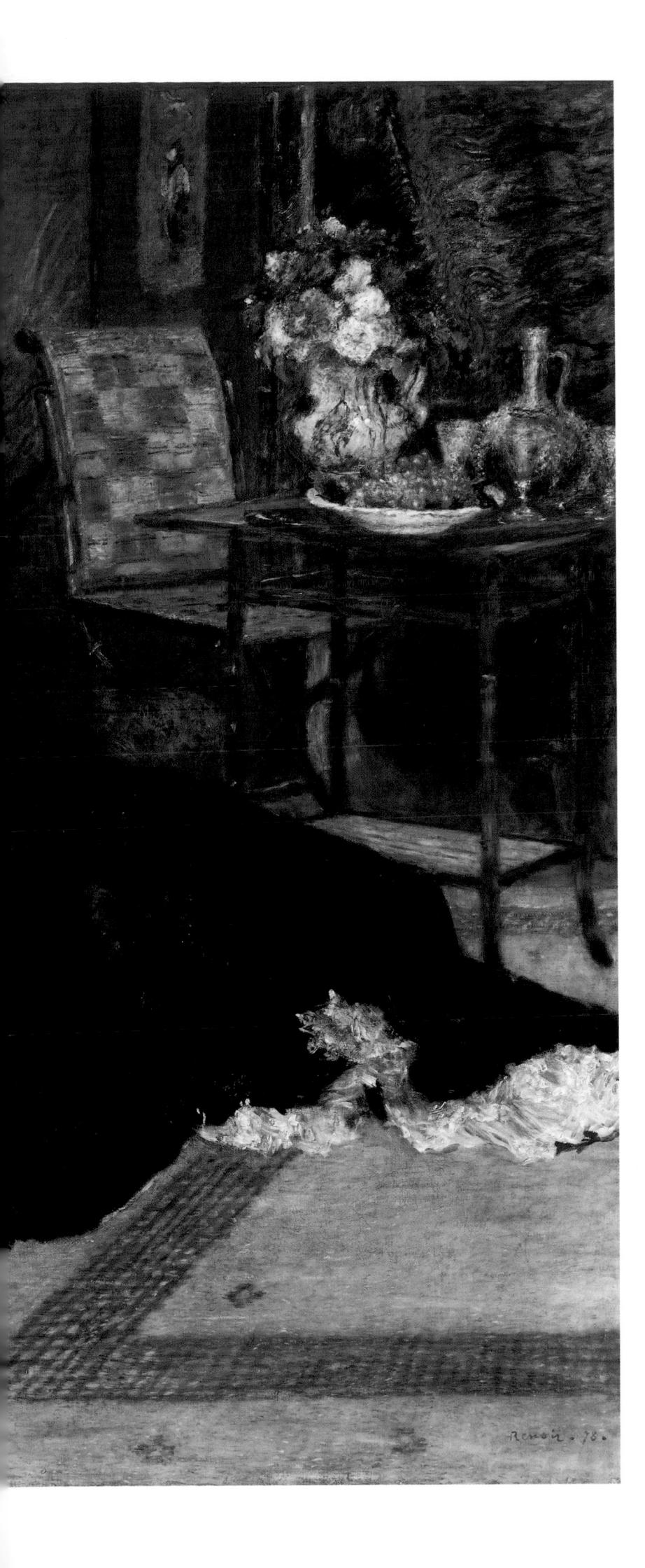

"Madame Charpentier reminds me of the sweethearts of my youth, the models of Fragonard. The two daughters had lovely dimples. I was congratulated. I forgot the attacks of the newspapers. I had models who were willing to sit for free and who were full of goodwill."

PIERRE-AUGUSTE RENOIR

F

Madame Charpentier and Her Children, 1878 Oil on canvas, 154 x 190 cm (60.6 x 74.8 in.) New York, The Metropolitan Museum of Art, Catharine Lorillard Wolfe Collection, Wolfe Fund

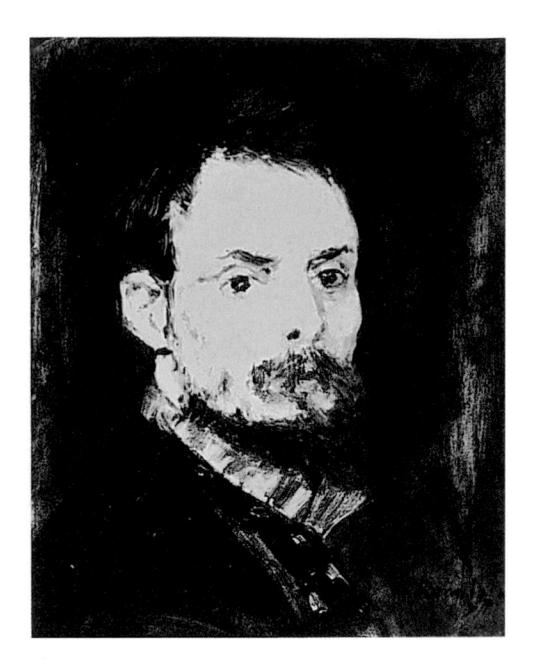

Self-Portrait, 1879 Oil on canvas, 39.4 x 31.7 cm (12 x 12.5 in.) Williamstown, Sterling and Francine Clark Art Institute

(illus. p. 37) both seem to be telling little tales, which puts them in the tradition of the gallant masters of the eighteenth century; at the same time, however, they emphasize the vibrant quality of various spots of colour and the subtle play of light and shade.

The most significant painting during this fruitful period in Renoir's life is *Le Moulin de la Galette* of 1879 (illus. p. 34/35). It has even been referred to as the most beautiful picture of the nineteenth century. The Butte Montmartre is a hill in the north-east of Paris, affording a magnificent view of the entire city. At the beginning of the nineteenth century the landscape painter Georges Michel, who was later rediscovered as one of the forerunners of the Barbizon Painters, had painted Montmartre as a hill with a thin growth of vegetation and towered over by windmills with turning blades.

By now the village had become a suburb, but it still had a certain rural simplicity about it and was therefore a popular place for excursions. Open-air restaurants and night bars soon opened their doors and provided merriment, until it gradually became the world-famous artists' and nightclub district. In the 1870s the Moulin de la Galette was a converted mill which served as a dance hall for the unpretentious lower-middle classes and the Bohemians among them. One of the two former windmills was still occasionally used for pressing orris root for the perfume industry, but both of them had been redecorated to accommodate bar rooms with low ceilings, and there were gas lanterns and tables in the gardens.

Renoir used to put up his painting equipment in the garden, between the tables, where people came on summer afternoons to drink, dance and flirt. His friends would help him carry his easel from his studio flat nearby, and they also served as models for the main figures in his pictures. Seated at the table, there are the painters Lamy, Goeneutte and Georges Rivière, who left us an account of that time, with the sisters Estelle and Jeanne and other Montmartre girls. At the centre of the picture is the somewhat dandyish Cuban painter Don Pedro Vidal dancing with his girlfriend Margot, who was also a popular model, and in the background there are the painters Gervex, Cordey, Lestringuez and Lhote. When we look at this picture we have the feeling that Renoir enjoyed an intimate friendship with every single person in the crowd and also with each of the objects that fill this glimpse of life.

The picture is rather large, and our first impression is one of disorderliness and chaos. Such was in fact the judgement of the leading art critics when the picture was shown to the public at the third Impressionists' exhibition in 1877. This effect is due to the random way in which the characters appear to be arranged, and also the consistent casualness with which both the foreground and the background have been painted. Above all, however, Renoir has dissolved and broken down the original colours of the place by means of the foliage, which casts a diffused sunlight onto the entire scene, permeating it with its light-blue shadow, and combining in a variety of ways with the green leaves, bright yellow straw hats and chairs, the blond hair of the people and the black suits of the men. The ground as well as people's faces and clothes are strewn with yellowish-pink spots – squiggles of sunshine that come through the foliage. The figures in this picture are surrounded by a somewhat dusty, flickering and uncommonly genuine atmosphere, which deprives their contours and details of that definiteness to which people's

PAGE 45: **Two Little Circus Girls**, 1879

Oil on canvas, 131 x 98.5 cm (51.6 x 30.8 in.)

Chicago, The Art Institute of Chicago,

Mr and Mrs Potter Palmer Collection

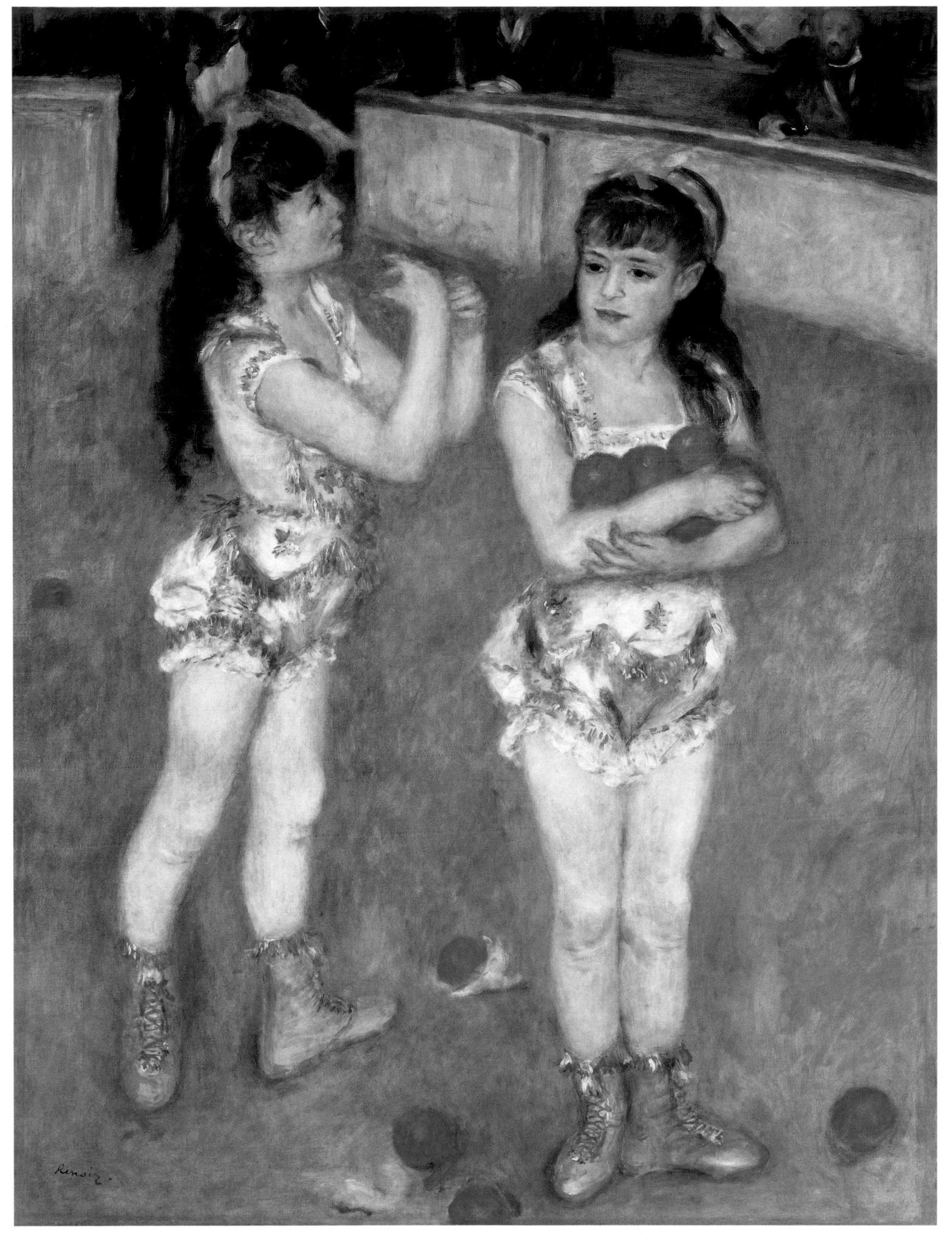

Berthe Morisot and her Daughter, 1894 Pastel, 59 x 44.5 cm (23.2 x 17.5 in.) Paris, Musée du Petit Palais

eyes were used to at the time. The impression of turbulence, which is inherent in the subject, was undoubtedly intended by Renoir. How could the joyful abandon of these cheerful people possibly have been pressed into the narrowly defined postures that were regarded as classical? Another impression that was intended is the generally random appearance of this section of reality: some figures are cut off at the edge of the picture, and the scene is speckled with motley spots of light. After all, did not this scene look almost exactly the same to the left and the right of this section, as well as before and after?

However, none of this means that such a picture is less intelligently composed than any of the paintings which were approved by the academic critics. Renoir arranged his figures in two circles: a more compact, closed group around the table in the bottom right-hand area, and a wider and more open circle around the dancing couple, who appear to have a special emphasis to the left of the centre. This composition is further reinforced by a group of three figures at the centre, forming an almost classically shaped pyramid. Also, the picture includes a whole system of verticals and horizontals. The vertical dimension is marked by the people, both dancing and standing, the trees, the backs of the yellow chairs as well as the standard lamps and those which are suspended from above. A clearly horizontal impression is created by the cluster of figures in the background, who all appear to be equally tall, as well as another group at the centre, the bright line of round lanterns and the white wooden buildings. These latter elements all form the upper third of the pictures, i.e. the background. They do not interfere directly with the less stringent composition of the foreground, which is dominated by the curved vertical lines of people's arms and backs, but they nevertheless lend stability to the entire painting, which depends, as it were, on these horizontal lines. This basic grid structure enabled the painter to introduce an element of apparent casualness.

Another principle of composition was Renoir's use of colour, which appears to result entirely from the play of the sunlight but was in fact quite intentional. There is a strong base of black submerged in blue and forming, as it were, a repeated theme in the bassline of this harmony of colours. This is accompanied by a powerful lemon-like yellow; the hair of the child and the back of the chair, both of them at the front of the painting, are thus emphasized very strongly and guide our glance to the top right-hand corner; our attention is attracted by two colours, pink and forget-me-not blue. Both colours combine in the striped dress of the figure at the centre, from where they separate again in the monochrome dresses of the two dancing girls further left until they are scattered about as patches of shade and sunshine, especially in the left half of the picture. A beautiful glowing vermilion is distributed very sparingly over the entire painting in spots that add fire to the overall effect.

However, any formal analysis would be rather incomplete if it did not also include the psychological arrangement of the figures. Again and again we become aware of the glances that are exchanged between the blonde beauty in black at the centre of the picture and the young man on the yellow chair. This line is emphasized by the postures of the two sisters, whose heads are exactly parallel. If we were to draw this line into the painting and then extended it, we would almost have one of the two diagonals of the blue dancing girl. Also, it has a sur-

"Even landscapes are useful for the portrait artist. The open air makes you put shades of colour on the canvas which you would not be able to imagine in the subdued light of the studio. But what a job painting landscapes is! You lose half a day just to spend an hour working. Out of ten pictures you finish one because the weather has changed."

PIERRE-AUGUSTE RENOIR

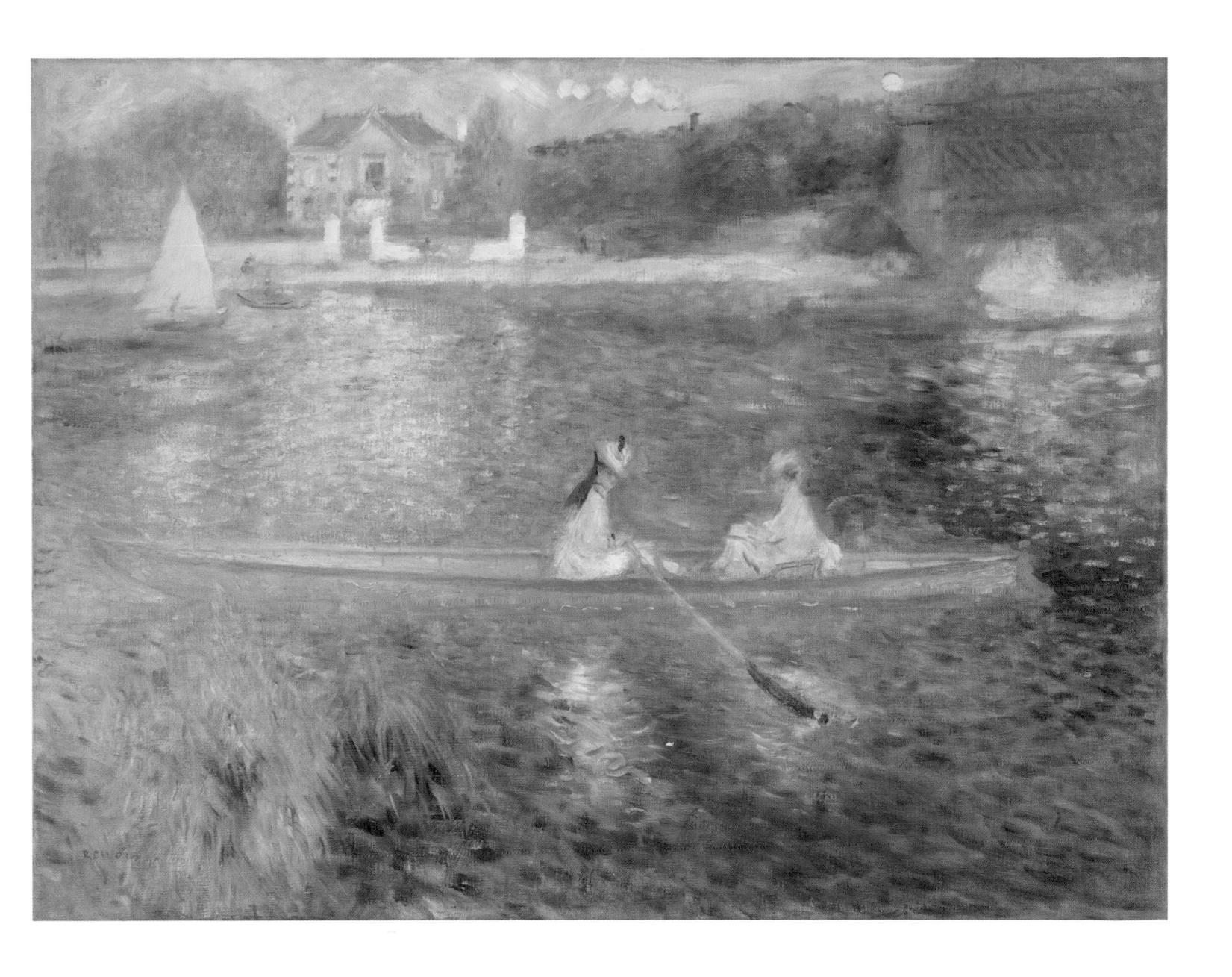

prising number of parallels in the general composition of the painting. The dominating eye contact between the two people is vividly counterbalanced by the loving glance of the handsome young man on the right who is looking towards Jeanne in the middle of the picture, while the girl is directing all her attention towards the other man. Thus they form a triangle which is so intense that they are almost detached from the rest of the people. There are several figures who seem to be looking straight at the observer, especially the three dancing girls. Two figures at the table, the pipe-smoker and Estelle, dressed in blue and pink, are lost in thought and are looking past the observer. And maybe this blissful, dreamy look in the face of a smiling young girl at the centre of the picture is its most important element, its pivotal point. The easy-going, tender cheerfulness of her glance, her face, her figure seem to provide a focal point which sums up the whole atmosphere and everything that the picture is trying to convey.

The joy of being young and in love, the pleasure of a free-and-easy party where everyone can relax and enjoy themselves together with other young people, the conscious affirmation of life in the form of sunshine, music and the babble of voices, the capricious naivety of a tender flirt – these are the feelings which Renoir expressed with every stroke of his paintbrush.

Banks of the Seine at Asnières, about 1879 Oil on canvas, 71 x 92 cm (28 x 36.2 in.) London, The National Gallery

Two Girls or "The Conversation", 1895 Pastel, 78 x 64.5 cm (30.7 x 25.4 in.) Private Collection

In doing so he was firmly rooted in two traditions which he both preserved and surpassed, thus abolishing them in his own perfect synthesis. With a picture like this he was paying tribute to the masters of the French Rococo period, i.e. Jean-Antoine Watteau, Nicolas Lancret and their *fêtes galantes*. There were the same yearning, courting glances, the same lightness and intimacy of postures and floating movement, the same blue and pink striped dresses, a similar loosening up of constellations of figures who seem to relate to one another freely. After all, Renoir did belong to the age of Neo-Baroque and Neo-Rococo, and ever since the time when he had had to paint Rococo scenes on china cups, he had admired the ingenious masters of the *Ancien Régime*. But rather than repeating their themes and methods in their precise historical settings, he translated them into the language of his own art and of his own period.

The second tradition which Renoir used was that of contemporary French graphic art: with its depiction of the pleasures of the middle classes in the big cities, it already had quite a long history. For several decades artists such as Honoré Daumier, Paul Gavarni, Constantin Guys and a number of others had been illustrating books and magazines with pictures of the merry life of Parisian bons viveurs, grisettes, Bohemians and the middle classes. These small-format drawings were made to suit particular occasions on certain days and were therefore quickly out of date. They were produced and duplicated by means of the simple method of lithography, and they covered all areas of Parisian life, both people's day-to-day routines and their leisure. Outdoor pleasures, however, were a relatively rare subject compared with the theatre. The Impressionists took up these themes and topics, depicting them in the form of large paintings. In 1862 Manet had made the first step with this Concert in the Tuileries (National Gallery, London), and Renoir's Le Moulin de la Galette was a further development. Manet had not really painted an open-air picture, whereas Renoir had achieved a merging of fully individualized human beings with an open space that was filled with sunshine and liveliness. What is more, he had managed to do so on the basis of a standard theme from the life of Paris, using a format that was unusually large and therefore quite an artistic challenge for him.

At the end of this period Renoir painted another gathering of young friends – this time at Alphonse Fournaise's inn at Chatou on the river Seine, near the Grenouillère, where they used to meet with their girlfriends for lunch after a boating party (Luncheon of the Boating Party, illus. p. 50). This large painting had been prepared very thoroughly, summing up all his endeavours to render this topic adequately. It was preceded by more sketchy pictures such as his Oarsmen at Chatou (illus. p. 41) and a different Luncheon of the Boating Party (illus. p. 51). The overall composition is firmly defined by both sides and held together by a number of lines. And yet the entire scene is even more broken up into individual figures and small groups than Le Moulin de la Galette. A scatter of relaxed people – this is how his art has often been summed up. The life-size figures are more individualized, and the colours are more glowing, though less regular. This is particularly true of the figure of a man - a portrait of Caillebotte - sitting astride a chair in the bottom right-hand corner: here Renoir anticipated the firmer, more solid style of the following years. On the other hand, the bottles, glasses and fruit on the table come alive, as it were, because of the spar-

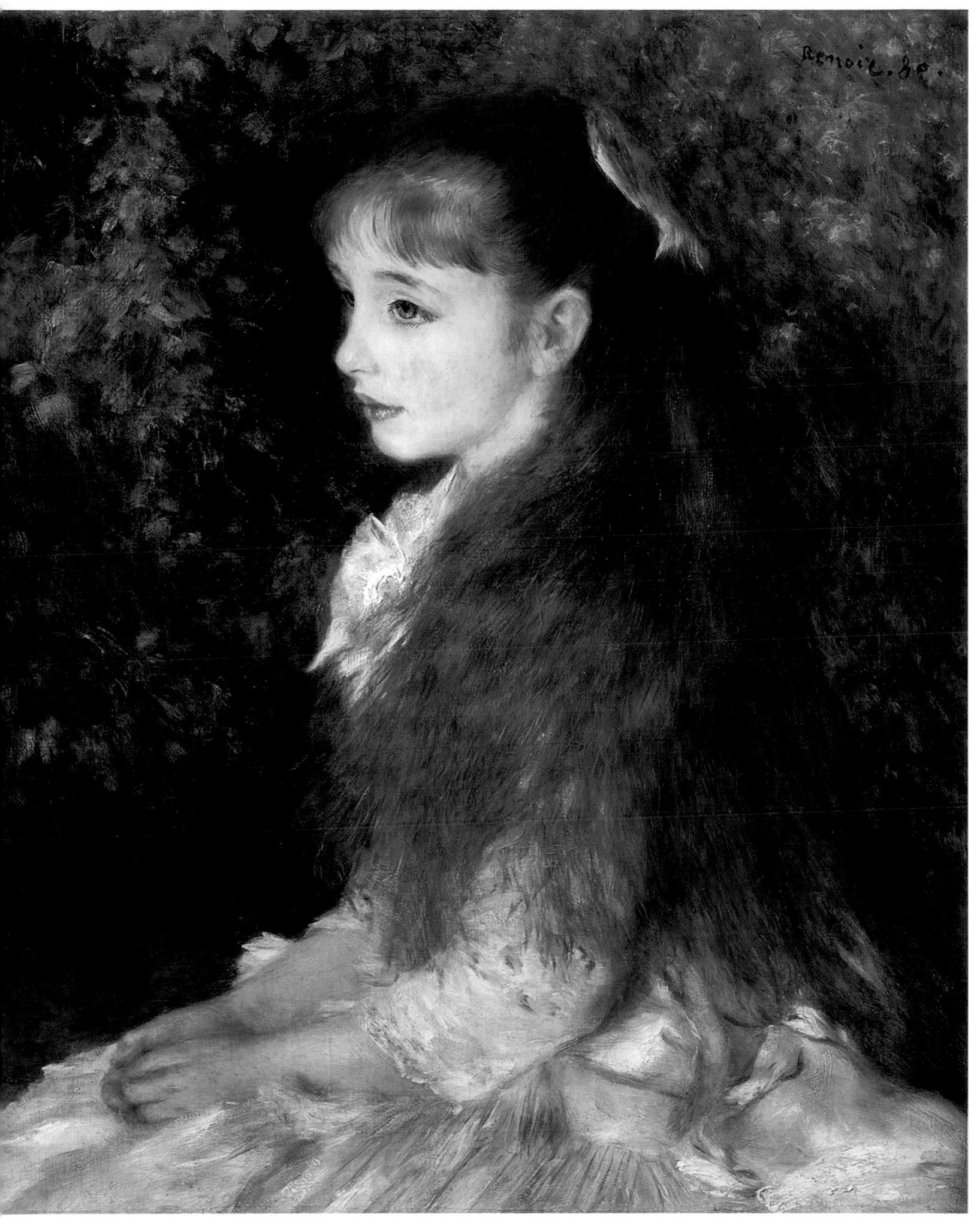

"This constant urge to look for inspiration in art! For my part, I am content to demand just one thing for a masterpiece: enjoyment."

PIERRE-AUGUSTE RENOIR

kling casualness with which they are depicted. And it was with loving tenderness that Renoir painted the charmingly attractive young girl with her flowery hat and a little dog. Her name was Aline Charigot, and she was to become his wife.

Before Impressionism hardly anybody had taken any interest in the inherent beauty of life in the big city, let alone in the hustle and bustle of the crowds in the streets and market squares. Although it cannot be said that this was his major theme, he nevertheless created a number of beautiful examples of the two prototypes of street scenes, i.e. both general impressions of streets and crowds of people randomly hurrying past one another and the same people observed at close quarters.

It was the latter type that Renoir sought to capture in the life-size figures of *The Umbrellas* (illus. p. 61). He used subtle shades of blue, grey and brown and then added emphasis by means of some brightly glowing colours. The main characters are some children with enormous hats, a grisette, and a milliner who is carrying a hatbox and is on her way to a customer, while a gentleman is very bravely offering to accompany her and carry her umbrella for her. The charm of the picture lies in the variations on the shape of the umbrella and in the beauty of the people's postures and faces, particularly that of the milliner. She is looking straight into the

The Luncheon of the Boating Party, 1881 Oil on canvas, 129.5 x 172.7 cm (51 x 68 in.) Washington, D.C., The Phillips Collection

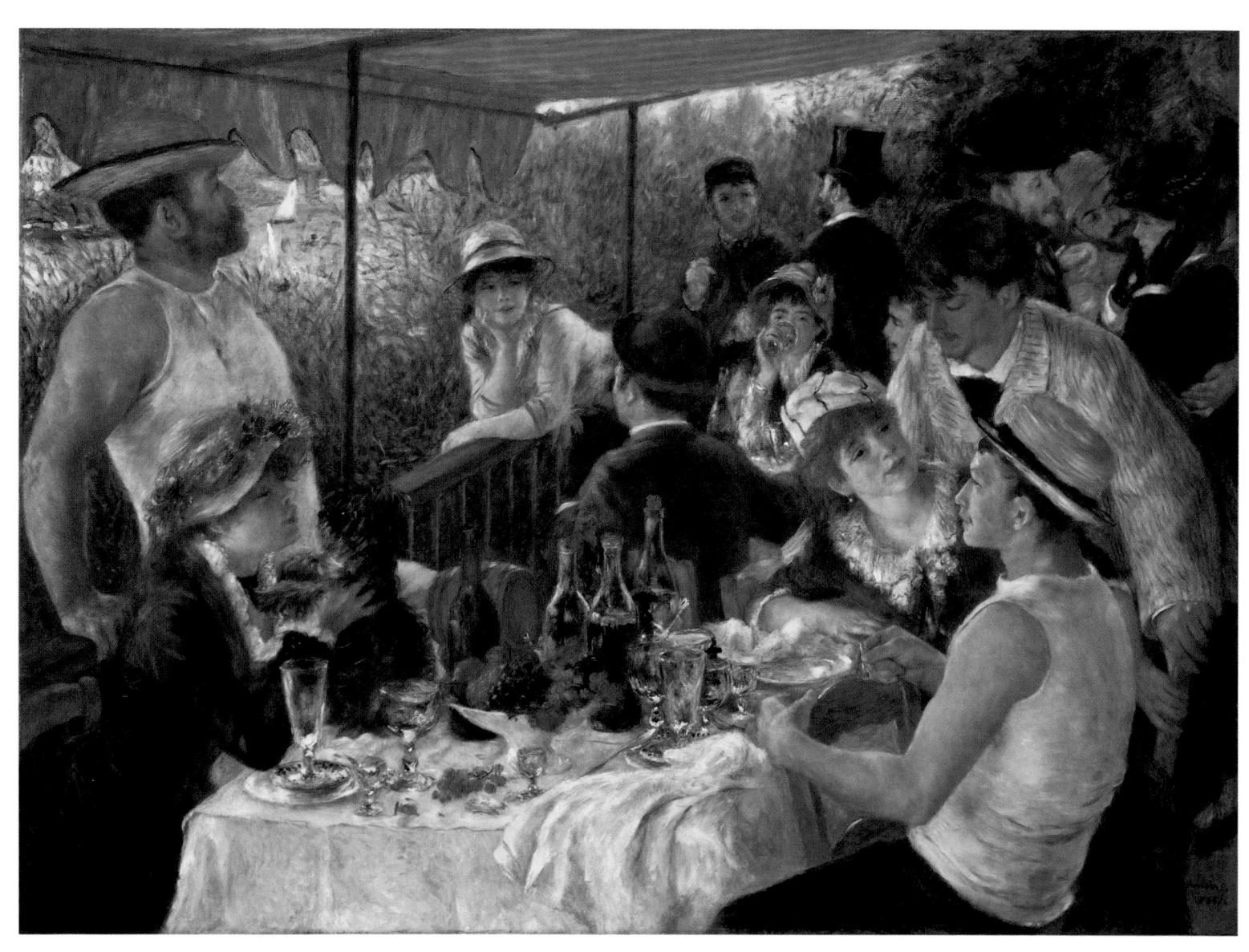

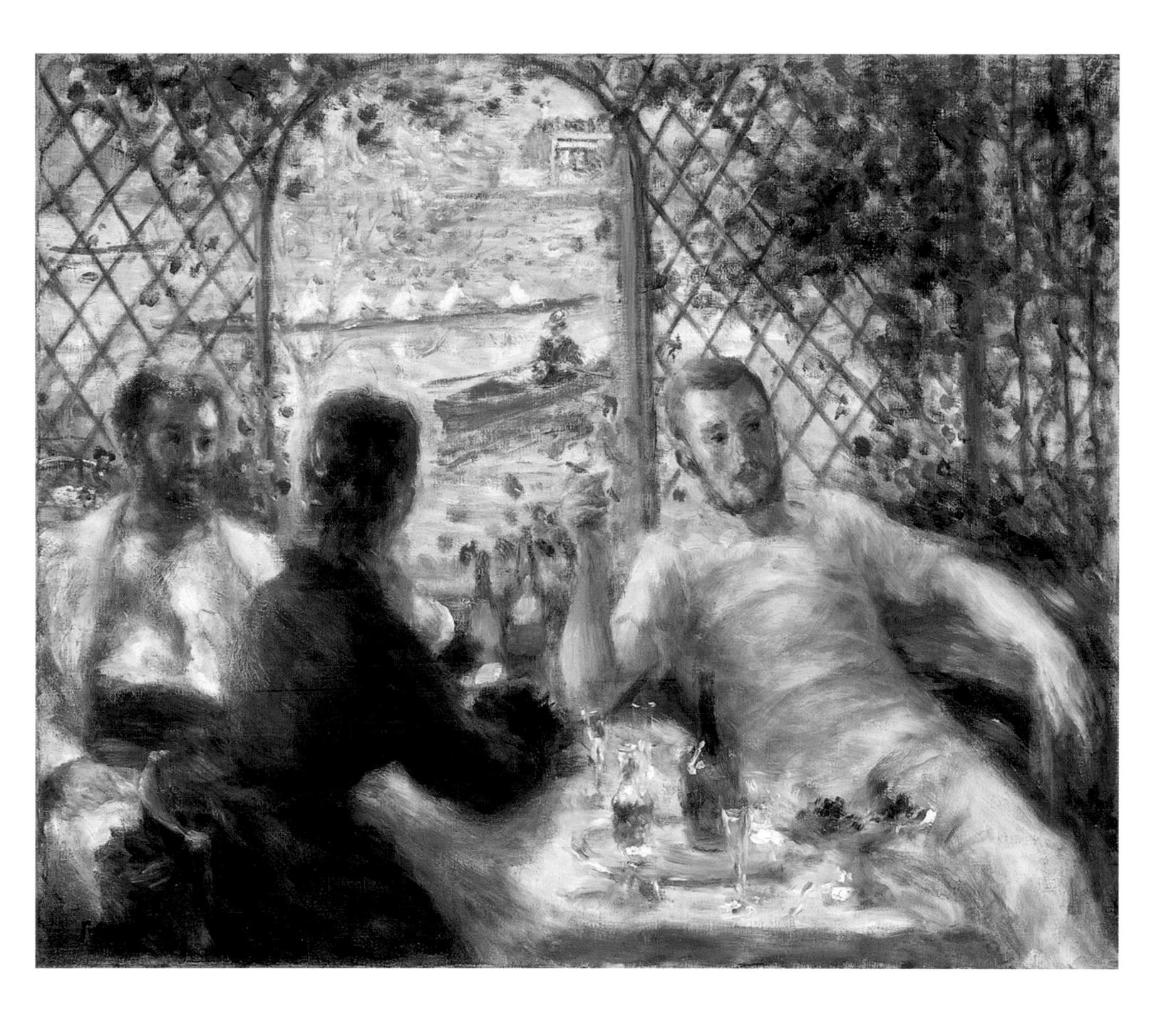

eyes of the spectator and seems to have the stature and dignity of an ancient goddess. But the picture rather lacks the convincing impact of the moment when the rain has just started: the sudden rush of people, the sparkle of moistness in the atmosphere. A somewhat artificial calm pervades the scene, a certain formal and emphatic self-consciousness, which is further enhanced by the fact that the spectator is looked at by two pairs of eyes. And yet, what is reflected even more clearly than in *Le Moulin de la Galette* or *The Boating Parly* is the isolation of man. Even the two main groups of people are totally unrelated, the parallel positions of their heads and the directions of their glances equally reflect a complete absence of responsiveness towards one another: the grisette is ignoring the gentleman, and the little girl with the hoop is paying no attention to her playmate.

The use of such themes unconsciously reflects a structural principle that was quite typical of society at that time, i.e. the dissolution of all continuity. Renoir was trying to move from the depiction of turbulence to a firmer order within his

The Luncheon of the Boating Party, about 1879/80
Oil on canvas, 54.7 x 65.5 cm (21.5 x 25.8 in.)
Chicago, The Art Institute of Chicago,
Mr and Mrs Potter Palmer Collection

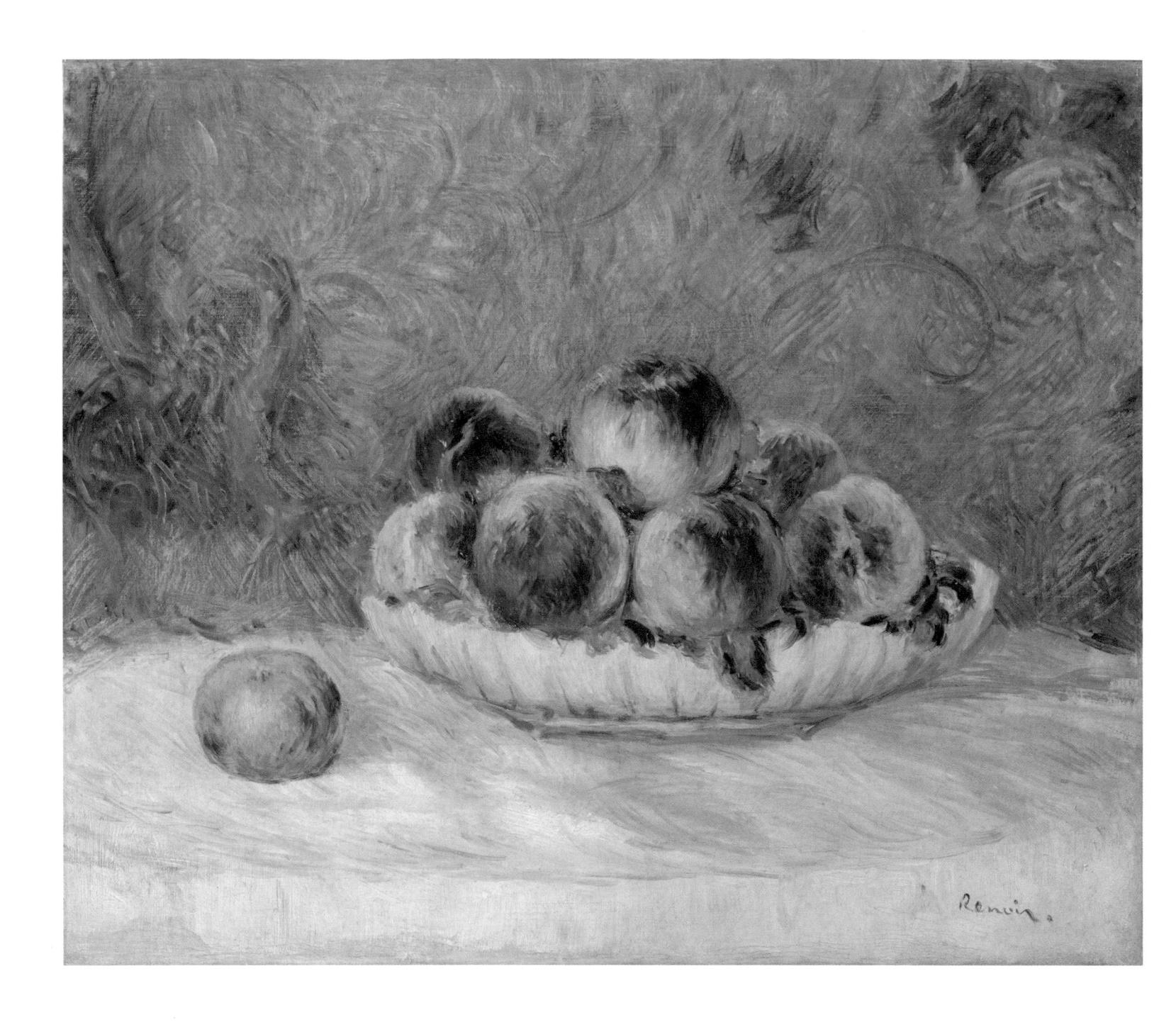

Still Life with Peaches, about 1880 Oil on canvas, 38 x 47 cm (15 x 18.5 in.) Paris, Musée de l'Orangerie

picture. Both objectives clash with each other, and Renoir's method of applying paint changed over the years which he must have spent working on the painting.

During the seventies, which were such a fruitful period in Renoir's life, he also painted a number of landscapes, among which his *Country Footpath in the Summer* (illus. p. 25) is particularly beautiful and quite typical. These compositions are nearly always dominated by flowers or other colour effects, and one might almost be inclined to say that the simple, graphically linear structures of these paintings have a certain dullness about them. Compared with the other Impressionist landscape painters, Renoir was even less concerned with clear, unambiguous and forceful structures, but preferred to weave colourful tapestries with his pictures, something which he began to do with landscapes long before he did it with people. He was just as capable as his contemporaries of rendering the flickering of the sun-soaked air above the grass and the shrubs, the warmth and the cheerful atmosphere of the summer, the exuberant sumptuousness of the different colours which, as an Impressionist, he was inclined to see in nature.

"I'm a little cork which has fallen into the water and is carried away by the current. I have given myself over to painting, following the whims of each moment."

PIERRE-AUGUSTE RENOIR

He would paint lovingly and skilfully, but he was not really a landscapist. He always preferred to paint human beings or female bodies. He even voiced his reservations about open-air painting, the technique which was inextricably linked with landscapes: "Nature leads the artist into loneliness; I want to remain among people."

By the Lake, about 1880 Oil on canvas, 46.2 x 55.4 cm (18.2 x 21.8 in.) Chicago, The Art Institute of Chicago, Mr and Mrs Potter Palmer Collection

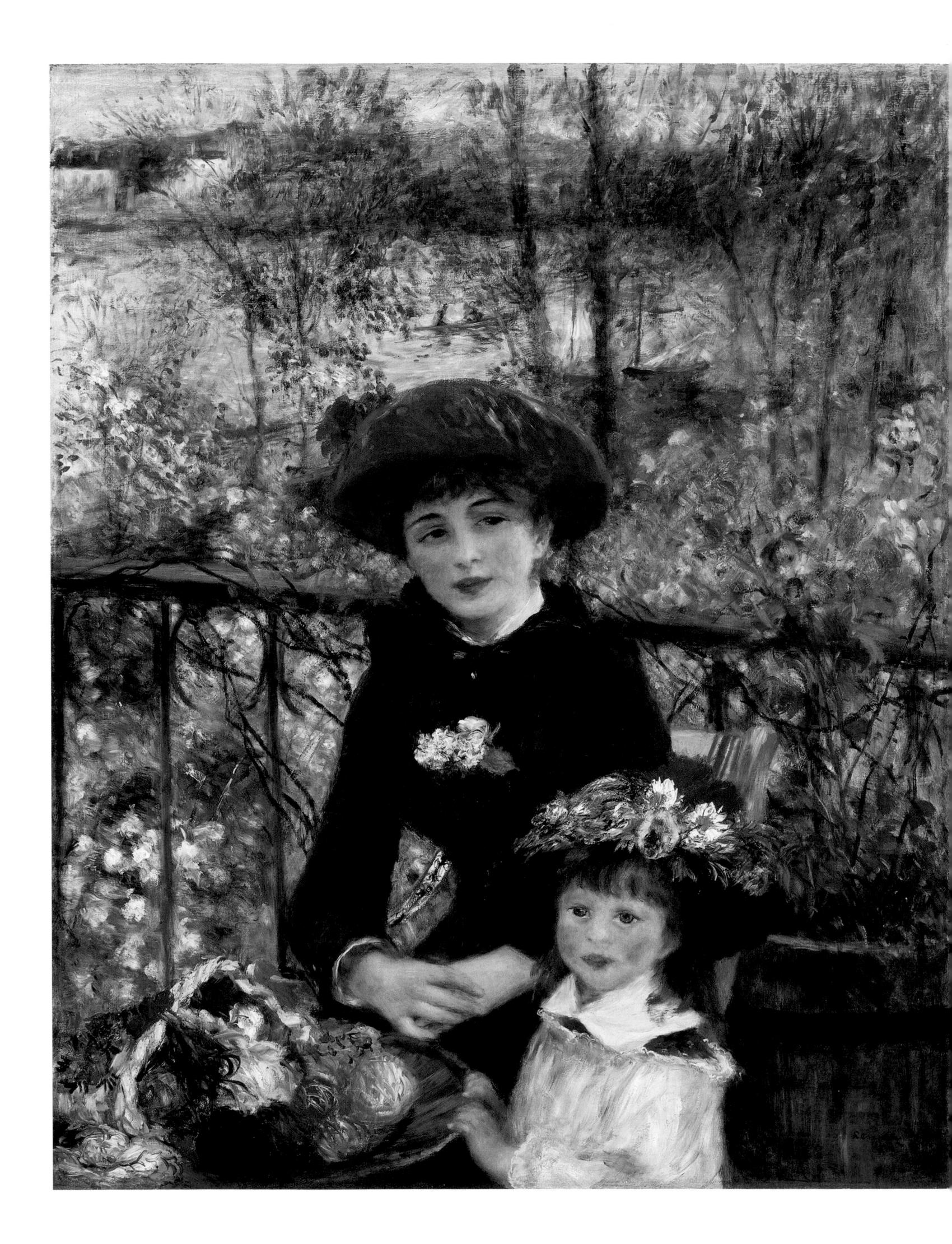

The Crisis of Impressionism and the "Dry Period" 1883–1887

During his visit to Italy in 1881, Renoir was deeply impressed by the works of Raphael. "They are full of knowledge and wisdom. Unlike myself, he never tried to achieve the impossible. But they are wonderful. I prefer Ingres' oil paintings. The frescos, on the other hand, are magnificent in their greatness and simplici ty," he wrote to Durand-Ruel, and, in a letter to Madame Charpentier, "although Raphael never worked in the open air, he still used to observe the sun, because all his frescos are filled by it." The full significance of such words does not really strike home until we consider that in the middle of the nineteenth century Ingres was considered by French painters to be the embodiment of Classicist rigidity. This was because, as a member of the Academy, he had bitterly opposed any expression of personal temperament, Realism and especially the colourful style of his contemporary Delacroix. Like all other Classicist painters, Ingres had regarded Raphael as the highest ideal since the sixteenth century. And now such words from Renoir who had only just followed in the footsteps of his much-admired Delacroix and returned from a trip to Algiers, that blaze of brilliant colours! But in fact Renoir had never been narrow-minded. Even during the days when there were heated discussions about art at the Café Guerbois, he did not entirely agree with his friends. "They did not want to know about Ingres. I just let them talk ... and secretly enjoyed the beautiful belly in Ingres' Spring and the neck and arms of Mme Rivère (a portrait by Ingres)," he later told his fellowpainter André. Renoir still saw himself as a searcher and was not content with himself. "Around the year 1883 I had exhausted Impressionism and came to the conclusion that I could neither paint nor draw," he said. The Impressionist style and the view that went with it were beginning to seem inadequate to him.

Renoir now began to work more carefully and meticulously, and his colours became cooler and smoother. He shaped his figures more precisely and paid more attention to their arrangement within the picture. The years between 1884 and 1887 are known as the "Dry Period" in the artist's life, and most critics at the time thought that he had gone astray. George Moore, an Irish contemporary of his, wrote that within a matter of two years Renoir had completely destroyed his own charmingly delightful art, after he had spent twenty years building it up. Everybody – including Renoir himself – saw this break with Impressionism as a profound crisis. This crisis, however, was not just an individual matter. It affected not only Renoir, but also Monet, Pissarro and Degas and finally led to a complete

"Around the year 1883 I had exhausted Impressionism and finally came to the conclusion that I could neither paint nor draw. In short, Impressionism had led to a dead end In the ond I saw that it was 100 complicated, an art that kept forcing me to compromise with myself. There is more diversity of light in the open air than in the studio where it remains unchangeable, whatever your purpose or intention may be. But this is precisely the reason why the light is too important in the open air. There is no time to work out a compromise, and you can't see what you're doing. I remember how, on one occasion, a white wall cast its reflections onto my canvas while I was painting. I kept choosing darker colours, but without success - whatever I tried, the picture was too light. But when I looked at the picture in the studio, it looked quite black. An artist who paints straight from nature is really only looking for nothing but momentary effects. He does not try to be creative himself and as a result the pictures soon become monotonous."

PIERRE-AUGUSTE RENOIR

PAGE 54: *Two Sisters (On the Terrace)*, 1881 Oil on canvas, 100 x 80 cm (39.4 x 31.5 in.) Chicago, The Art Institute of Chicago, Mr and Mrs Lewis L. Coburn Memorial Collection

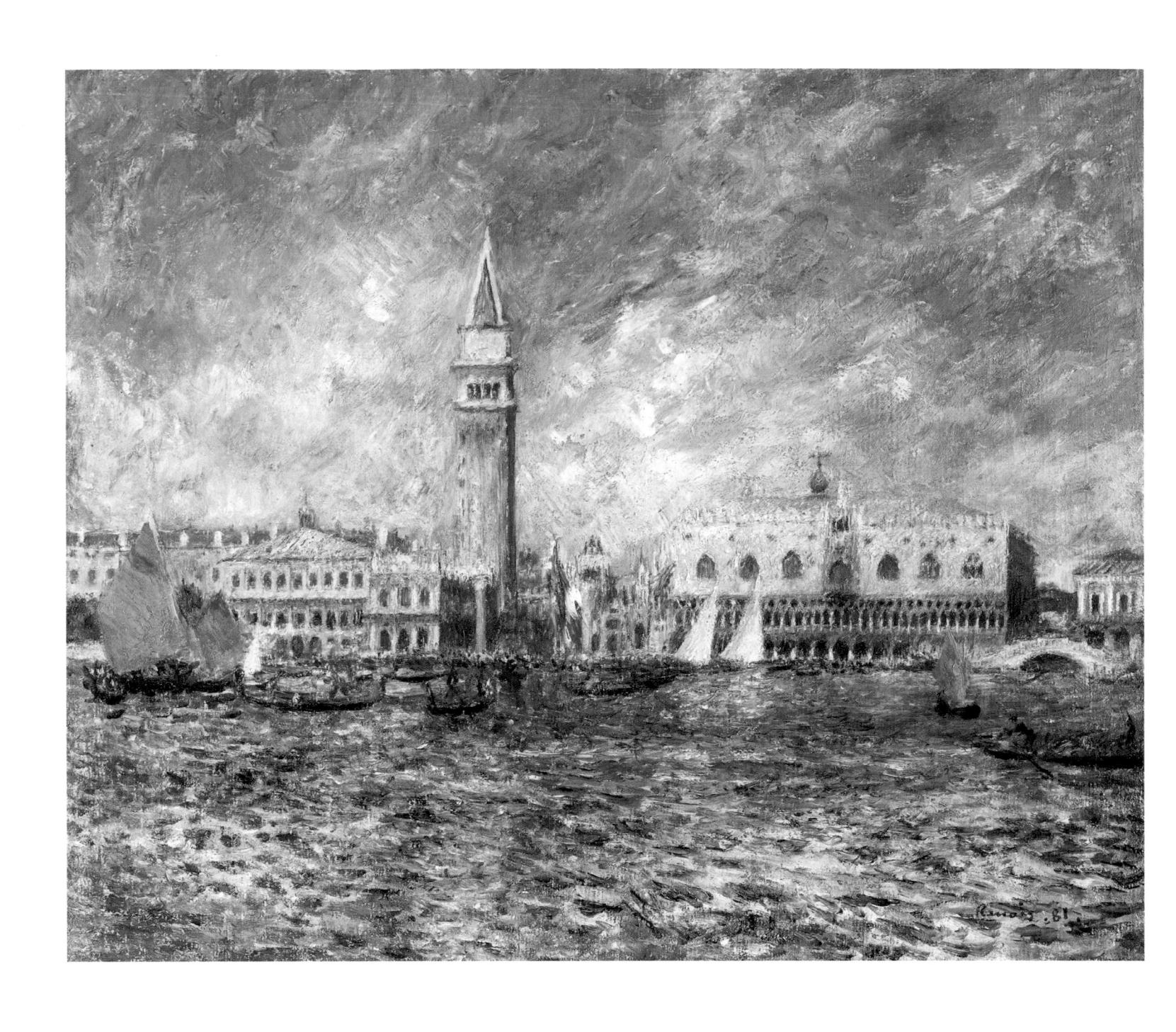

Doges' Palace, Venice, 1881 Oil on canvas, 54.5 x 65 cm (21.5 x 25.6 in.) Williamstown, Sterling and Francine Clark Art Institute

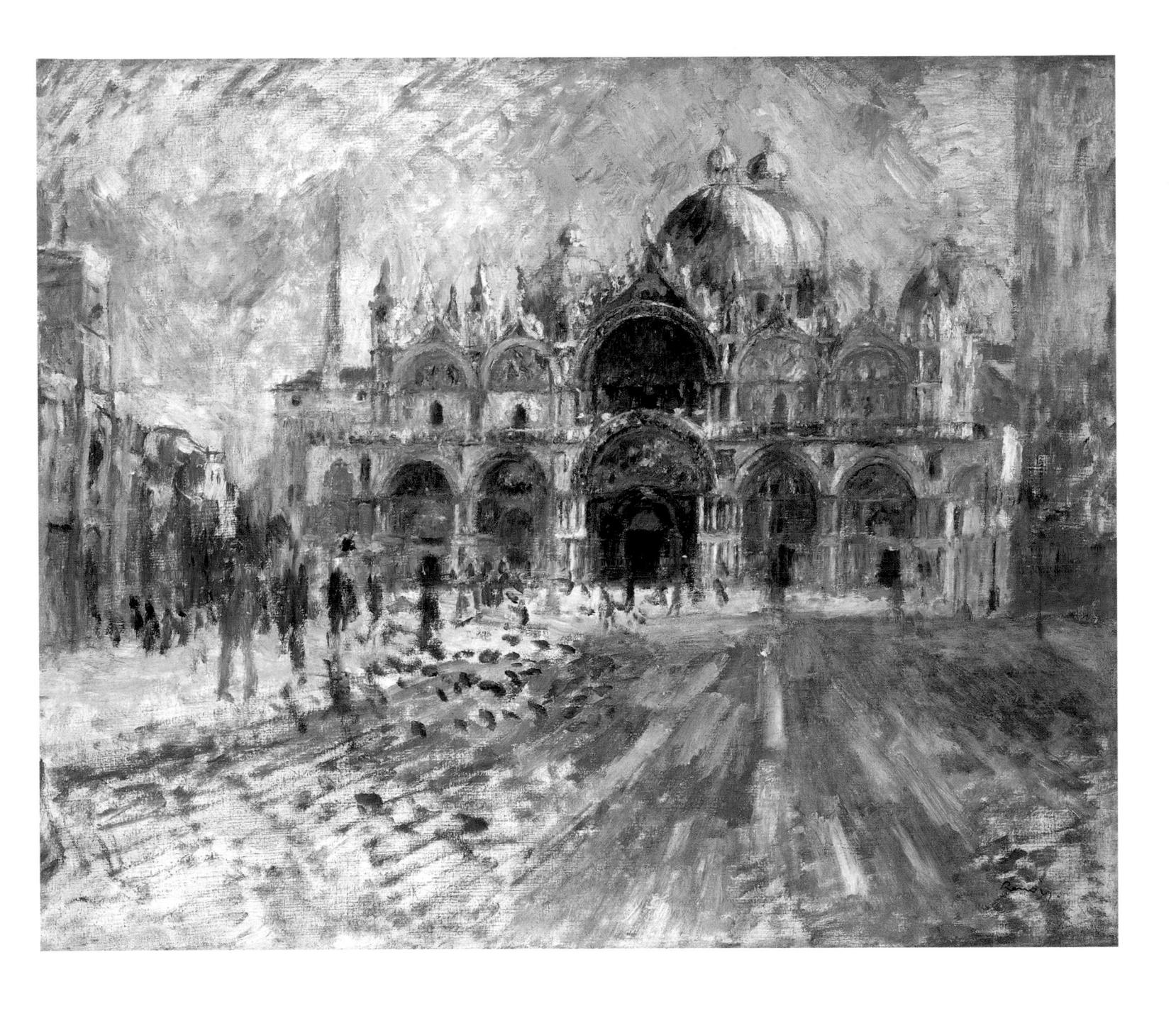

collapse of this group of Impressionists. The eighth and last joint exhibition took place in 1886 – this time without Renoir.

It was indeed the final and absolute crisis of Impressionism, inasmuch as Impressionism was the final phase of middle-class Realism. The areas of middle-class life which had been painted by the Impressionists turned out to have been exhausted artistically, and they came to the conclusion that honest seekers of the truth would not find it satisfying in the long term. In limiting itself to merry parties and the beauty of intimate relationships, the world which was depicted in Impressionist paintings drifted further and further away from real life and society in general. The Impressionists had been concentrating on observing external phenomena, and this is where they had made a lot of progress. To see accurately and to paint what one could see, to be no more than eye and hand – that was their aim. "Corot said, 'When I paint, I want to be a stupid fellow,' I'm a little bit from Corot's school," admitted Renoir. He did not want to think or use his mind while painting – just as was demanded by the contemporary British art critic John Ruskin, who

St. Mark's Square, Venice, 1881 Oil on canvas, 65.4 x 81.3 cm (25.7 x 32 in.) Minneapolis, The Minneapolis Institute of Arts, The John R. Van Derlip Fund

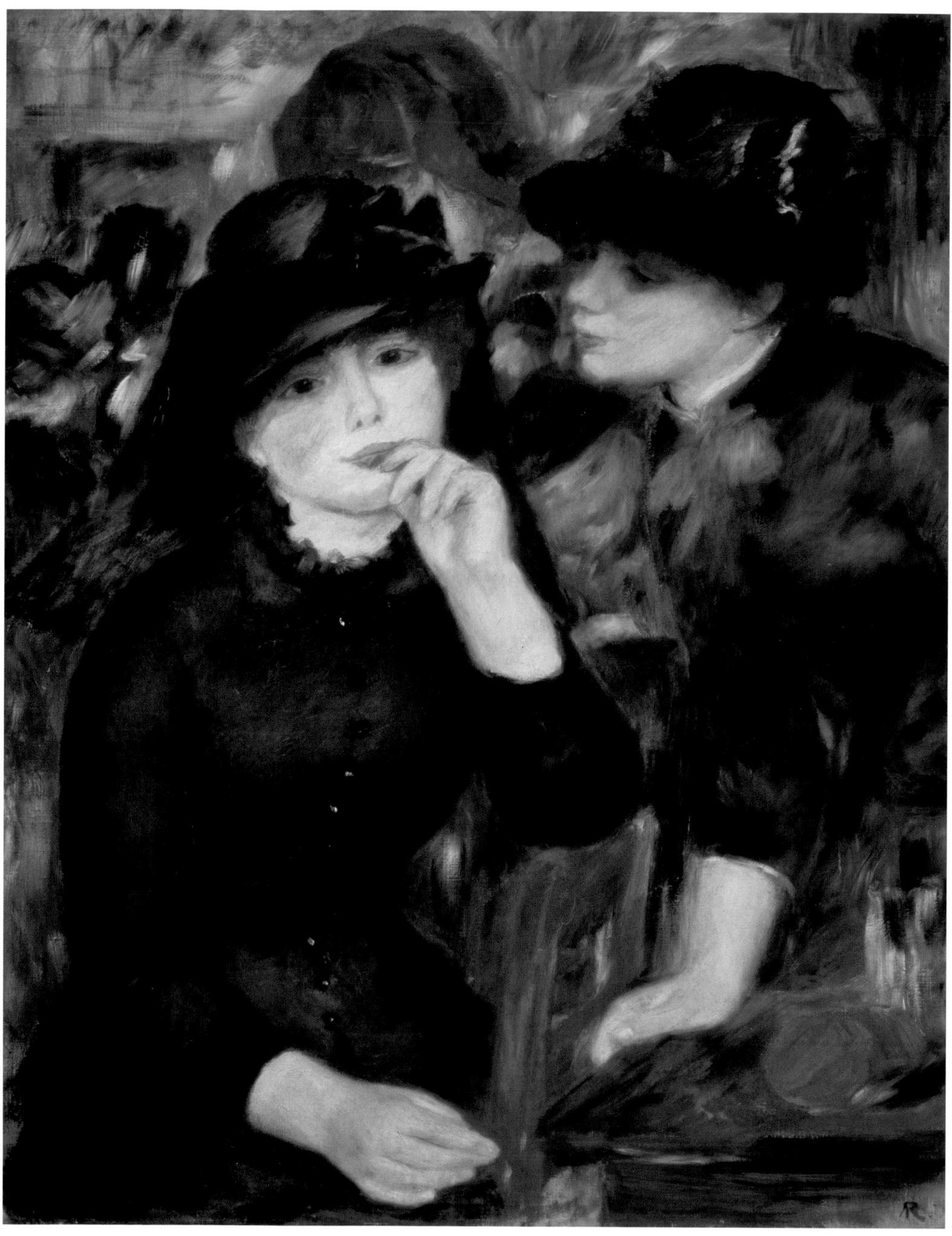

was very influential at the time. But any mindless copying of what was there, and that only if it was "beautiful", became a rapid exercise. Most of the things and people around them were not "beautiful". The painters knew that. And if they pushed their knowledge aside while they were painting, they ceased to be Realists. But if they wanted to remain Realists, they had to move from telling of the beautiful side of middle-class life to criticizing it. None of the Impressionists wanted to take such a revolutionary step. Renoir avoided it. He did not have to give in where people had been fighting against him: in the glowing luminosity of colours, in their subtle play with light and colourful shadows, or in the open arrangement of shapes or the general sketch-like character of his paintings. Probably without being aware of it, he gave in whenever he felt that there was a basic contradiction between a certain topic or message on the one hand, and reality on the other.

Renoir's "Dry Period" marked the turning point in his art: with the exception of a small number of family portraits, he virtually ceased to paint scenes from everyday life in Paris. There was still the odd picture of a girl resting in the grass, a woman selling apples, or a washerwoman, but such paintings had now lost much of their specificness with regard to time and space. And the mass of work which he produced during this period was in fact quite different. Renoir and his Impressionist colleagues were beginning to shift their emphasis onto something that had already been present in their art in the form of a tendency, i.e. the expression of purely subjective feelings and the subjective use of their artistic methods. Having selected these methods as carefully as possible, they then proceeded to apply them to subjects that were neutral as regards the social conditions of the times. As soon as Impressionism had achieved general recognition, it became socially harmless by no longer concentrating on painting the world as it really was. Or, to put it the other way round, it began to be tolerated because of its change of topics. Nevertheless, many contemporaries had formed the mistaken idea that Impressionism was "the embodiment of communism" and that it "boldly advocated the use of unrestrained violence."

In 1885 and 1886 Renoir worked in La Roche-Guyon and Wargemont on several different occasions. In the following years he displayed his pictures together with those of a modern artists' group called *Les Vingt* in Brussels and also at the art exhibitions organized by Georges Petit, one of Durand-Ruel's rivals in the art trade of Paris. However, this did not mean that Renoir broke off his contact with his old benefactor. In 1886 Durand-Ruel exhibited thirty-two of Renoir's paintings in New York, thus opening the American market for French Impressionism. His success can still be seen in the enormous number of Renoir's pictures and those of other Impressionists, which can now be viewed in several museums in Washington, New York, Chicago and other American cities.

Renoir's transition to a new style was very gradual, but could be seen quite clearly in his three large upright paintings which were to serve as decorative panels in one of Durand-Ruel's rooms (illus. pp. 64/65). They are three pictures of waltzing couples. The first one, which is set at the open-air restaurant in Bougival, shows a man with a straw hat and without a shirt collar somewhat crudely swinging around his beloved. The second picture, also outside, is a little more refined and graceful and shows the painter Paul Lhote dancing with Aline Charigot, the young girl who was to become Renoir's wife and whose radiant

Lady with a Muff, about 1883 Pencil, ink and watercolour, 52.7 x 36.2 cm (20.7 x 14.3 in.) New York, The Metropolitan Museum of Art, H. O. Havemeyer Collection

PAGE 58: *Two Girls in Black*, about 1881 Oil on canvas, 80 x 65 cm (31.5 x 25.6 in.) Moscow, Pushkin Museum of Fine Arts

PAGE 60:

Young Girl with Parasol (Aline Nunès), 1883 Oil on canvas, 130 x 79 cm (51.2 x 31.1 in.) Paris, Private Collection

PAGE 61: *The Umbrellas*, 1883 Oil on canvas, 180 x 115.4 cm (70.9 x 45.4 in.) London, The National Gallery

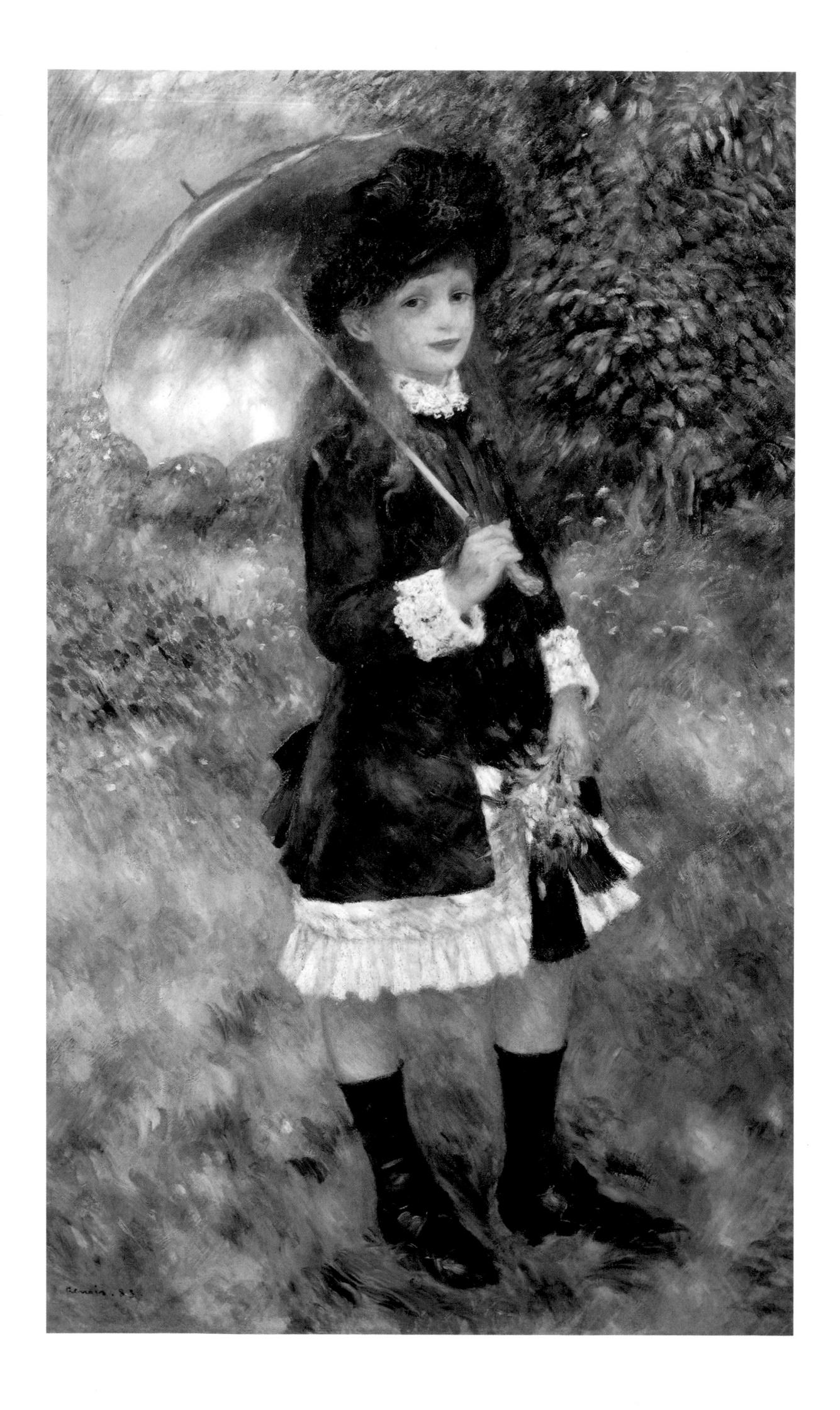

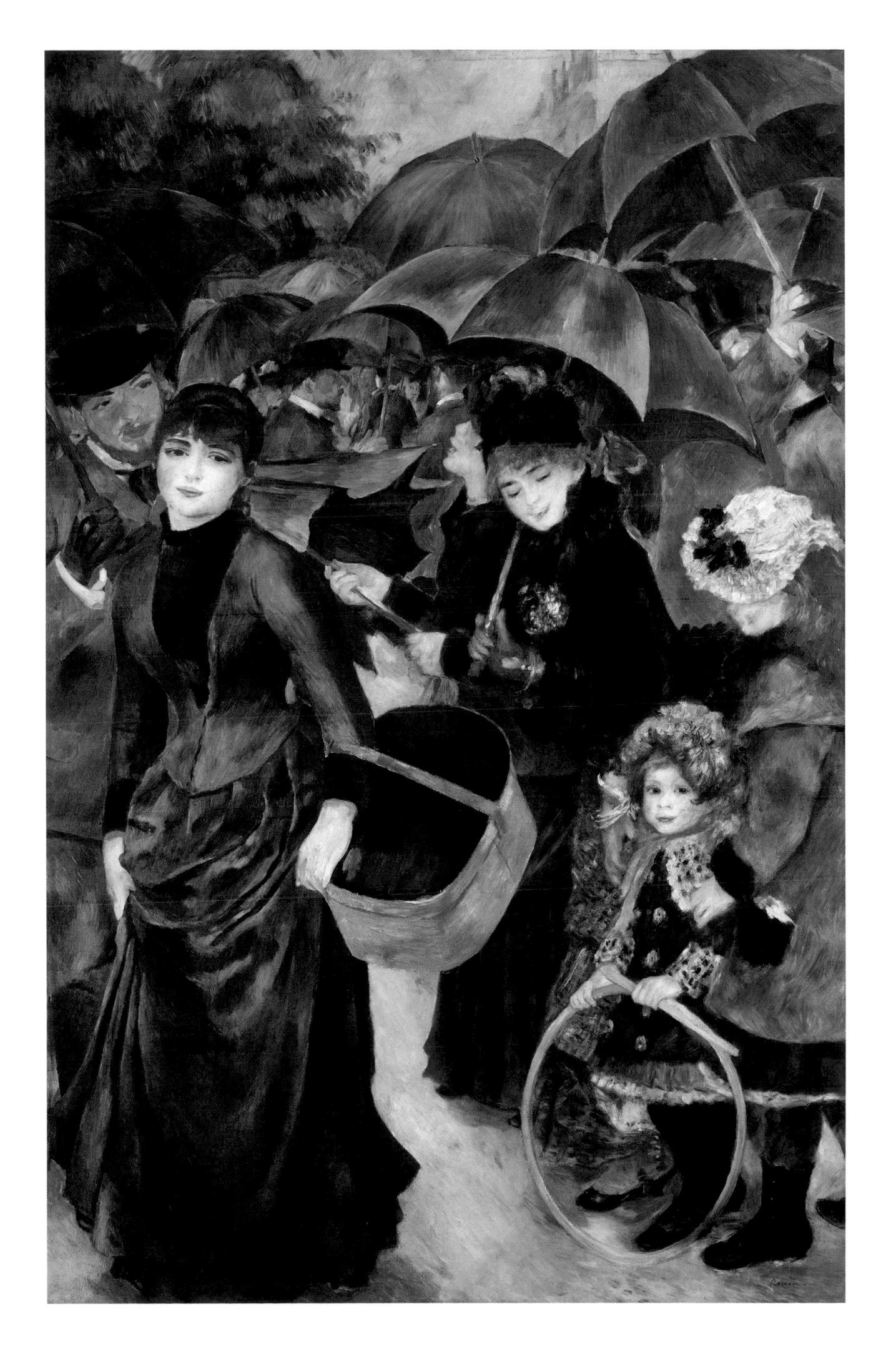

Young Girl with a Rose, 1886 Pastel, 59.7 x 44.2 cm (23.2 x 17.4 in.) Paris, Private Collection

Piano Study, 1891 Crayon, 37 x 33.2 cm (14.6 x 13.1 in.) Budapest, Szépművészeti Múzeum

PAGE 63: *Le Jardin du Luxembourg*, about 1883 Oil on canvas, 64 x 53 cm (25.2 x 20.9 in.) Geneva, Private Collection smile dominates the picture even more than the rich intensiveness of her colourful dress. The third painting shows the young model Suzanne Valadon dancing in the arms of the painter Eugène-Pierre Lestringuez at a function organized by the city of Paris. The movement of the last couple is least convincing, whereas in the other two we feel swept along by the swirling and swaying of the young women who are happy and in love and whose beauty and gracefulness forms the most important message of these paintings.

Later, in 1886, Renoir painted several pictures of his wife Aline breastfeeding their oldest son Pierre (illus. p. 67). He showed a certain amount of restraint in his use of colour, which reflects his tendency to be more concerned with accurate modelling and graphic precision. He felt that objects had been falling apart under his paint-brush, and so he wanted to make them solid and tangible again – very much like his contemporary Cézanne, who set himself the aim of turning Impressionism into an art that was as "durable" as that of the old masters. To achieve this, Cézanne tried to analyse everything into the basic stereometric forms of cones, spheres and cylinders. Renoir emphasized everything that was round. The young woman and the sprightly little baby have a plump rotundity about them so that they appear to be composed of spherical segments. It may of course be that Aline's face gave rise to that sort of style, but it is nevertheless noticeable that there was an increase in graphicness from Renoir's *Boating Party* via his dancing couple to this picture of Aline and Pierre. Later, however, Renoir turned to a softer style again.

Although, as we saw, Renoir painted a number of significant nude pictures before 1885, it was not a subject that occupied a major position in his art. This changed in the second half of the 1880s. Nudes in the open air, frequently called *Bathers*, began to take a dominant role in the artist's repertoire. More and more, his pictures were filled with a uniform degree of brightness. Unlike in his *Nude in the Sunlight* of 1875/76 (illus. p. 30), Renoir no longer tried to achieve an accurate rendering of the squiggly patches of sunlight and purple spots of shadow moving about on a person's skin, which itself was breathing and constantly in motion. Rather, he aimed at an evenly distributed glow of peaceful lines which he drew clearly and accurately. The nonchalance of people's movements and the casualness of their postures still provided a link with the convictions that Renoir had expressed in his Impressionist paintings half a decade earlier. Generally, his style of painting and drawing showed that Renoir had been studying the Classicist Ingres.

Renoir was indeed struggling to change his whole concept of art, in fact he was constantly searching and experimenting. This can be seen in the fact that the pictures which he painted at that time still somehow reflected his previous views, even though their colours were cooler, and he applied the paint more loosely and sketchily. It can be observed in several portraits of children (cf. illus. p. 70 and p. 74) as well as still lives with flowers (cf. illus. p. 68 and p. 79) and his little study of young women and children playing in the Jardin du Luxembourg (illus. p. 63).

Unlike with any other painting, Renoir spent three years on his major work of this period before having it displayed by Georges Petit in 1887. *The Bathers* (illus. p. 72/73) is a picture of girls with firm, cool bodies enjoying themselves at a pond in the woods. The atmosphere is one of joyful abandonment, and the girls are in fact very close to life and quite typical of that particular time, especially the boisterous, tomboy-like teenager who is about to splash her friends

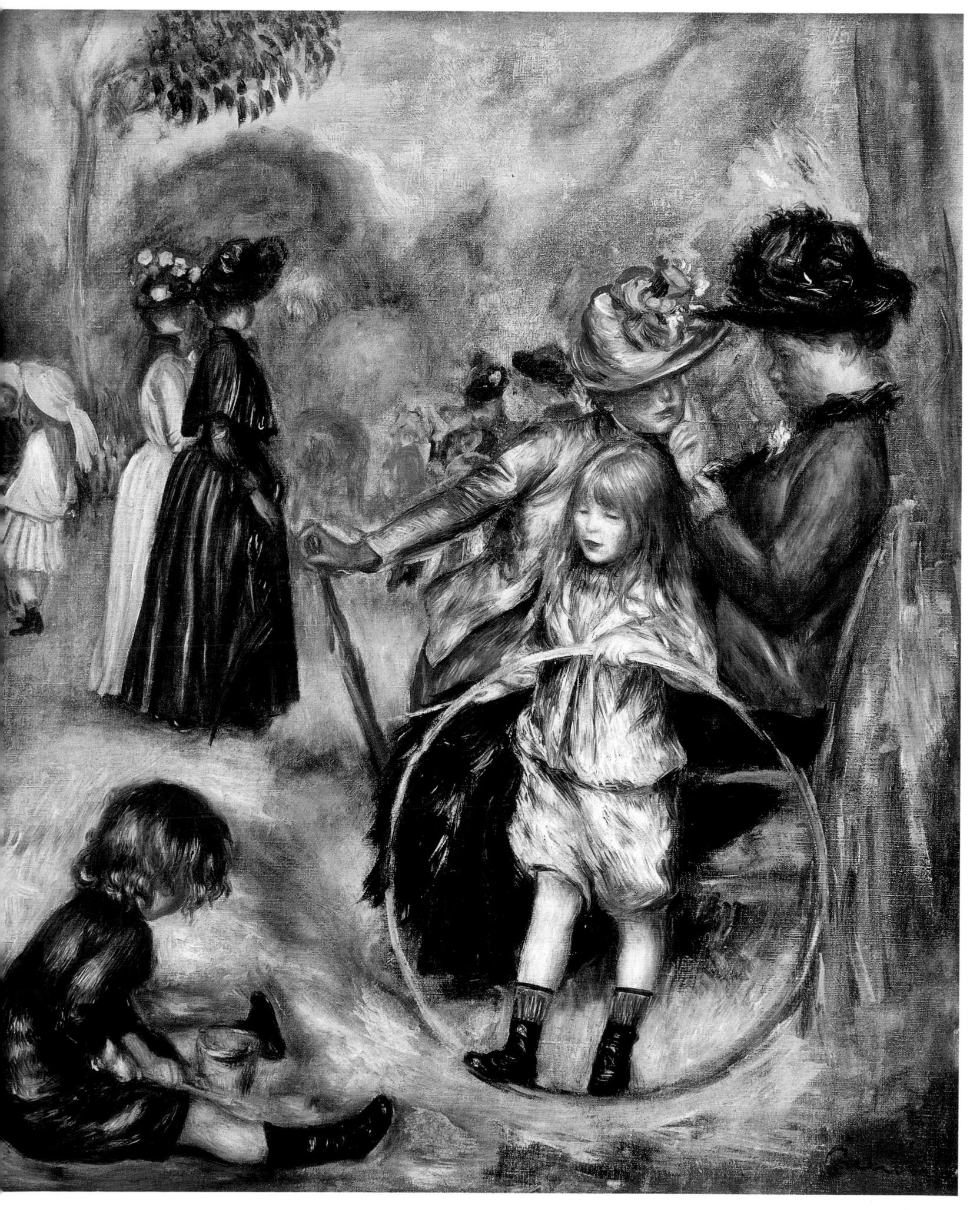

The Dancers: Dance at Bougival, 1883 Lithograph Paris, Bibliothèque Nationale, Cabinet des Estampes

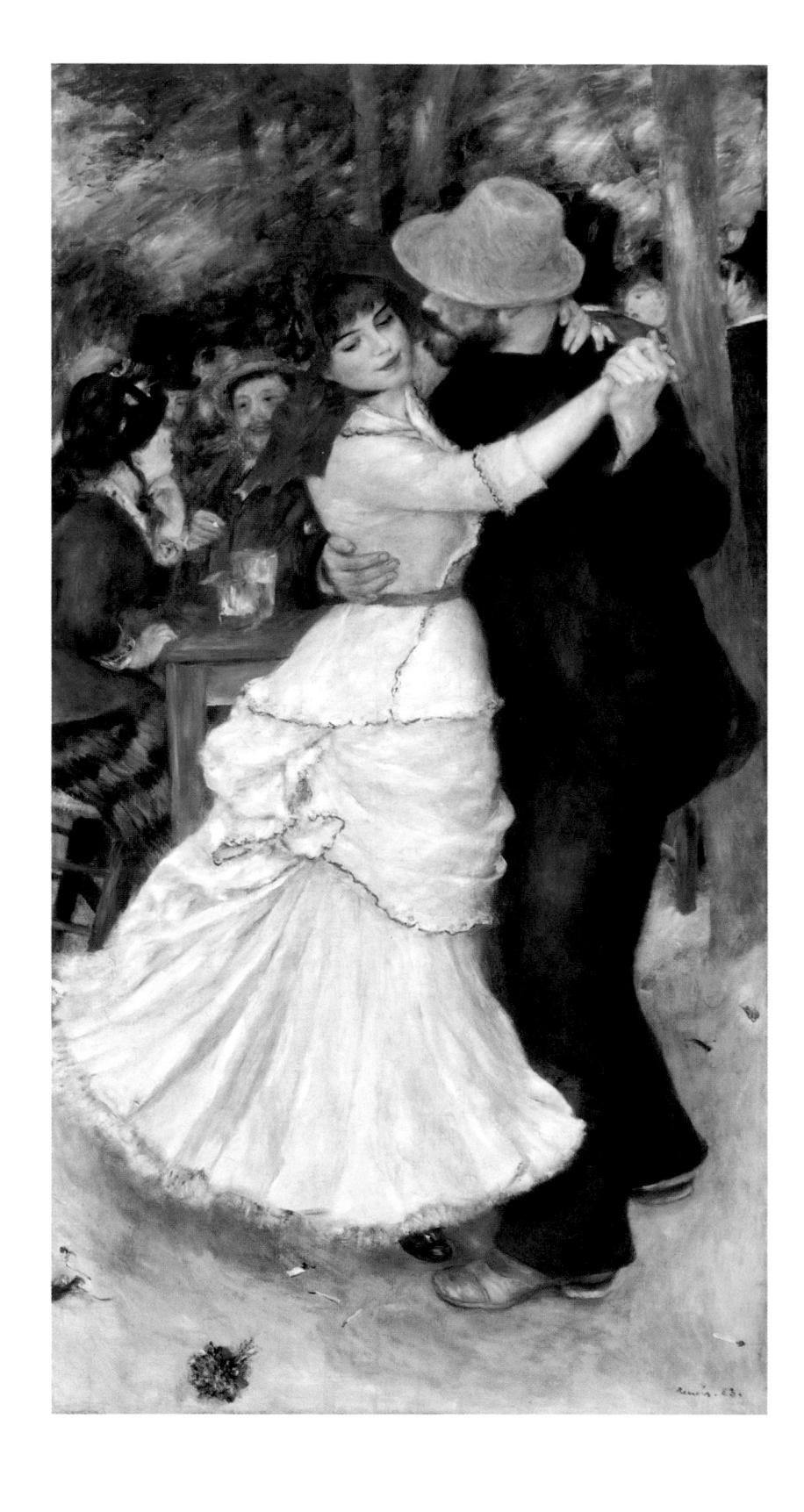

RIGHT: **Dance at Bougival**(Suzanne Valadon and Paul Lhote), 1883
Oil on canvas, 182 x 98 cm (70.5 x 37.8 in.)
Boston, Museum of Fine Arts, Picture Fund

with water. But the sewing-girls have become nymphs, and their play has become secondary to a composition of graphic shapes and lines, which includes some amazing details but does not add up to a convincing whole. The girls' gestures have become affected, and the kicking mass of entangled legs at the centre of the picture seems confused. The faces of the playing girls lack expressiveness. Renoir was first inspired to paint this picture when he saw one of François Girardon's lead reliefs of 1672 on a fountain in the park of Versailles. His subsequent sketches clearly show his inability to come to grips with the classical or-

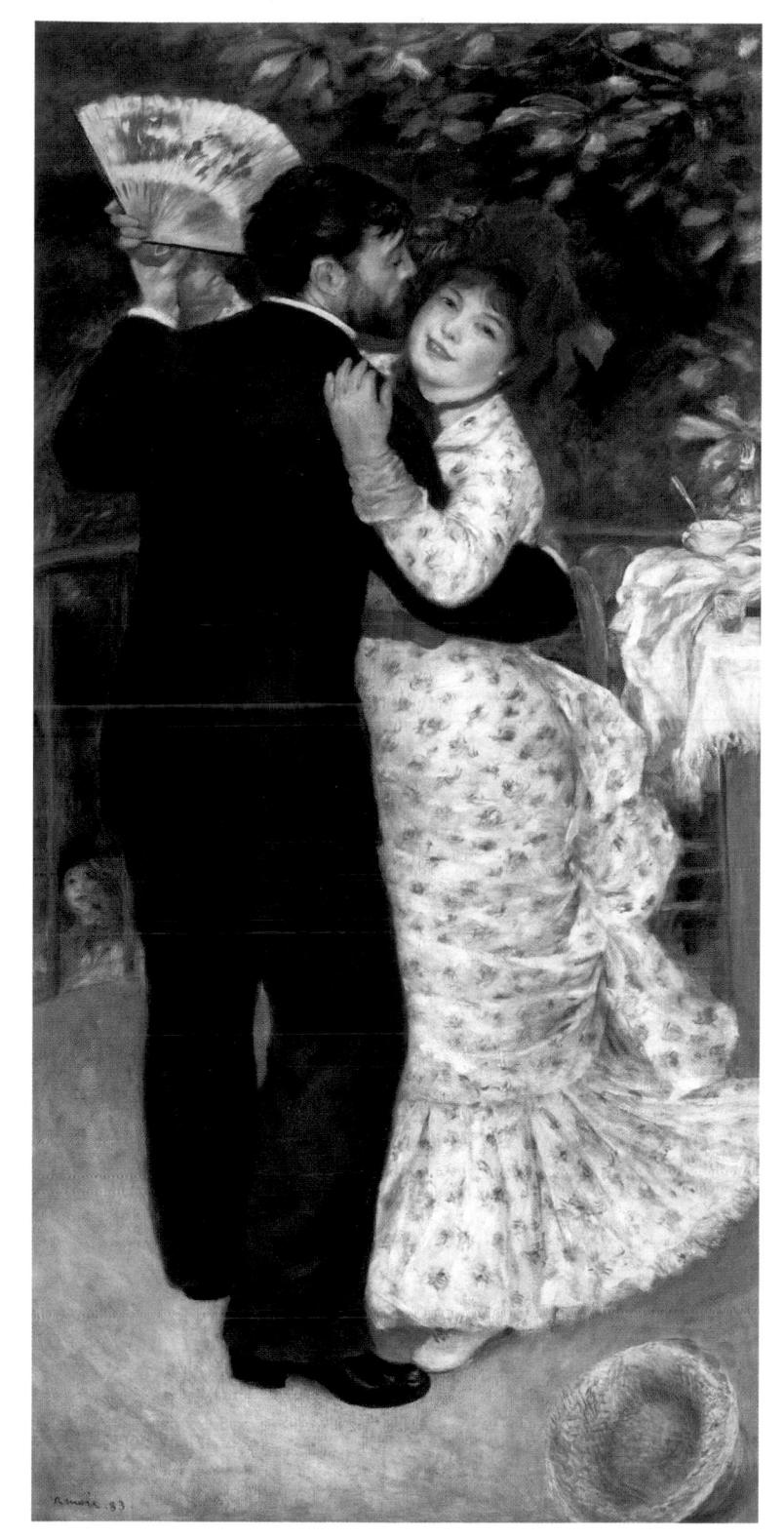

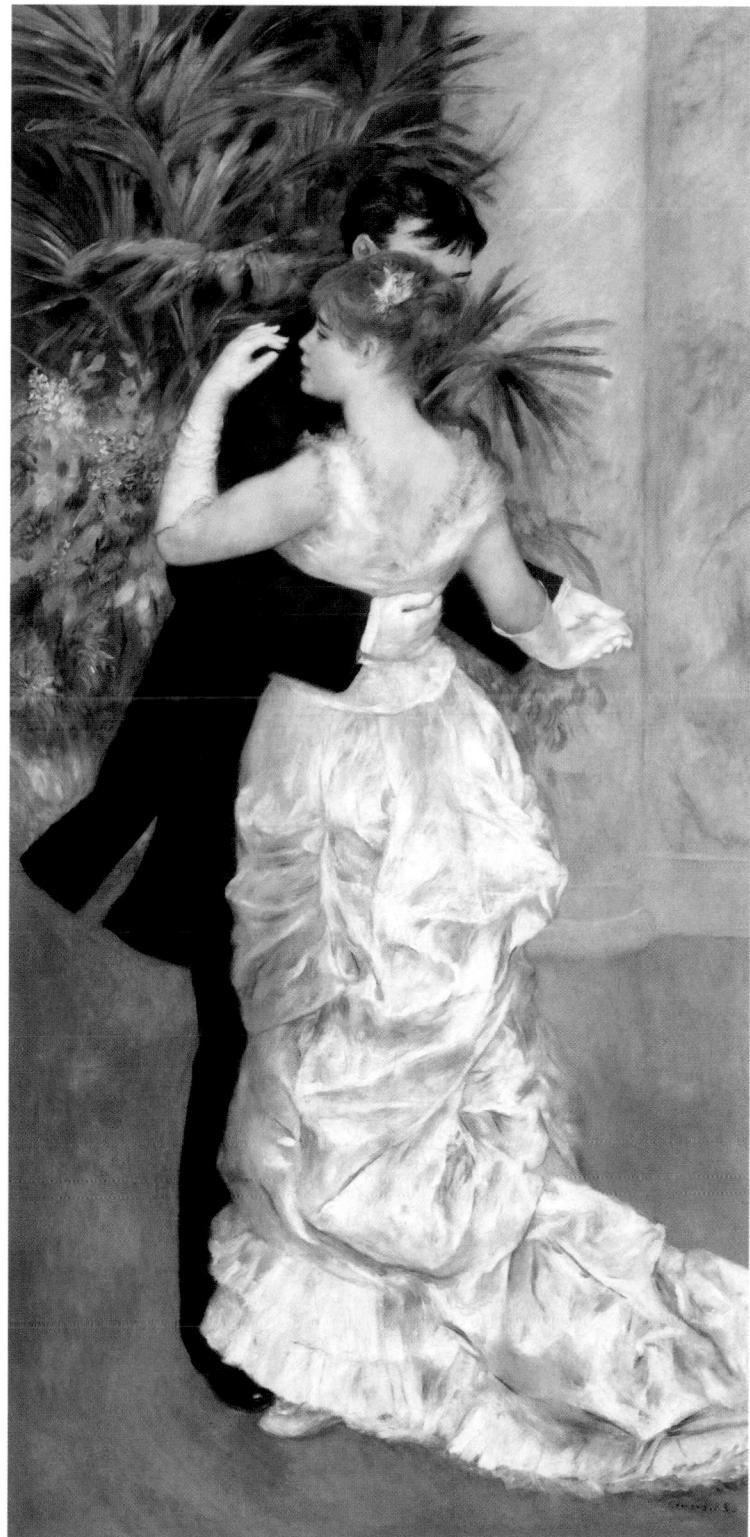

derliness he was aiming at; it is only in his very careful studies of the girls' movements that we can detect any vigour and liveliness (cf. his drawing of 1884, p. 71, now in the Art Institute of Chicago).

The Realist element of the Impressionist masterpieces had been the way in which they rendered aspects of contemporary life that were momentary but nevertheless characteristic. Renoir wanted to move away from this style. He wanted to give his pictures a greater universal appeal while at the same time retaining the freshness of a personal impression. Neither did he want to go back on the ar-

Country Dance
(Aline Charigot and Paul Lhote), 1883
Oil on canvas, 180 x 90 cm (70.9 x 35.4 in.)
Paris, Musée d'Orsay

RIGHT: City Dance (Suzanne Valadon and Eugène-Pierre Lestringuez), 1883 Oil on canvas, 180 x 90 cm (70.9 x 35.4 in.) Paris, Musée d'Orsay

tistic achievements of Impressionism, i.e. the use of brightness, of colourful shadows and the capturing of people in motion. What he was looking for was more firmness as well as a unified, self-contained whole within the organic structure of the picture. He tried to achieve this by superimposing Classicist structural principles on the seemingly coincidental turbulence of his subjects. This, however, gave rise to contradictions which remained largely unsolved.

Renoir was no more able to reach his goal in a convincing and productive way than any other Neo-Classicist painter in Europe at that time. Faced with a reality that was complicated and full of contradictions, it had become necessary to aim at a more profound and varied way of capturing the truth, one that would solve these contradictions. However, there would have been no need to idealize reality by turning towards Classicist principles. What was called for was a vigorous depiction of tangible scenes and figures, and they had to be historically and socially truthful. Renoir did not take this path. Instead, he concentrated on inventing a charmingly beautiful refuge that was full of harmony and bliss and that consisted of creatures who dwelt somewhere between fantasy and reality.

This so-called "Dry Period" in Renoir's life added a firmness of line to his artistic handwriting. Soon, however, he combined this with a new surge of sumptuously blossoming colourfulness that was even richer than the previous one. Whole torrents of colour began to pulsate rhythmically in the pictures he created and gave them a festively decorative effect. It was in the course of 1888 that Renoir began to develop this late style of his.

LEFT:

Mother Nursing Her Child (Aline and Pierre), 1886 Oil on canvas, 114.7 x 73.6 cm (45.2 x 29 in.) Private Collection

RIGHT:

Aline and Pierre, 1887 Pastel on paper on wood, 81.3 x 65.4 cm (32 x 25.7 in.) Cleveland, The Cleveland Museum of Art

PAGE 66:

Girl Braiding Her Hair
(Suzanne Valadon), 1885
Oil on canvas, 56 x 47 cm (22 x 18.5 in.)
Switzerland, Private Collection

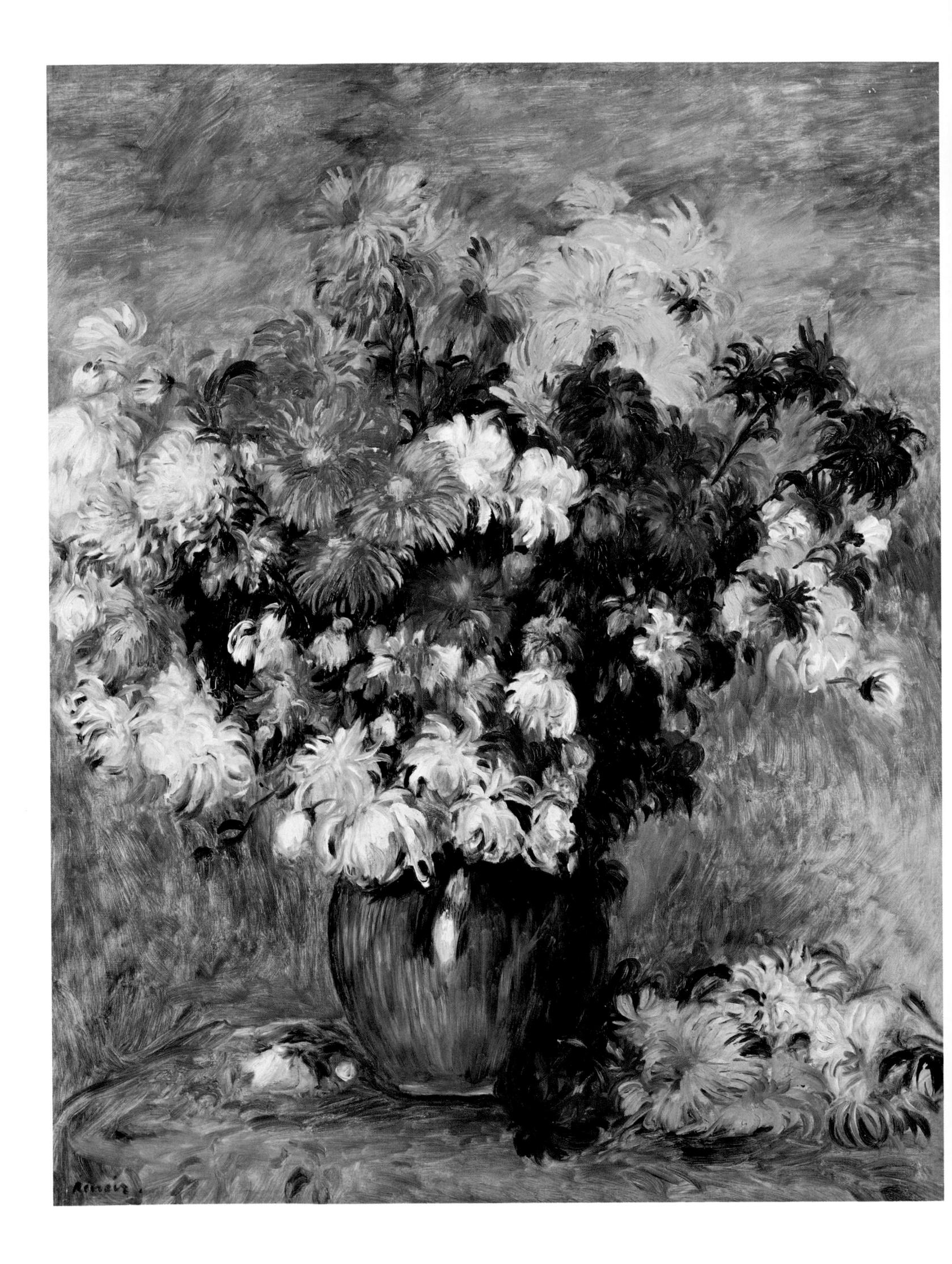

Sickness and Old Age

Although the last three decades in Renoir's life do not appear to have been very dramatic, they were overshadowed by personal tragedy. On the one hand, they were filled with the quiet triumph of his art, its general recognition and also financial success, so that these external worries were taken off his shoulders. On the other hand, however, they were darkened by the bitter fate of serious illness, against which he had to fight very hard. Also he was to suffer the same destiny as all ageing artists, i.e. that of seeing their art being overtaken and reduced to nothing by the subsequent generation.

At the end of the 1880s he worked together with Cézanne several times, and then with Berthe Morisot, who was the most gifted woman among the Impressionist painters and whom Renoir admired very much indeed. She died in 1895. The year 1890 was the first and last time for seven years that he exhibited paintings at the Salon again. In 1892 he travelled to Spain with his friend Gallimard and was very impressed by the treasures in the museums there. But whereas in the early phase of Impressionism Spanish paintings by Diego Velázquez and Francisco de Goya had had quite an impact, especially on Manet, it had now become too late for Renoir to change. 1890 was also the year when Renoir finally achieved public recognition. Durand-Ruel exhibited 110 of his works at a special exhibition, and for the first time the French government bought a picture for the Musée du Luxembourg: Yvonne and Christine Lerolle at the Piano (illus. p. 83). But when, two years later, Caillebotte's inheritance became the property of the state and Renoir was appointed executor, he still had to struggle hard to persuade the authorities to accept at least the larger part of the collection. The old gentlemen on the relevant committees were still extremely sceptical toward an art that had been rejected and ridiculed for such a long time, and they were rather reluctant to put them into state-owned, public museums. What is more, the Parisian middle classes at that time were still trembling with fear after a wave of anarchist assassinations, and some of the anti-academic painters were known to have anarchist leanings. Professor Gérôme of the École des Beaux-Arts publicly referred to Impressionist paintings as filth, saying that accepting them would be a sign of moral cowardice on the part of the state. And so only thirty-eight out of sixty-five paintings by Caillebotte were hung at the Luxembourg, and only six instead of eight Renoirs.

Renoir now spent several summers (1892, 1893, 1895) in the coastal town of Pont-Aven, a spot which was very popular among painters. In particular, it

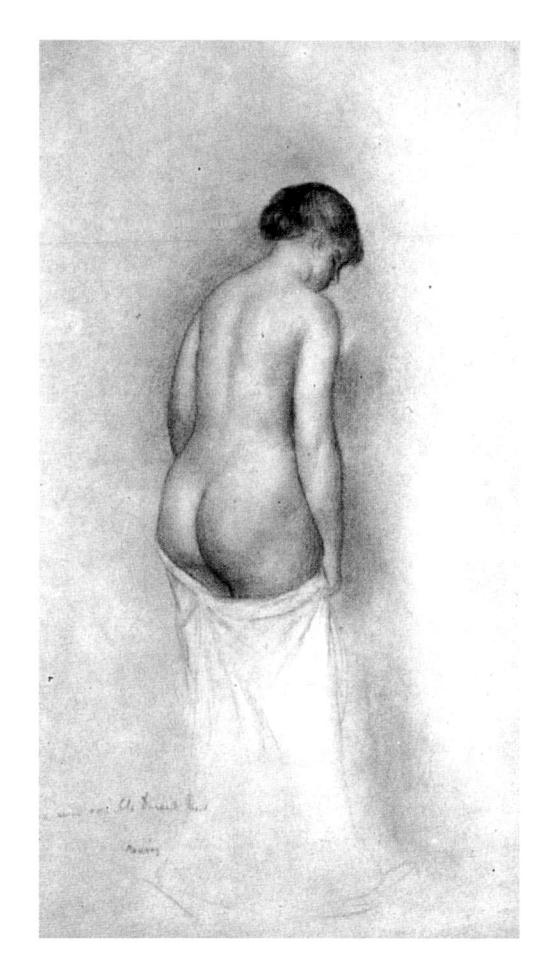

After the Bath, 1884 Red crayon, 44.5 x 24.5 cm (17.5 x 9.6 in.) Paris, Private Collection

PAGE 68: **Bouquet of Chrysanthemums**, about 1885 Oil on canvas, 82 x 66 cm (32.3 x 26 in.) Rouen, Musée des Beaux-Arts et de la Céramique

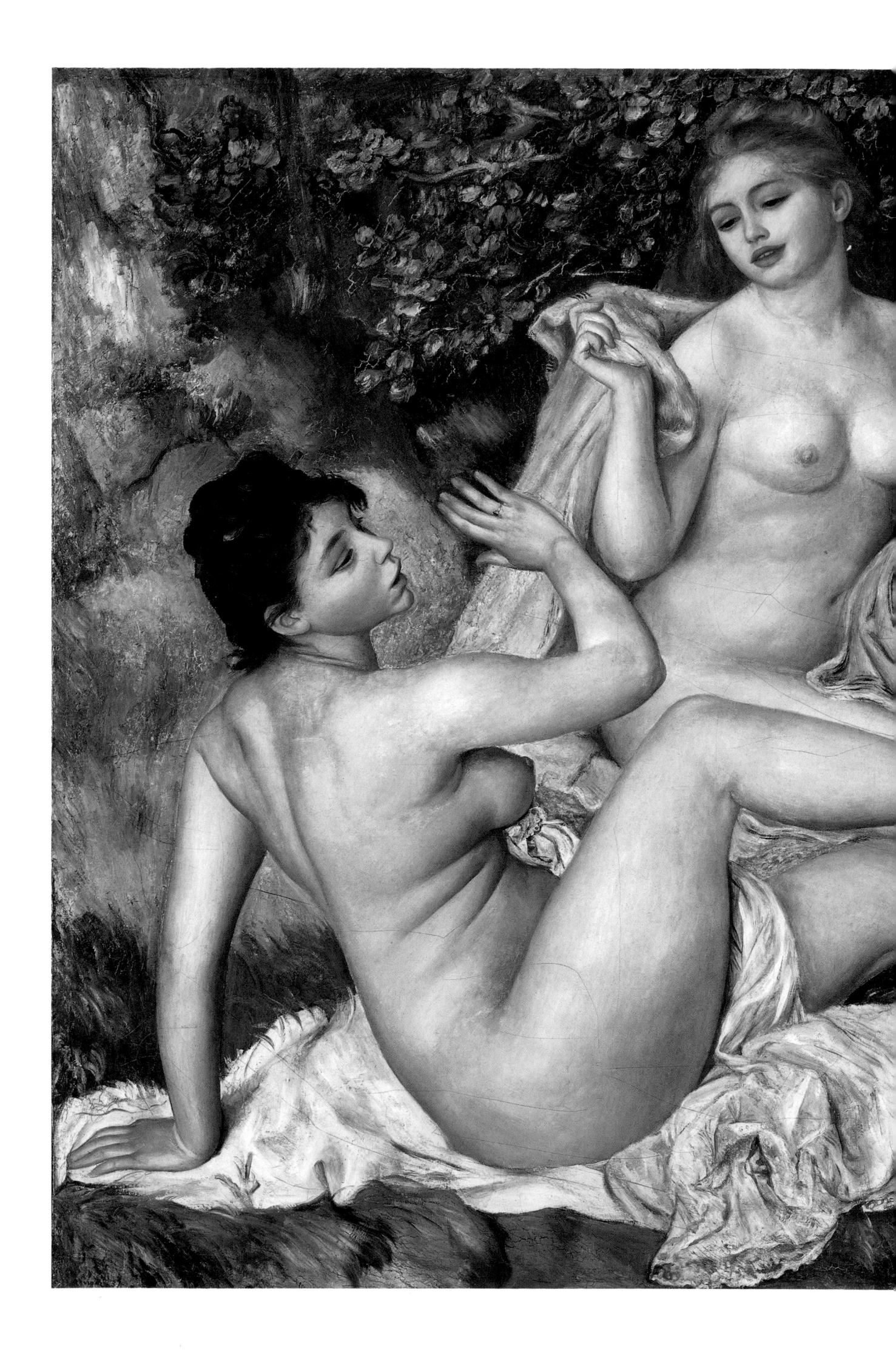
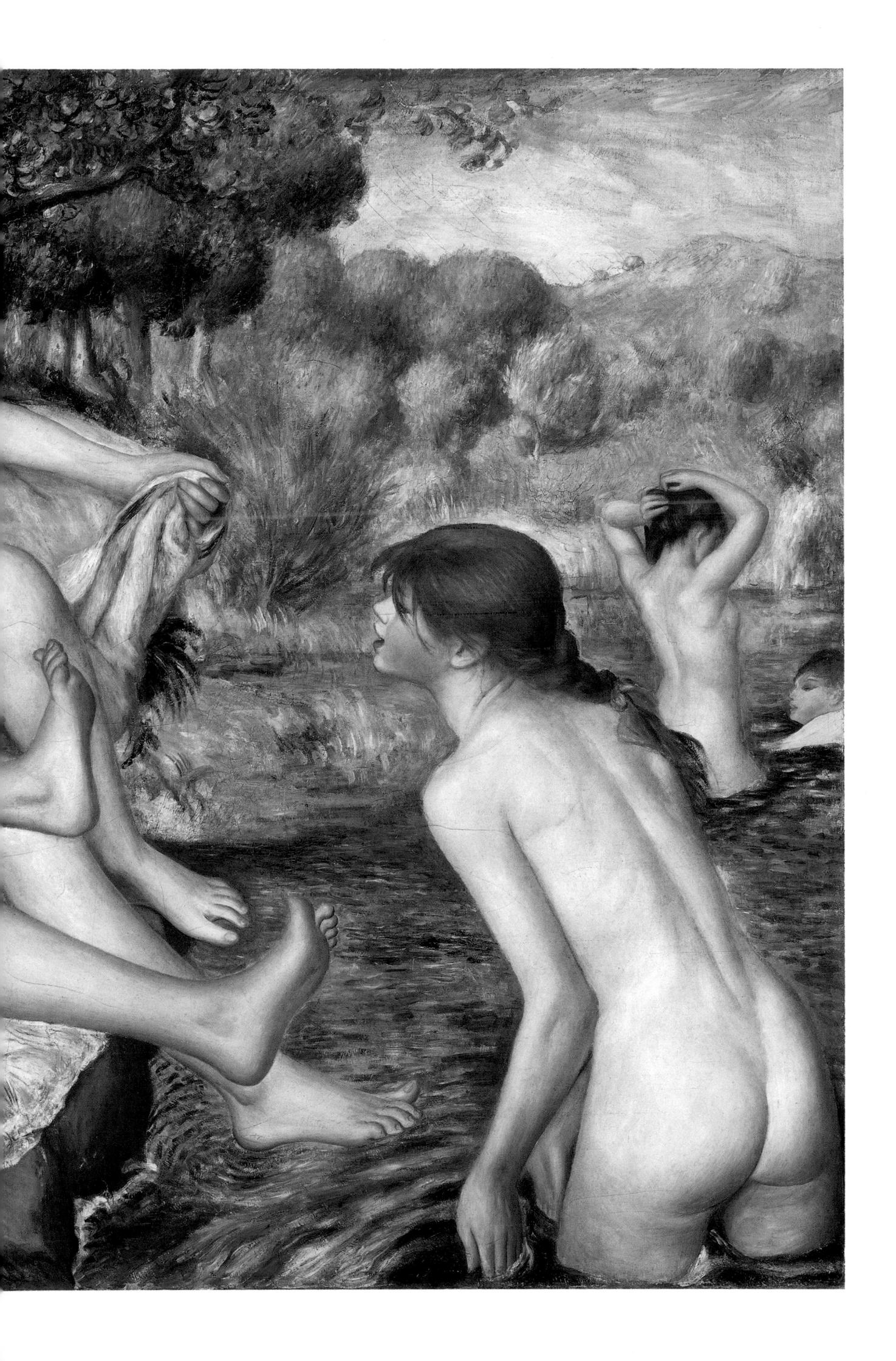

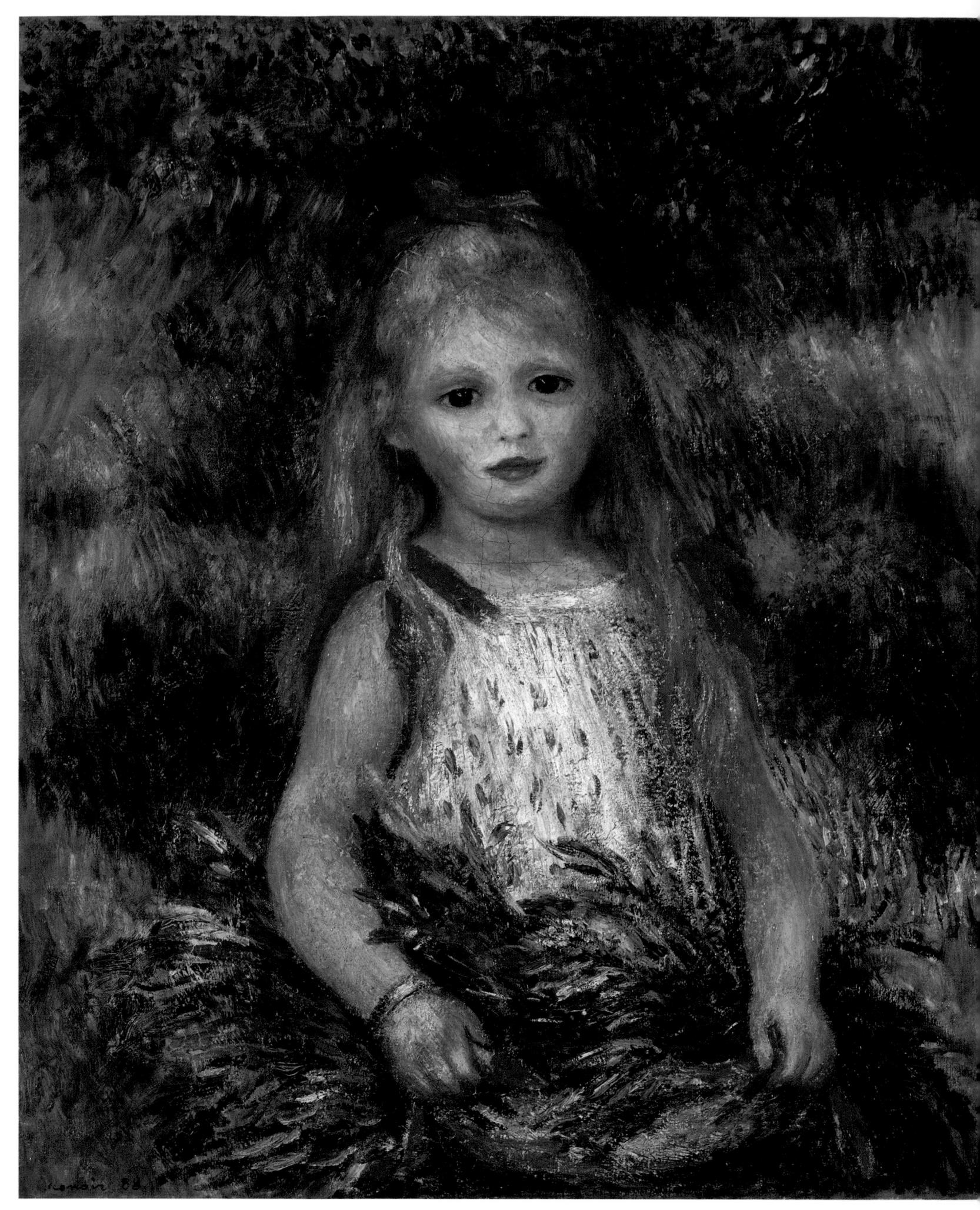

dealer Ambroise Vollard. All of these have handed down to us some valuable notes of their talks with the old master (who hated this term). He always expressed himself in simple words and without any clever philosophical ideas. A large number of pretentious theories of art were being discussed at the time, and it was probably because of these that Renoir was suspicious of any theory whatsoever. Above all, however, he felt profound respect for the tradition of the great masters and that craftsmanlike skilfulness which had been destroyed completely by the increasing division of labour. He was neither a critic nor a rebel, and, in a way, he was living outside his own time, but this enabled him to maintain a purity and kind-heartedness that was rare in those days.

His rheumatoid arthritis soon became excruciatingly painful and gave him a lot of trouble. His bones became deformed, and his skin dried up. In 1904 he only weighed about seven and a half stone and was scarely able to sit. From 1910 onwards he could not even move about with crutches and became a prisoner in his wheelchair. His hands were completely deformed, like the claws of a bird, and a gauze bandage had to be used to prevent his fingernails from growing into the flesh. He was no longer able to pick up his paintbrush, and it had to be wedged between his rigid fingers. And so, day after day, he continued to paint undaunted, unless an attack forced him to lie on his bed where a wire construction protected his body from being touched by the bedclothes. There were occasions when he was completely paralysed. Visitors were getting used to interruptions in a conversation, when Renoir would suddenly stop and then have a painful attack that

LEFT:

On the Meadow, about 1890 Oil on canvas, 81 x 65 cm (31.9 x 25.6 in.) New York, The Metropolitan Museum of Art, bequest of Sam A. Lewinsohn

RIGHT:

The Washer-Women, 1889 Oil on canvas, 56.5 x 47 cm (23.2 x 18.5 in.) Baltimore, The Baltimore Museum of Art, The Cone Collection

PAGE 74: *Little Girl Gleaning*, 1888 Oil on canvas, 61.8 x 54 cm (24.3 x 21.3 in.) São Paulo, Museu de São Paulo Assis Chateaubriand

PAGE 76: *The Bather (After the Bath)*, 1888 Oil on canvas, 81 x 66 cm (31.9 x 26 in.) Private Collection

PAGE 77: *After the Bath*, 1888 Oil on canvas, 65 x 54 cm (25.6 x 21.3 in.) Tokyo, Private Collection

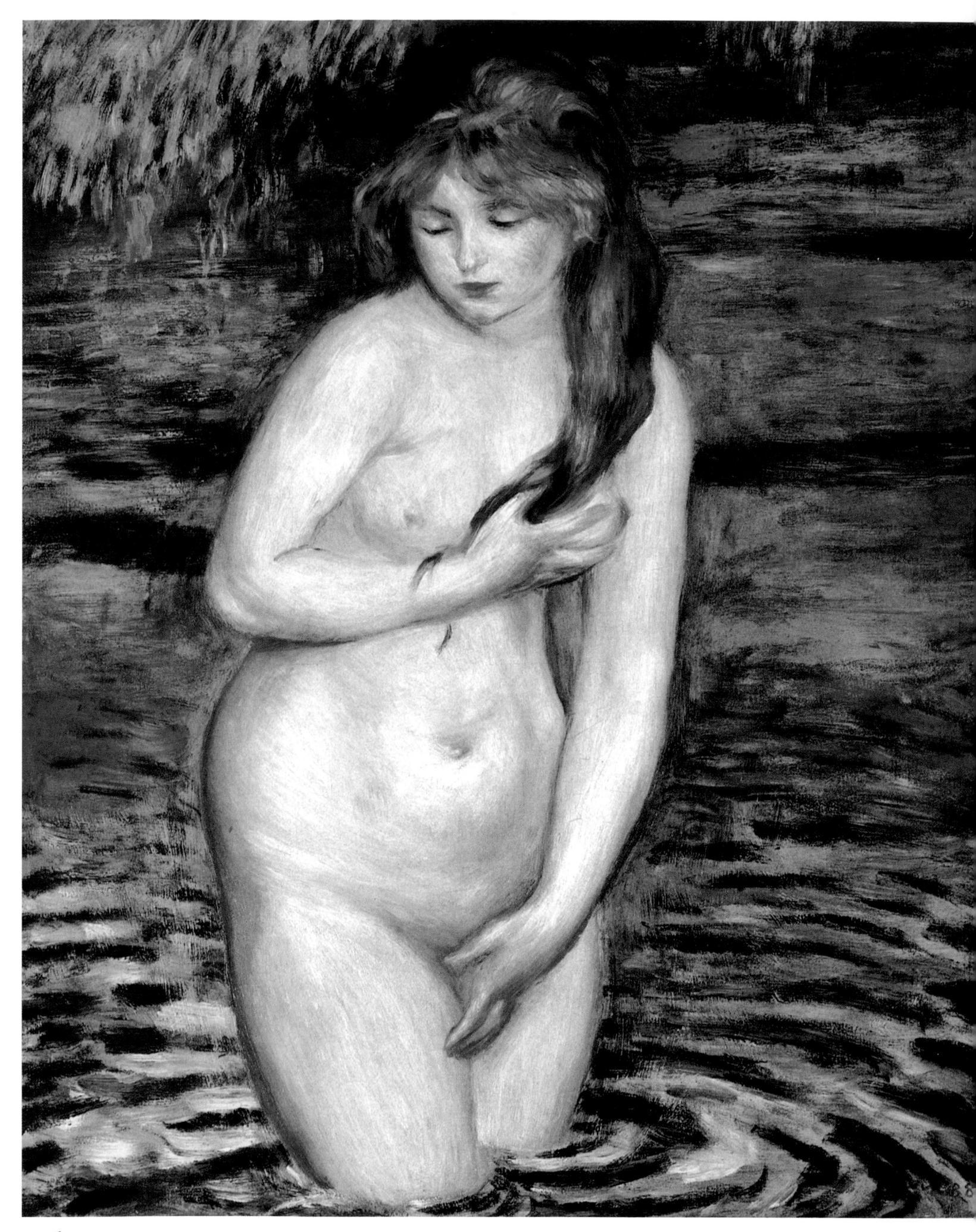

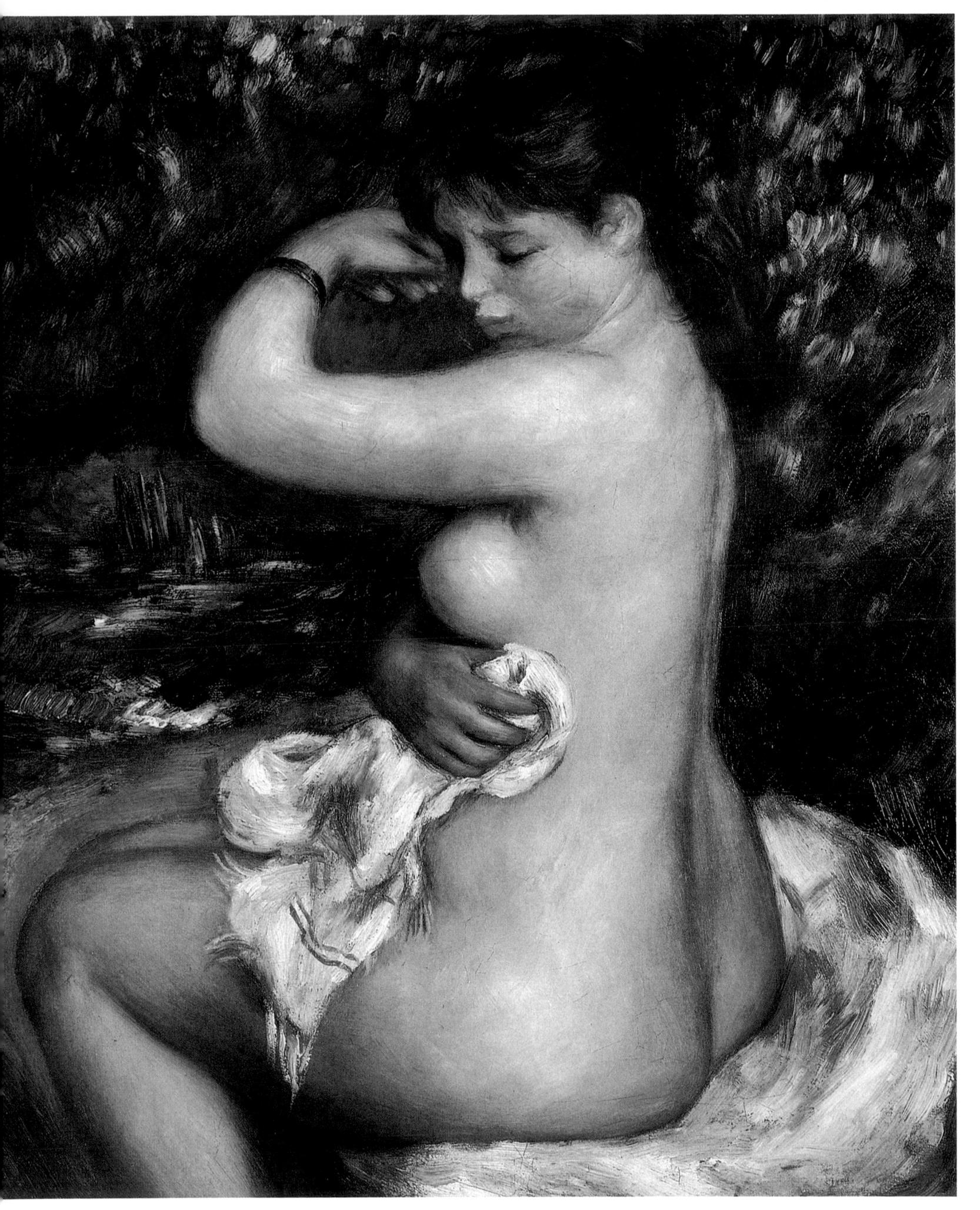

Self-Portrait with a White Hat, 1910 Oil on canvas, 42 x 33 cm (16.5 x 13 in.) Paris, Private Collection

"When I paint flowers, my mind has a rest. I do not make the same mental effort with them as when I am face to face with a model. When I paint flowers, I put down different shades of colour and try out some bold tonal values, without worrying about spoiling a canvas. I wouldn't dare to do that with a person for fear that I might make a mess of it all. And the experience which I get from these experiments can then be applied to the other pictures."

"I think I'm gradually beginning to understand

something about it."

PIERRE-AUGUSTE RENOIR

PIERRE-AUGUSTE RENOIR, on 3 December 1919 after finishing his last painting. lasted for a quarter of an hour, after which he usually continued at exactly the same point where he had left off. He had an casel where each canvas could be rolled up like a woven product on a loom. Thus he was able to cope with larger formats, even though he had to sit in a wheelchair and could only move his arm to thrust the paintbrush forward in short, sudden jerks. "You see," he said to the art dealer Vollard who was watching him paint with his deformed claw, "you don't even need a hand for painting!"

It was at this time that Renoir took up sculpture: he used somebody else's hands to form the clay according to his instructions. The young Spaniard Richard Guino turned out to be a very thoughtful and diligent assistant, though the person who took over from him was less suited for this task. He used sketches by Renoir as his starting point and then carried them out in detail. Moving close to him with his wheelchair, Renoir would then give instructions with a pointer: "Take a bit off there... a little more... that's right! This should be rounder, fuller...!" The two were so well coordinated that in the end they communicated with each other by means of short noises and exclamations, and a critical or pleased grunt from Renoir was sufficient. In this way sculptures were created which had never been touched by Renoir's hands but which are nevertheless works that come from his own mind and nobody else's, made according to Renoir's ideas of what is beautiful in a human being.

One thing is indeed incredible, unique and wonderful about these late works: even though Renoir was old, sick and decrepit, there was never so much as a shadow of despair or weariness in his art. Nor did he ever allow it to be invaded by feelings of envy or anger towards those who were in good health. In fact, all the hundreds of works which he produced during the last few years of his life were a single ode to happiness and joy, a single Arcadian smile.

At the beginning of the First World War, which Renoir abhorred as being totally pointless, his sons Jean and Pierre were badly wounded. They were nursed to health by their mother until she died herself in 1915, overwhelmed by sorrow. Renoir visited her grave in Essoyes during the first summer after the war, and then went on to Paris for the last time in his life. The 78-year-old man was taken in his wheelchair to his favourite paintings by François Boucher, Delacroix and Corot, as well as to Paolo Veronese's large and extremely colourful *Wedding in Cana*. At Renoir's request it had been displayed side by side with a small portrait of Madame Charpentier, which he had painted as a study in 1917 and which was now given a special place of honour. As soon as he had returned to Cagnes, he continued to paint. "I'm still making progress," he said a few days before his death, and the last words which are reported to have come from his lips on 3rd December 1919 were about the arrangement of a still life that he was going to paint: "Flowers..."

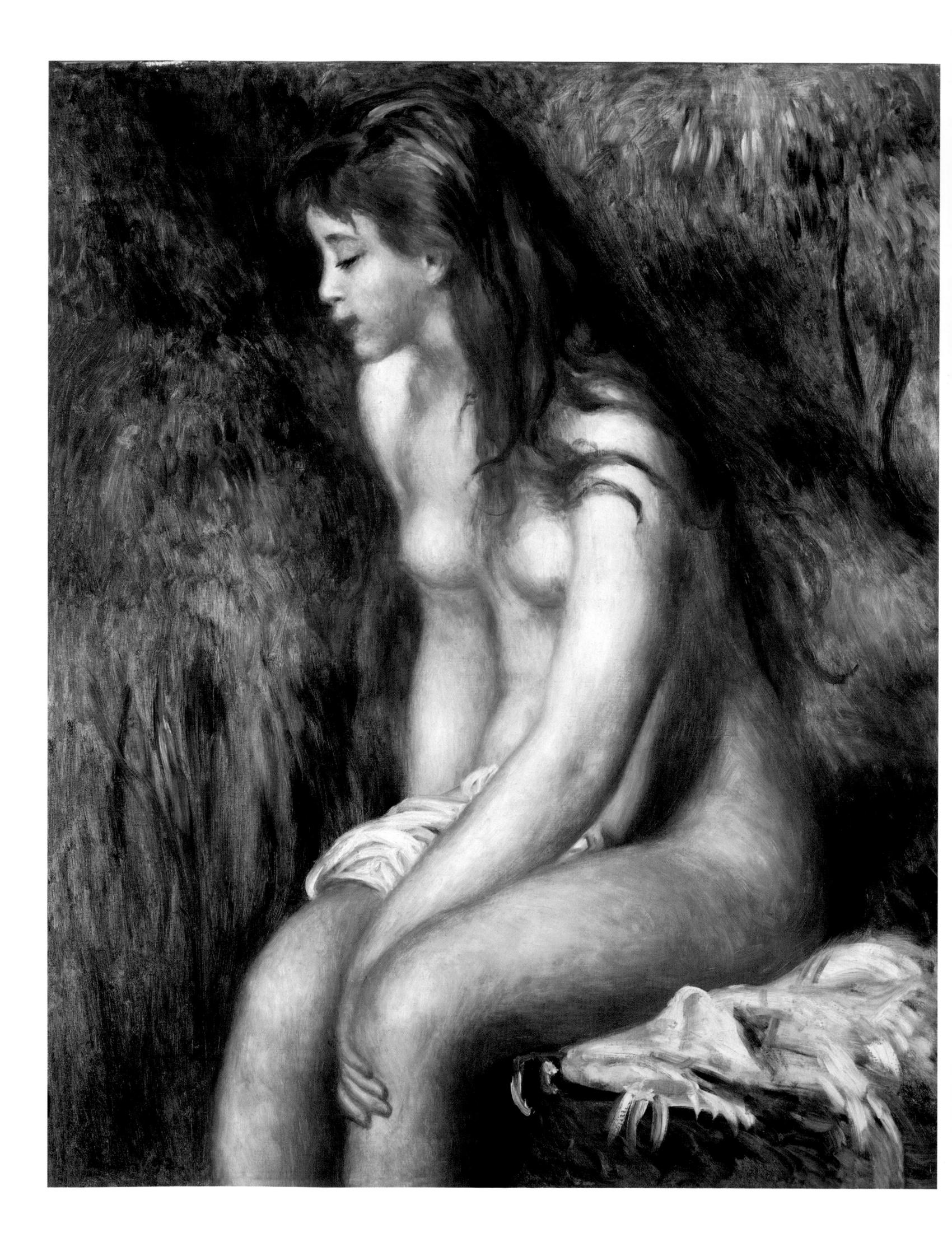

Renoir's Late Works

Once Renoir had got over his "Dry Period" in 1888, there was a flower-like quality in practically everything he painted. His pictures vibrate with strong, sparkling colours, evenly distributed. But even a picture as early as his *Young Girl Reading* (now in Frankfurt) calls to mind the way in which Renoir treated the same subject ten years earlier (illus. p. 27). The magic of the colours has become even more sumptuous and powerful. In his previous pictures, Renoir used to show people in new situations and immersed in light, whereas now the person in the painting is virtually engulfed by a whole sea of colourful flowers and is no longer interesting as an individual, but rather as someone who serves as a vehicle for colours – colours which almost transcend the material world.

The beauty of his late works is due to their intoxicating blaze of colour and the lightness of Renoir's brushwork. The lines in these compositions move in broad curves, and the paint is often dotted across the canvas like the fine dust on the wings of a butterfly. Whether it is the white cubes of houses, seen quite differently by Cézanne, or the gnarled shapes of olive trees, dramatized so expressively by Vincent van Gogh, the bright light of Provence always flows through his land-scapes and lets the colours blossom in all their fantastic splendour. Renoir painted everything as a veiled fairy-tale garden with cheerful harmonies of red, yellow, green and blue, or a woven fabric of confusing, decorative splendour.

Whenever Renoir painted people in their natural environment, he linked them to their surroundings by using the same texture of colours. He still had the sensitivity of an Impressionist when it came to detecting various nuances and the charm of an uninhibited, impulsive movement, especially that of a lithe young girl. Take, for example, his picture of the two girls at the piano, which he painted in several different versions (illus. pp. 82/83). There is a delightful naturalness about the postures of the Lerolle sisters, and also their facial expressions as they are trying out a new tune. Their faces, however, are the least important element.

The girls who are sitting and making garlands of flowers on a meadow under a tree are images of a romantic pantheism that flows in torrential waves and effortlessly merges man and nature into one another. The girls are no longer tangible people at a given point in time, people with distinct actions and feelings placed in the surroundings of sun-soaked nature, as they might have been had they appeared in the scenes which Renoir depicted in the seventies and early eighties.

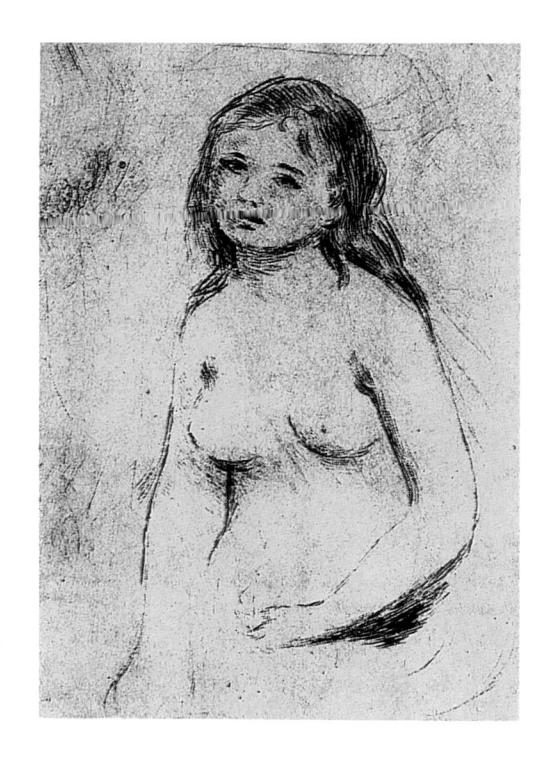

Bather, 1906 Etching, 23.7 x 17.5 cm (9.3 x 69.1 in.) Paris, Bibliothèque Nationale

PAGE 80: **Seated Bather**, 1893 Oil on canvas, 81 x 65 cm (31.9 x 25.6 in.) New York, The Metropolitan Museum of Art, Robert Lehman Collection

Not only was the painter's relationship towards "simple people" without pretence, it was also full of sympathy. This can be seen in a series of pictures showing servant girls doing their washing by the side of a river (illus. p. 75). Renoir focused on the beauty of their figures and movements. He was not interested in the seriousness of their hard work, as painted by Daumier decades before.

As a rule, his pictures no longer show signs of psychological composition, and there is less tension in the constellation of the figures. This is because the rhythmic pattern of the colours has detached itself from the objects and has spread across the entire area of each picture in the form of a pattern that springs from the artist's imagination. Spots of light on the grass or on the objects are still the result of accurate observation of colours in real life, but they no longer serve to render objective reality as authentically as possible. Rather, they have become playthings of the artist's dream colours.

We must bear in mind that the works which Renoir produced during the last fifteen years of his life were already contemporaneous with the expressive pictures of the so-called *Fauve* group of artists around Henri Matisse (who visited Renoir shortly before he died), as well as the birth of Cubism, as represented by

Yvonne and Christine Lerolle Playing the Piano, 1897 Oil on canvas, 73 x 92 cm (28.7 x 36.2 in.) Paris, Musée de l'Orangerie

PAGE 82: *Girls at the Piano*, 1892 Oil on canvas, 116 x 90 cm (45.7 x 35.4 in.) Paris, Musée d'Orsay "What we think of as an innovation, both in nature and in art, is really only a more or less modified continuation of the old."

PIERRE-AUGUSTE RENOIR

View of the New Building of the Sacre-Cœur, about 1896
Oil on canvas, 41.5 x 32.5 cm (16.3 x 12.8 in.)
Munich, Neue Pinakothek

Picasso and Georges Braque, and also the abstract or "absolute" art of Wassily Kandinsky.

Most of Renoir's later paintings of people are devoid of any psychological appeal. Many of the faces are disappointingly empty, while others still show signs of an attempt to achieve an appropriate individualization of each character. The most beautiful ones are the pictures he painted as the delighted father of his little son Coco (illus. p. 86), a relatively late addition to the family. They tell the tale of how Coco grew up with the help of Gabrielle, how he was fed by the girl, how he developed the bewitching charm of a spoilt little Goldilocks. In fact, when Renoir concentrated on the flower-like quality of little children in his pictures, he was always at his best.

Then there are a number of beautiful portraits and studies of Gabrielle (illus. p. 88). Some of them show her with simple, grave industriousness which must have been painted by Renoir with a feeling of calm and sincere gratitude. Most of the time, however, Renoir painted her in a state of transfiguration, with flowers and ornaments and with movements that were probably far more graceful

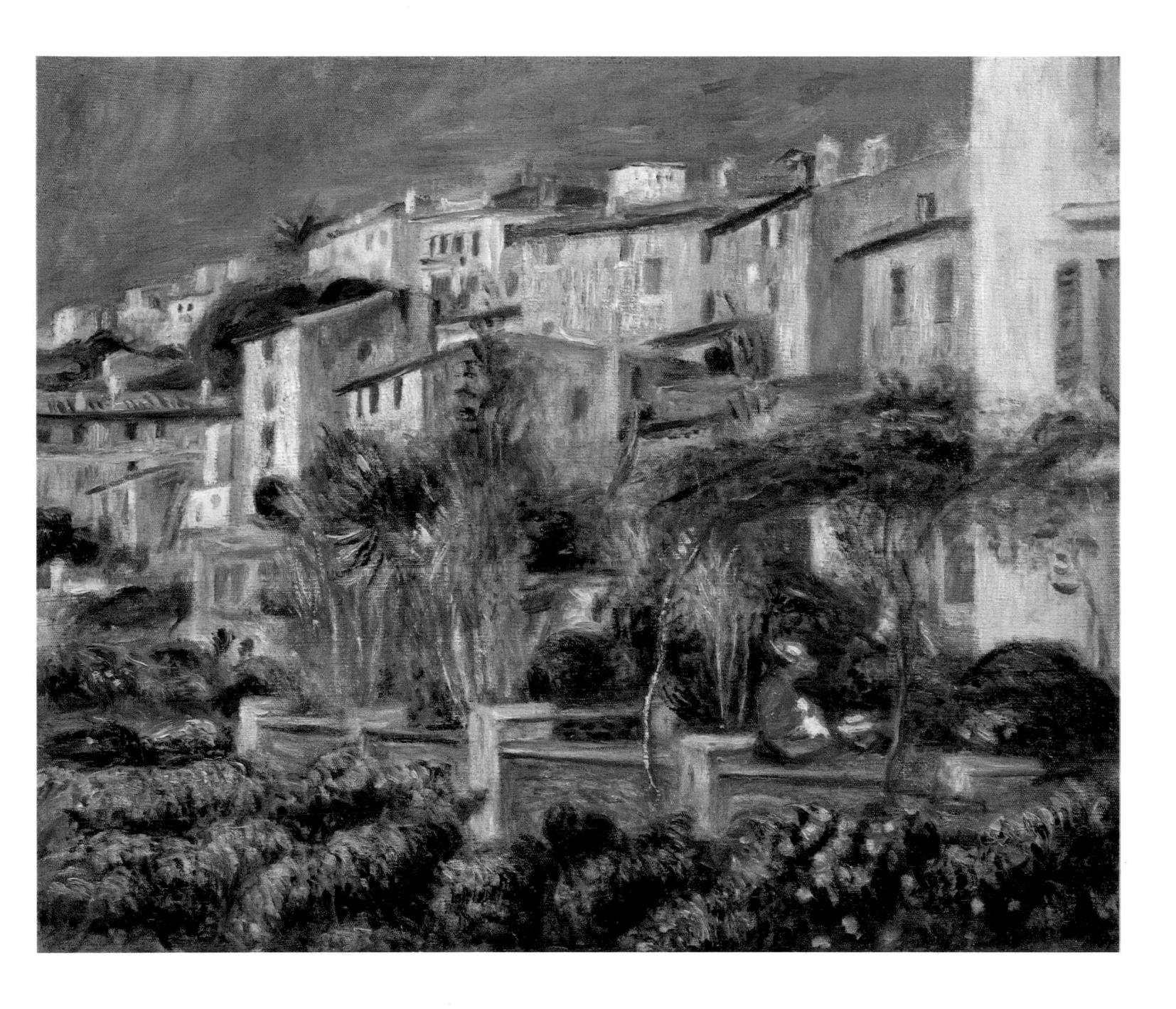

than in real life. Rather than creating a completely accurate image of his model, he used her as a source of inspiration. Intimate scenes, such as that of a girl putting on make-up or combing her hair, have become far more simple than they used to be, without complicated lighting effects or capricious movements.

The gestures which he built into his pictures were of a more general nature, they were calm and timeless and did not display any of the clashes and tensions that he used to love in the 1870s. On the other hand, they were far from commonplace or banal, due to the magical formulas of Renoir's colour fantasies. We no longer see them as mere everyday routines, but as the free rhythmic patterns of lyrical plainsong. What helped him was a mild tendency towards music and dance, which enabled him to appreciate the harmonious movements of his models. In summer 1909 he asked Gabrielle and another favourite model to pose as dancers with tambourines and castanets in oriental costumes that were reminiscent of Delacroix's Algerian women. This painting was to decorate the dining room of the Parisian art collector Maurice Gagnat (illus. p. 87).

Terrace in Cagnes, 1905 Oil on canvas, 45.3 x 54.3 cm (17.8 x 21.4 in.) Tokyo, Private Collection

"As for myself, I've always disliked being called a revolutionary. I have always believed – and still do – that I am merely continuing something that others before me did a lot better."

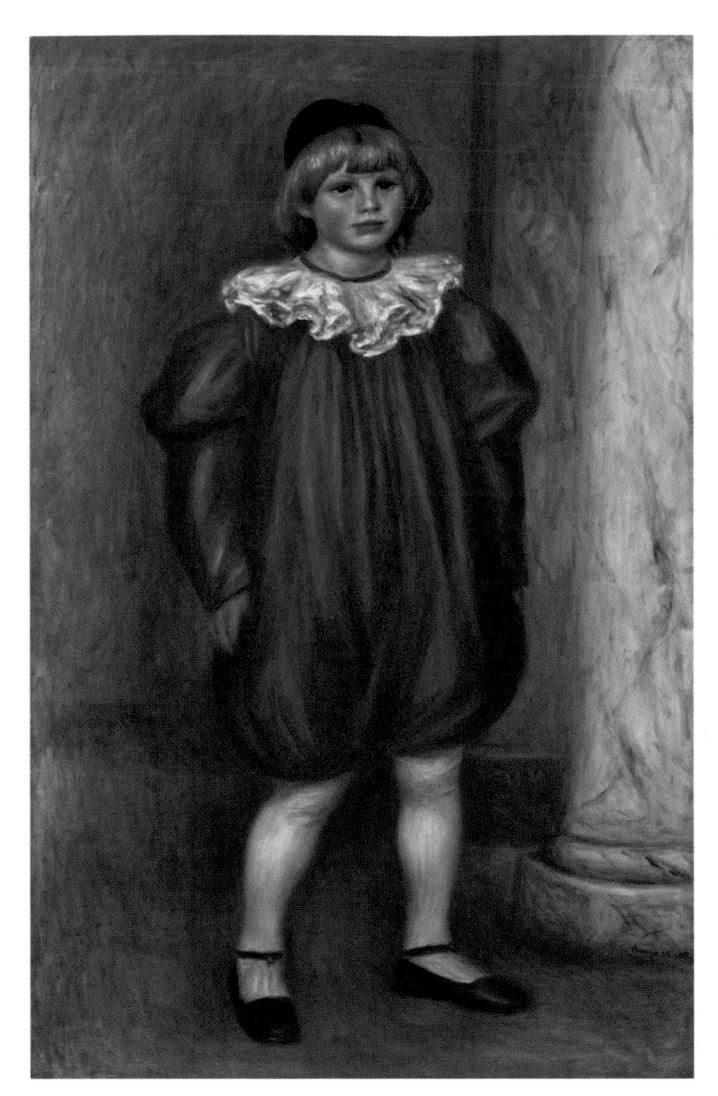

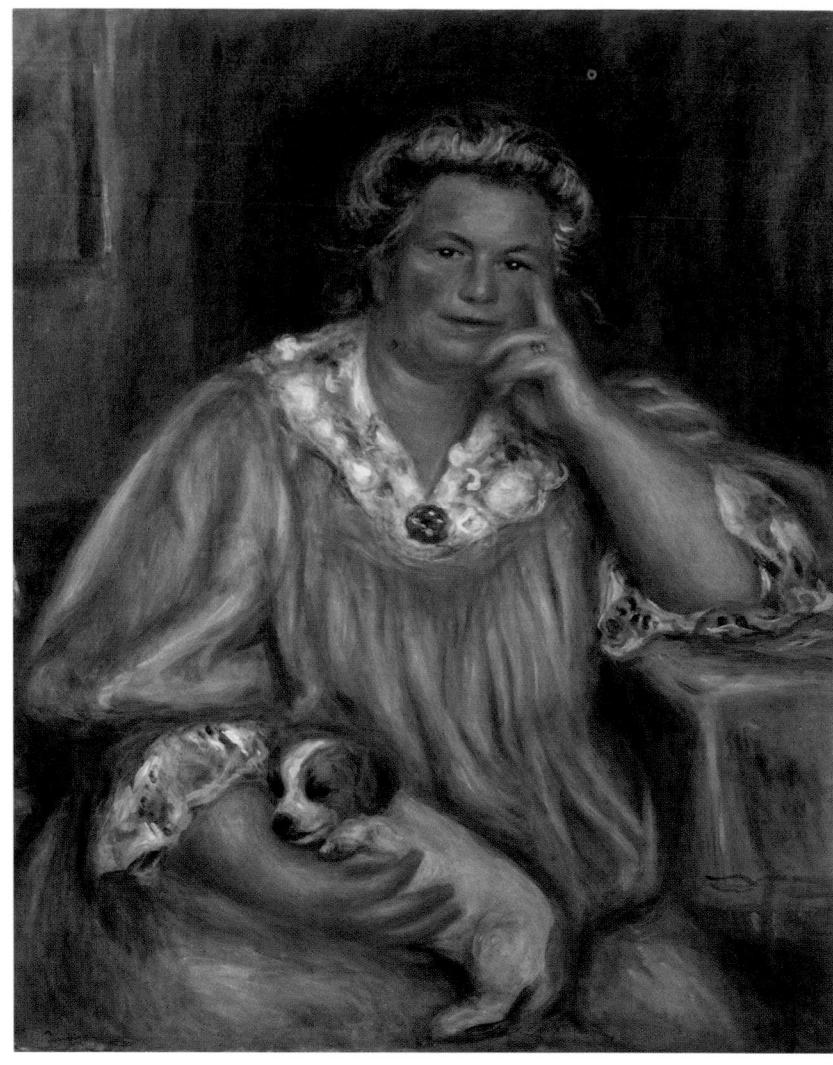

LEFT:

The Clown (Claude Renoir), 1909 Oil on canvas, 120 x 70 cm (47.2 x 27.6 in.) Paris, Musée de l'Orangerie

RIGHT:

Madame Renoir with Bob, about 1910 Oil on canvas, 81 x 65 cm (31.9 x 25.6 in.) Hartford, Wadsworth Atheneum, The Ella Gallup Sumner and Mary Catlin Sumner Collection Fund

PAGE 87 LEFT:

Dancer with Tambourine, 1909 Oil on canvas, 155 x 64.8 cm (61 x 25.5 in.) London, The National Gallery

PAGE 87 RIGHT:

Dancer with Castanets, 1909
Oil on canvas, 155 x 64.8 cm (61 x 25.5 in.)
London, The National Gallery

From Renoir's "Dry Period" onwards his favourite theme was nude girls. Once people had got used to the vivid porcelain-like colours of the early nineties and the strawberry pink of his later works, these were the pictures which had the greatest impact on subsequent generations and which they came to associate most closely with the artist. This is somewhat misleading, because during the time when Impressionism was at its height, i.e. in the seventies, there were relatively few nude pictures compared with scenes from the life of the middle classes. The Realism of this genre of pictures, however, had been given up by Renoir and the majority of contemporary French painters. Instead, they wanted to create a realm for their art that was pure and detached from the life of society with all its contradictions.

Renoir's blissfully innocent nude girls were nearly always painted in the open air (cf. illus. pp. 76, 77 and 80), and it is obvious from their bodies and faces that all his models must have been of a certain type which he preferred. He was not trying to revive Classicist rules of proportion or to construct slim, pseudo-antique and idealized figures in line with the academic tradition. His ideal of beauty was that of a well-rounded woman with broad hips. Unlike many other contemporary painters, Renoir always remained closely in touch with nature and had his feet firmly on the ground of reality. This, however, was a reality which was confined to individual people whom he could perceive with his own

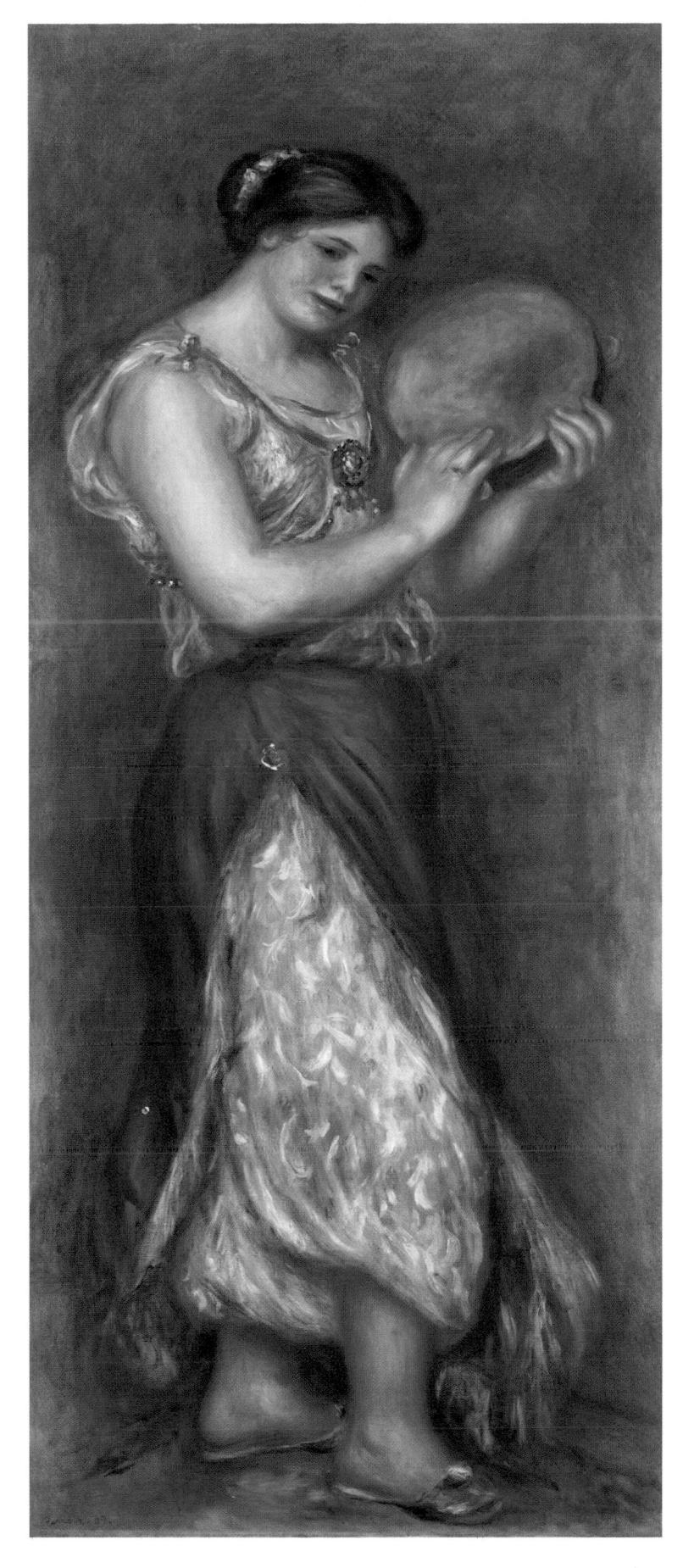

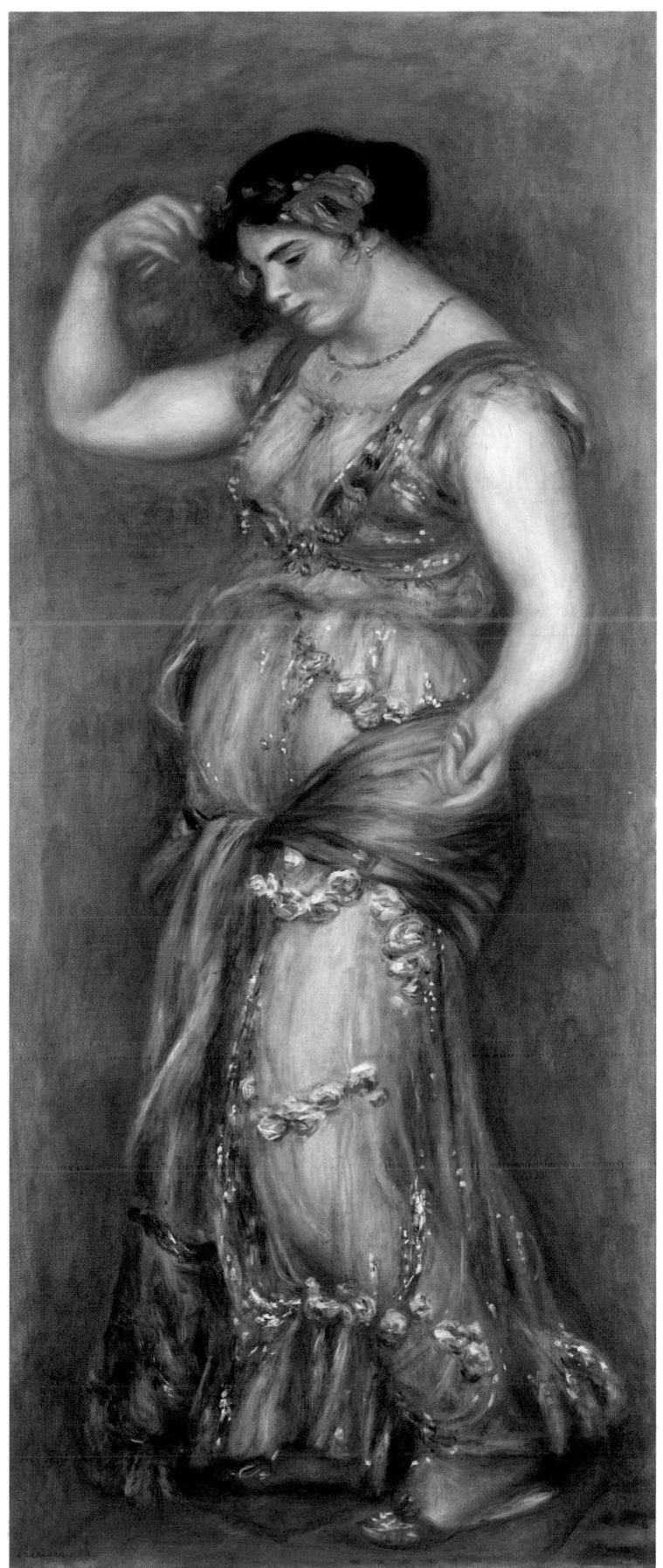

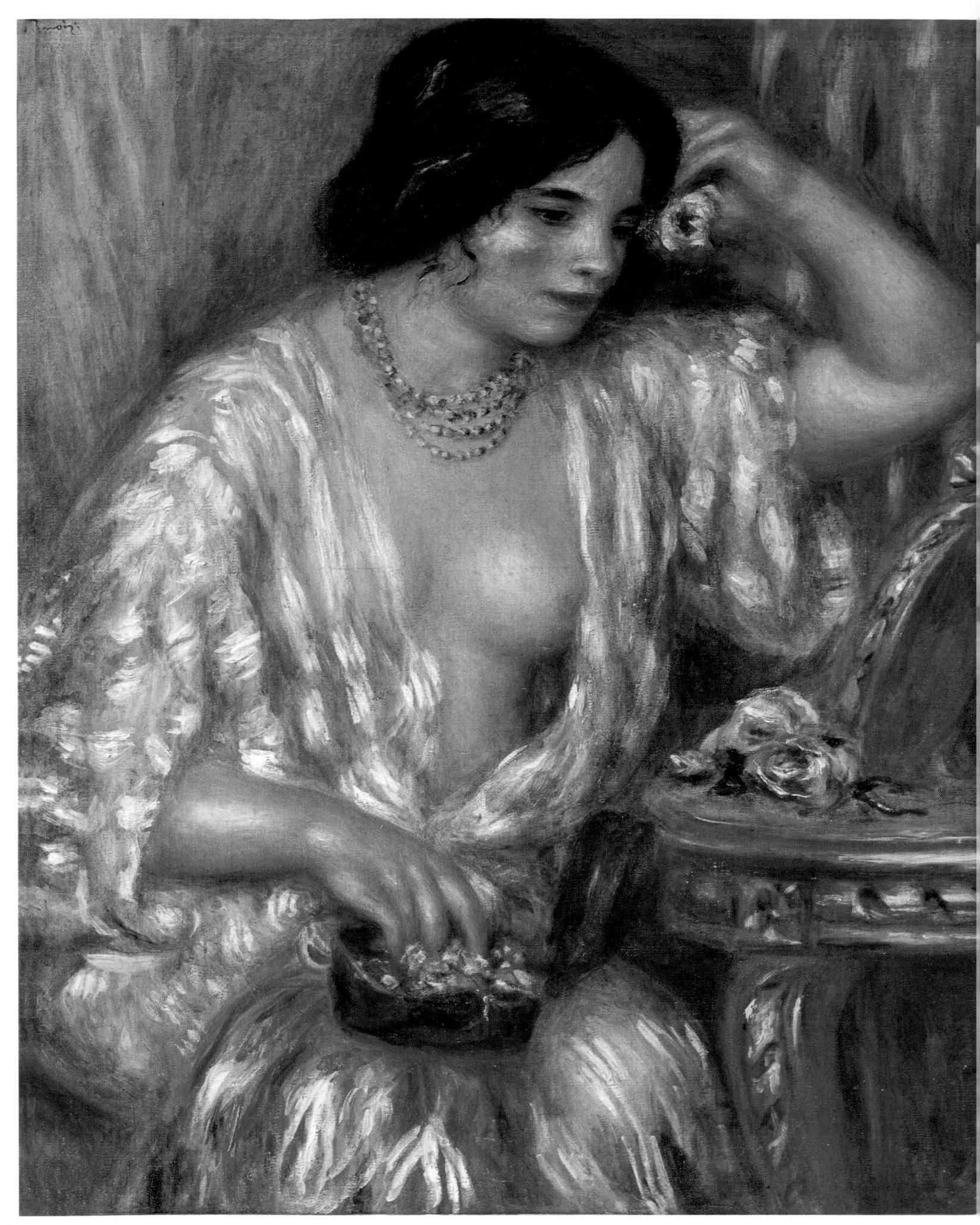

eyes; or, to be more precise, it was confined to their bodies. He only ever painted the bodies of girls.

He saw girls and women as exclusively animal-like creatures that were mainly guided by their instincts. It was a dominant view in contemporary society that women were generally less intelligent and more instinctive creatures. There was a certain way of looking at human beings entirely in terms of science and biology, and this view had persisted among positivist philosophers and naturalist authors since the time of Impressionism. But it was not until his later works that Renoir gave so much emphasis to the animal-like nature of human beings. His girls are endowed with no more "soul" than their bodies are able to express. They are without spirit or intellect or even the awareness that they form part of society at large. In their abundant sumptuousness, they were like beautiful animals for him, or like fruits or flowers. Whenever he employed a servant girl, he always took her on as a model at the same time, and all he demanded was that "their skins should respond well to the light". Renoir himself admitted without embarrassment that, for him, the most beautiful part of a woman's body was her buttocks, although on another occasion he said that if God had not created women's breasts, he might never have become a painter. The main artistic aim of his late works was to praise and glorify the fascination of the female body. He did so without the slightest hint of lust and – paradoxical as it may seem – with a chaste sensuousness that was in itself animal-like, natural and naive. In his pictures he displayed a certain aesthetic relationship towards nudity that could be called classical because it does indeed come closest to the works of the ancient Greeks. But this was as far as his Classicism went, i.e. the yearning and striving for beauty in human beings who dwelt in a timeless, sun-soaked Arcadian paradise.

Sometimes he even quoted, as it were, the well-known postures of Greek Venuses, whereas on other occasions he painted his models in a totally unself-conscious, and usually somewhat dream-like, mood –with their heavy bodies, small, firm breasts, round shoulders, small, spherical heads, beaming eyes and broad lips. At the beginning of the 1890s he painted their complexion with shades of silvery grey – a colour known as "mother-of-pearl", though later he preferred warmer, more glowing colours.

Right at the end of Renoir's life his nudes acquired a certain dignity and greatness that was indeed truly classical. His *Seated Bather* of 1914 shows this quite clearly. With their strawberry red, which is overshadowed by a flamboyant purple, embedded in orgies of green, yellow and blue, they often seem rather obtrusive; their flesh sometimes seems unbearably supple and ample, like the feverish dream of a painter who had become a haggard, emaciated cripple. Not only do some of them recall the postures of ancient Greek sculptures again, but their rare movements have a natural forcefulness and a detached timelessness that makes them earthly goddesses. There is a magnificent bronze figure, which Guino modelled for Renoir, of a woman with a smile, strutting about fully conscious of her own power, and she was very appropriately called *Venus Victrix*: the goddess of love has won her victory.

This is a name which, in a deeper sense, can serve to summarize the whole of Renoir's works. He was a good and unsophisticated man. In his pictures he un-

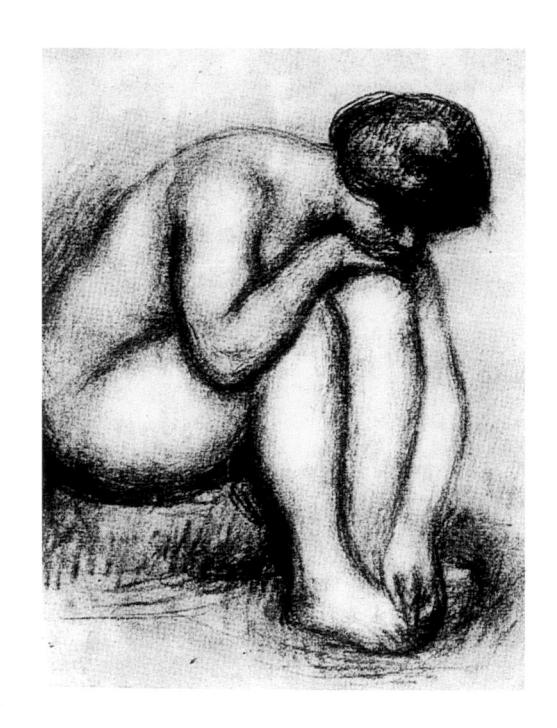

Bather Drying Horcolf, 1910 Red crayon, 52 x 47.5 cm (20.5 x 18.7 in.) Paris, Private Collection

PAGE 88: *Gabrielle with Jewel Box*, 1910 Oil on canvas, 82 x 65.5 cm (32.3 x 25.8 in.) Geneva, Private Collection

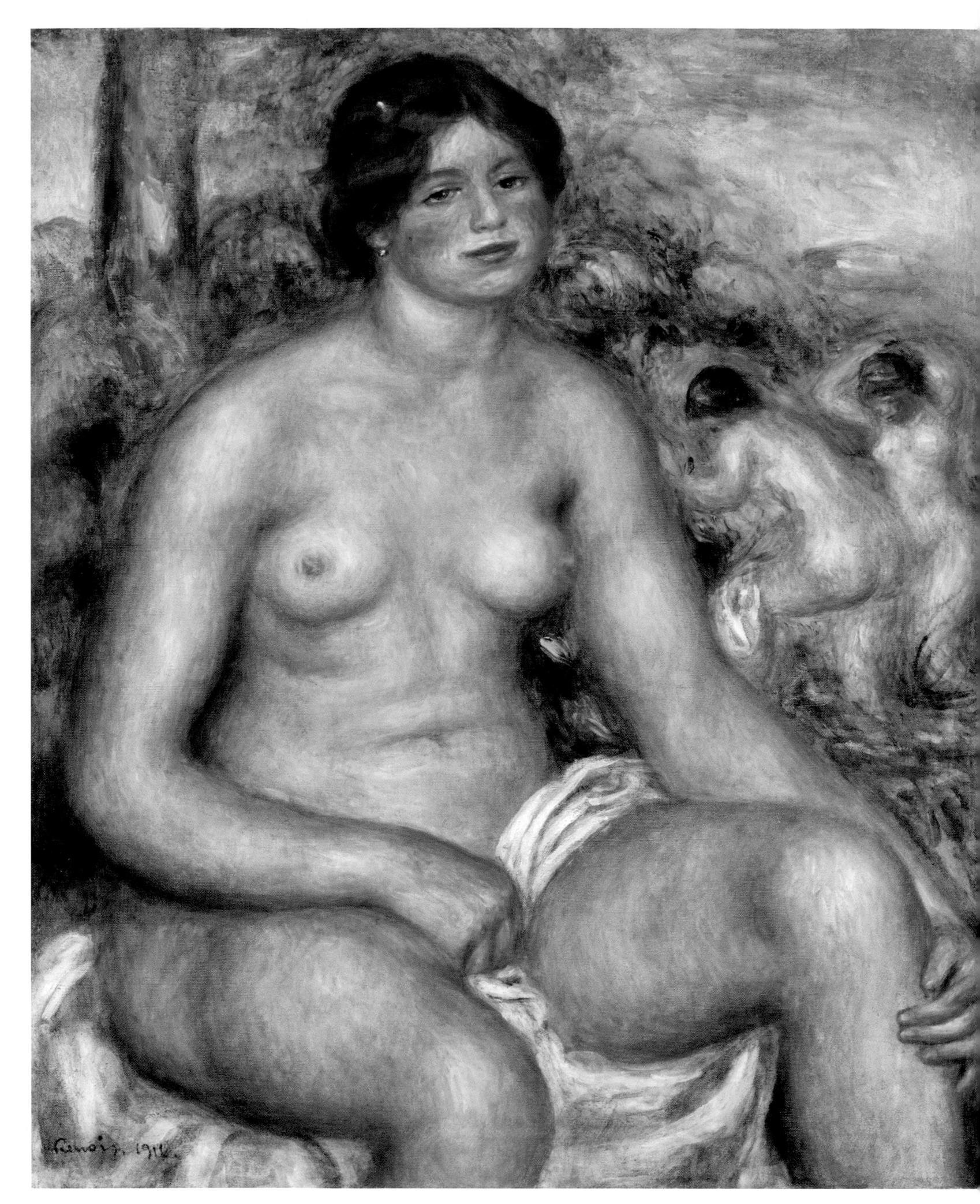

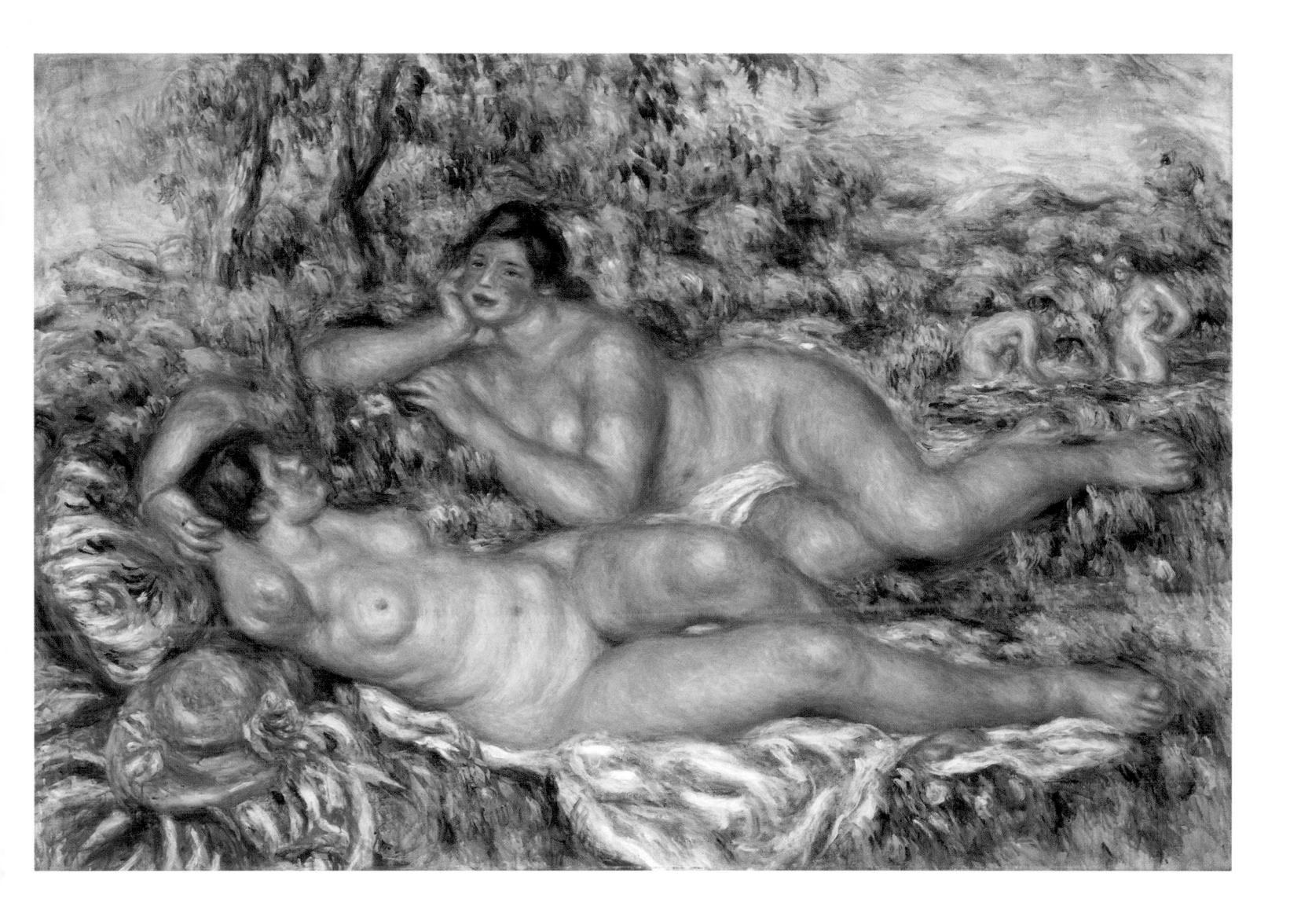

folded a world that was pure and beautiful, and he could not relate to people who wanted to see that world as being founded on a firmer and more rational basis than the cult of beauty as perceived by our senses. Such people were questioning the whole of his little world. Renoir, however, did not want to be a revolutionary. In his continuous search for new and eternal expressions of beauty he was only ever able to see and shape a part of the truth. But he never lied, and he never inflated his own ego to the extent that the proportions of reality around him became distorted. His art never humiliated or offended man. He loved man, light and eternal nature. At a time when all around him there was an increasing feeling of existential fear, uneasiness with the world of the middle classes, and despair, Renoir never ceased to show the possibility of a life of happiness and harmony in his pictures.

The Great Bathers (The Nymphs), around 1918/19
Oil on canvas, 110 x 160 cm (43.3 x 63 in.)
Paris, Musée d'Orsay

PAGE 90: **Seated Bather**, 1914 Oil on canvas, 81.6 x 67.7 cm (32.1 x 26.5 in.) Chicago, The Art Institute of Chicago

Pierre-Auguste Renoir 1841–1919: His Life and Work

1841 Pierre August Renoir born 25 February in Limoges, sixth of the seven children of Lèonard Renoir (1799–1874) and his wife, Marguerite Merlet (1807–1896). His father was a tailor.

1844 His family moves to Paris.

1848–1854 Goes to a Catholic primary school.

1849 Birth of his brother Edmond Victoire.

1854–1858 Apprenticeship as a porcelain painter. Paints flowers, and later also portraits, onto vases and plates. Also takes evening classes in drawing.

1858 The invention of a technique for printing pictures onto porcelain makes him redundant. Spends some time painting ladies' fans and colouring in coats of arms for his brother Henri, an engraver, later also transparent curtains for a decorator. Earns a lot because he works ten times as fast as others.

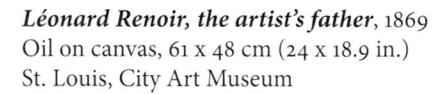

Renoir, about 1875

1860 He is admitted to the Louvre as a copyist. Studies Rubens, Fragonard and Boucher.

1862–1864 Studies at the *Ecole des Beaux-Arts* and Gleyre's studio, where he meets Monet, Sisley and Bazille.

1863 Takes up open-air painting in the woods of Fontainebleau together with Sisley, Monet and Bazille. Meets Pissarro and Cézanne.

1864 Decides to work as a painter independently and rents studio, while his family moves to Ville-d'Avray. His painting *Dancing Esmeralda* is accepted by the *Salon*, but he destroys it after the exhibition.

1865 Paints in the woods of Fontainebleau together with Sisley, Monet and Pissarro. Moves into Sisley's studio. Goes sailing on the river Seine as far as Le Havre. Meets Courbet, whom he admires. In Marlotte he meets Lise Tréhot who becomes his model.

1866 Commutes between Marlotte and Paris. Moves in with Bazille when Sisley gets married. Is rejected by the *Salon* despite recommendation by Corot and Daubigny. Paints *At the Inn of Mother Anthony* in Marlotte (illus. p. 11).

1867 Monet joints Renoir and Bazille. Diana (illus. p. 13) is not accepted by the *Salon*. Protests together with Bazille, Pissarro and Sisley, demanding a *Salon des Réfusés*. Paints *Lise* (illus. p. 14).

1868 Commissioned to paint two pictures for Count Bibesco. Portraits of Sisley and his wife (illus. p. 16). *Lise* is shown at the *Salon* and given recognition. Spends summer with Lise and parents. Frequently at the Café Guerbois, where he meets Manet and Degas.

1869 Exhibits at the *Salon* together with Degas, Pissarro and Bazille. Parents move to Voisins-Louvecienne, where he spends summer with

Self-Portrait, 1876 Oil on canvas, 73.6 x 57 cm (29 x 22.4 in.) Cambridge, Fogg Art Museum, Harvard University

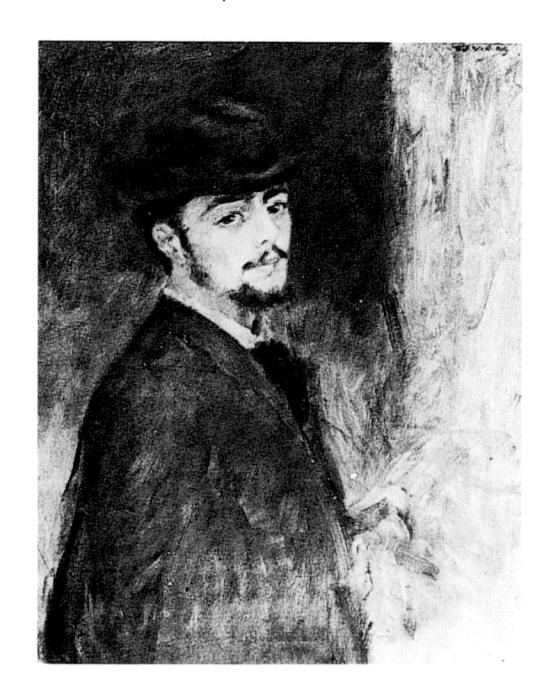

Renoir's flat at the Château des Brouillards, 13, Rue Girardon, Paris, about 1890

1870 Military service with cavalry regiment in Bordeaux July 1870 to March 1871. Bazille is killed in the war.

1871 Returns to Paris during the time of the Commune. Paints views of Paris, then stays with his parents and in Bougival.

1872 Two pictures bought by art dealer Durand-Ruel. Lise gets married. Joins Manet, Pissarro and Cézanne in signing a petition to the Minister of Culture for a *Salon des Réfusés*. Spends summer painting with Monet in Argenteuil.

1873 Meets the writer Duret at Degas's studio. Duret buys Renoir's *Lise*. Moves into larger studio at Montmartre. Spends summer and autumn painting with Monet in Argenteuil. Joins a newly founded group of independent artists which also includes Cézanne, Degas, Manet, Pissarro and Sisley.

1874 First "Impressionists' exhibition" (a term of abuse, coined by the art critic Leroy in the magazine *Charivari*) at Nadar's photographic studio. Sells three pictures, including *La Loge* (illus. p. 22). Visits Monet in Argenteuil, where he also meets Manet and Sisley.

1875 Organizes an auction of paintings together with Morisot, Sisley and Monet at the Hotel Drouot, where there are some scandalous scenes and fights. Sells twenty pictures for no more than 2254 francs. Meets the collector Choquet

Renoir with a cigarette on the staircase of his flat in the Rue Girardon, about 1890

and several wealthy merchants and bankers who buy or commission pictures. Summer in Chatou. Paints *Nude in the Sunlight* (illus. p. 30).

1876 Shows fifteen pictures at the second Impressionists' exhibition. Meets Charpentier, the publisher, and his family, who order pictures. Visits the poet Daudet in Champrosay. Paints *Le Moulin de la Galette* (illus. p. 34/35) and *The Swing* (illus. p. 37).

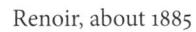

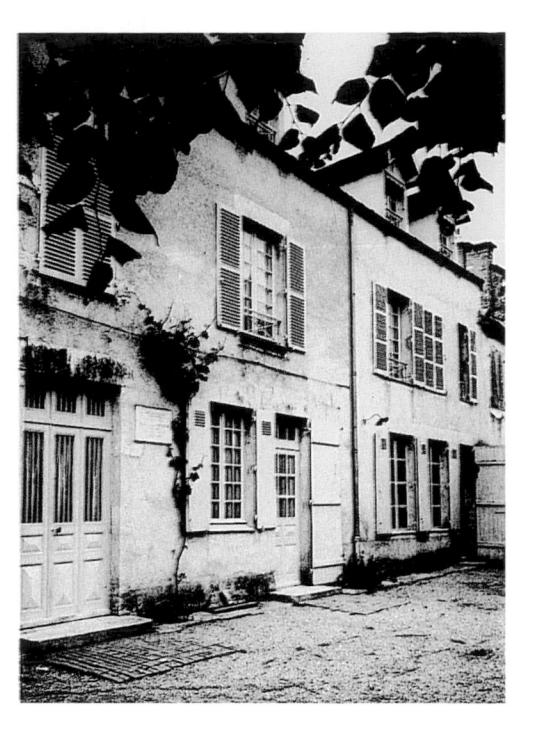

Renoir's house in Essoyes

1877 Shows twenty-two pictures together with other Impressionists. Organizes a second auction at the Hotel Drouot together with Caillebotte, Pissarro and Sisley. Sclls 16 pictures for 2005 francs.

1878 Represented at the *Salon* again after a long gap. Sells three pictures for 157 francs at the Hoschede auction. Paints *Madame Charpentier* and Her Children (illus. p. 42/43).

1879 Like Cézanne and Sisley, he does not take part in the fourth Impressionists' exhibition. Success at the *Salon* for *Madame Charpentier*. First individual exhibition on the premises of the magazine *La Vie Moderne*. Summer in Wargemont (Normandie). Paints women and children on the beach.

1880 Breaks his right arm and paints with his left. Together with Monet, he protests against unfavourable positions at the *Salon*. First doubts about his own art. Spends some time in Chatou with Aline Charigot, his future wife. Cahen d'Anvers, a banker, commissions him to paint portraits of his daughters (cf. illus. p. 49).

1881 Travels to Algeria with friends (spring). April in Chatou, where he is visited by Whistler. Paints *Breakfast of the Boating Party* (illus. p. 50), with portraits of his friends. Visits Italy in autumn and winter, including Venice (illus. pp. 56 and 57), Florence, Rome and Naples.

1882 After he returns, joins Cézanne in L'Estaque. Paints landscapes. Ill with pneumonia. Durand-Ruel shows 25 of his pictures at the seventh Impressionists' exhibition. Holiday in Algeria in March/ April. Summer in Wargemont and Dieppe.

Renoir, about 1901/02

1883 Beginning of his so-called "Dry Period". Important individual exhibition of seventy pictures at Durand-Ruel's in April. Exhibitions in London, Boston and Berlin. Summer in Etretat, Dieppe, Le Havre, Wargemont, Trepart. Spends some time on the Channel Islands with Aline. Finishes series of three "Dance" pictures (illus. pp. 64/65). In search of subjects together with Monet on the Mediterranean, between Marseille and Genoa. Visits Cézanne.

1884 Commutes between Paris and Louvecienne because his mother is ill. Plans new painters' circle. Spends some time with Aline in Chatou. Travels to La Rochelle to study Corot's landscapes.

1885 Birth of his son Pierre on 23 March. Longer holiday with Aline in La Roche-Guyon. Visited by Cézanne. Autumn in Essoyes, Aline's home. Frequently paints bathers. Attacks of depression.

1886 Shows eight pictures with the "XX" in Brussels, then thirty-two in New York. Paintings sell well. Summer with Aline and Pierre in Roche-Guyon, then in Dinard (Brittany). In October he destroys all the pictures painted during the last two months. Durand-Ruel dislikes his new style. Spends December with Aline's family in Essoyes.

1887 Finishes *Bathers* (illus. pp. 72/73). Makes friends with Morisot.

1888 Visits Cézanne in Aix, but leaves for Martigues earlier than planned. Spends summer working in Argenteuil and Bougival. In Essoyes from autumn onwards. Attack of rheumatoid arthritis and facial paralysis in December.

1889 Has to avoid the cold and works in Essoyes most of the time. Spends summer with family in Montbriant. Visits Cézanne in Aix. Refuses to participate in world exhibition in Paris. Depressions, doubt about his own work.

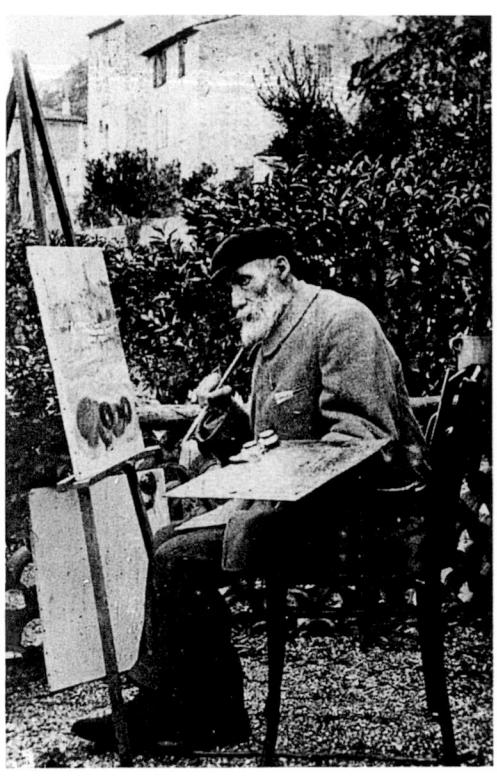

Renoir at his easel in Iront of the Villa de la Poste, Gignes-sur-Mer, 1903

1890 Exhibits pictures with the "XX" again. First etching. Marries Aline, Pierre's mother, on 14 April. Moves into the Rue Girardon on the Montmartre. Spends July in Essoyes. Visits Morisot in Mezy.

1891 Travels to Toulon, Tamaris-sur-Mer, Lavandou and Nîmes. Spends summer in Mezy. Durand-Ruel buys the three "Dance" pictures for 7500 francs each.

1892 Durand-Ruel organizes largest retrospective exhibition with 110 pictures. First purchase by French state and end of financial worries. Visits Spain together with the collector Gallimard, and admires Titian, Velázquez and Goya at the Prado. With his family in Brittany. Visits artists' colony in Pont-Aven.

1893 Seeks the warmth of the Mediterranean sun. Spends June with Gallimard near Deauville, and August with his family in Pont-Aven.

1894 Death of Caillebotte. Renoir is appointed executor. Museums are not interested in important Impressionists' collection left by Caillebotte. Gabrielle Renard, Aline's cousin, is employed as a nanny, stays until 1914 and becomes Renoir's favourite model. 15 September: birth of his son Jean, who is to become an important film director. First contacts with the art dealer Vollard. His rheumatoid arthritis forces him to walk on crutches. Seeks healing in thermal baths.

Renoir's house "Les Collettes" in Cagnes-sur-Mer

1895 Seeks refuge from the Parisian cold in Provence. Returns to attend Morisot's funeral. Spends summer with family and Gabrielle in Brittany. Breaks with Cézanne in winter.

1896 Goes to Wagner Festival in Bayreuth, Germany. Finds music boring. 11 November: death of his 89-year-old mother.

1897 Caillebotte's collection is accepted by museums. Summer in Essoyes. Falls from his bicycle and breaks his right arm.

1898 Spends summer in Berneval. Buys house in Essoyes. Travels to Holland, where he is more impressed by Vermeer than by Rembrandt. Serious attack of rheumatoid arthritis in December. Right arm paralysed.

1899 Winter in Cagnes and Nice. Paints in the open air again. Spends summer in Cloud and Essoyes, followed by health holiday in the thermal baths at Aix-les-Bains. Falls out with Degas.

1900 Spends January in Grasse. Has special health holiday for his rheumatoid arthritis in Aixles-Bains. Changes his mind and takes part in Paris world exhibition with eleven pictures. He is made Knight of the Legion of Honour. Rheumatic pains increase. Hands and arms are deformed.

1901 Another health holiday in Aix. Summer in Essoyes, where his third son Claude, called "Coco" is born on 4 August.

1902 Moves into a villa near Cannes with Aline, Jean and Claude. Has house in Essoyes extended. His health deteriorates. Weakness in his left eye, bronchitis.

1903 Because of his illness, he now spends every winter on the Mediterranean, and the summers in Paris and Essoyes. Some trouble because of forgeries of his pictures.

1904 Paints at his easel despite great pain. Has a health holiday in Bourbonne-les-Bains together with his family. Triumphant success at the autumn *Salon* (35 pictures), which gives him new courage.

1905 Finally settles in Cagnes because of climate. Shows fifty-nine pictures at an exhibition in London. The number of his admirers is steadily increasing. Exhibits at the autumn *Salon* and is made honorary president.

1906 Paints models, especially Gabrielle. Meets Monet in Paris.

1907 *Madame Charpentier and Her Children* is bought for 84,000 francs by the Metropolitan Museum, New York, at an auction. Renoir buys "Les Colettes", an estate in Cagnes, and has a house built on it.

1908 Moves into his new house. Following suggestions by Maillol and Vollard, he makes two wax sculptures. A visit from Monet.

1909 Continues to paint despite painful illness. Spends summer in Essoyes, where he finishes the two *Dancers* (illus. p. 87). Claude poses as a clown (illus. p. 86).

1910 Has a mobile easel made for himself in Cagnes, to enable him to work more easily. After some improvement in his health, he and his family travel to Wessling near Munich, where he paints the Thurneyssen family. Sees pictures by Rubens at the Pinakothek Museum. After his return, both legs are paralysed.

1911 He is now confined to a wheelchair. Has the paintbrush tied to his crippled hand with pieces of string so that he can paint. He is made Officer of the Legion of Honour. Renoir monograph by Meier-Graefe is printed.

1912 Rents studio in Nice. A new attack leaves his arms paralysed, too. Deep depression

Renoir's wife Aline and son Claude, called "Coco", 1912

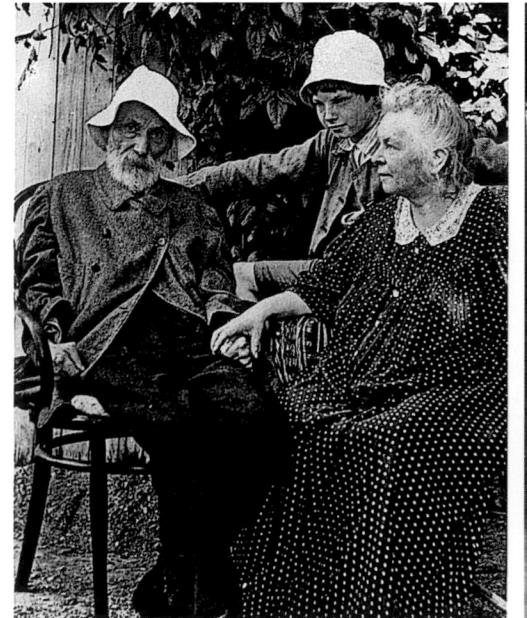

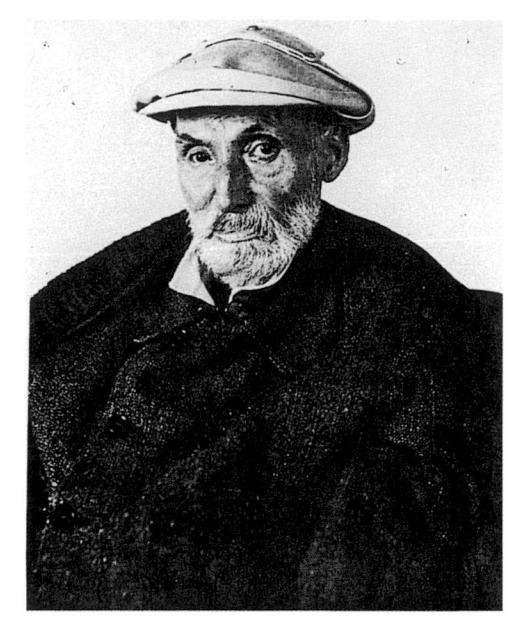

Renoir, 1914

because he cannot paint any longer. Short-term reprieve after he is operated on by a Viennese doctor. High prices at auctions.

1913 Works on sculptures together with Guino, a pupil of Maillol's. Renoir "dictates" the shapes which are then moulded by the healthy hands of Guino.

1914 Renoir is visited by Rodin. Pierre and Jean have to serve in the army and are wounded in the war. Hard times for Aline and Renoir. Gabrielle Renard marries and leaves Cagnes.

Renoir in a wheelchair with Andrée Heuschling, called "Dédée", 1915

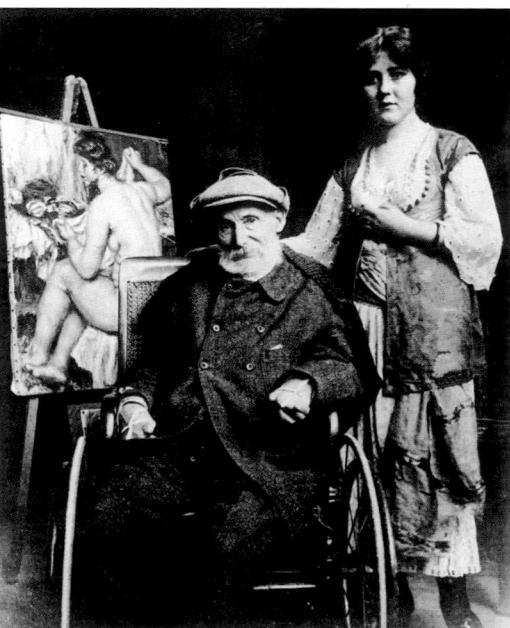

1915 Jean is badly wounded again. Aline dies in Nice on 27 June at the age of 56 and is buried in Essoyes. Renoir is carried to his easel every morning and continues to work. Has a garden studio built in Cagnes, to enable him to work in the open air again.

1916 Although he can hardly sleep at night, he feels revived again by his work. Takes Guino with him to Essoyes.

1917 A picture by Renoir is displayed at the National Gallery in London. He is visited by Vollard in Essoyes. Exhibits 60 paintings in Zurich. The end of his work with Guino. A visit from Matisse.

after a Bath (illus. p. 91) in great pain. He is made Commander of the Legion of Honour. Spends July with his sons in Essoyes. Visits the Louvre where one of his pictures is displayed next to Veronese. In his wheelchair he is wheeled through the various rooms like a "Pope of Painting". November: pneumonia, which results in congestion of the lungs. Paints one more still life with apples. Dies in Cagnes on 3 December and is buried in Essoyes, next to Aline, on the 6th.

Pierre-Auguste Renoir's grave, as well as those of his son Pierre and his wife Aline (left) in the Essoyes cemetery

Photo Credits

The publisher wishes to thank the museums, private collections, archives, galleries and photographers who gave support in the making of the book. In addition to the collections and museums named in the picture captions, we wish to credit the following:

akg-images, Berlin: 14 right, 66, 67 left – photo Erich Lessing: 52

Courtesy The Art Institute of Chicago, Chicago: 45, 51, 53, 54, 90

ARTOTHEK, Weilheim – photo Blauel/Gnamm: 84 – photo Ursula Edelmann: 27 right – photo Jochen Remmer: 09 – photo Peter Willi: 86 The Baltimore Museum of Art, Baltimore: 75 right Bildarchiv Preußischer Kulturbesitz, Berlin: 58 The Cleveland Museum of Art, Cleveland: 06, 67 right

Winterthur: 24 Courtauld Institute Gallery, London: 22 Foundation E.G. Bührle Collection, Zurich: 49 Giraudon, Paris: 63, 68 The Metropolitan Museum of Art, New York: o2, 42/43, 75 left, 80 The Minneapolis Institute of Arts, Minneapolis: 57 Museu Calouste Gulbenkian, Lisbon: 23 Museu de Arte de São Paulo, São Paulo, Assis Chateaubriand, photo Luiz Hossaka: 74 Courtesy Museum of Fine Arts, Boston - All Rights Reserved: 64 right Museum Folkwang, Essen, photo J. Nober: 14 left The National Gallery, London/akg-images, Berlin: 47 The National Gallery, London, Picture Library:

29, 61, 87 left, 87 right

Collection Oskar Reinhart "Am Römerholz",

National Gallery of Art, Washington © Board of Trustees: 13, 18, 26, 33, 41, 70 Norton Simon Art Foundation, Pasadena: 15 The Philadelphia Museum of Art, Philadelphia: The Phillips Collection, Washington: 50 Rheinisches Bildarchiv, Cologne: 16 RMN, Paris – photo R.G. Ojeda: 25 – photo Hervé Lewandowski: 27 left, 30, 34/35, 37, 40, 65 left, 65 right, 79, 82, 91 - photo J.G. Berizzi: 38 photo C. Jean: 83, 86 left Scala, Florence: 88 Sotheby's Picture Library, London: 20 Statens Konstmuseer, Stockholm: 11, 19 Sterling and Francine Clark Art Institute, Williamstown: 56 Wadsworth Atheneum, Hartford: 86 right